R & D FRAMING CO.
529 DEINES CT.
FT. COLLINS, CO 80521
PH: (303) 484-7394

Practical Guide to
PRINT COLLECTING

Ann Buchsbaum

VNR VAN NOSTRAND REINHOLD COMPANY
New York Cincinnati Toronto London Melbourne

Acknowledgements

It was a joy to spend so much time and thought on art, and especially on graphic art. It is my hope that you will share this enjoyment with me and that the information contained in this book will serve you well.

It is customary to acknowledge help given the author. I have received much assistance from curators, galleries, and photographic departments. My appreciation for their time, interest, and willingness to assist me is very sincere, as it is for the cheerful and able typing job by Inge Seymour.

Three persons deserve special thanks. They have contributed even more than the others. George Parker encouraged me in the nicest possible way when I needed it the most. To gain him as a friend was a special kind of experience. Leonard Slatkes taught me about art and scholarship. At the outset he was a mentor; in the end he was a friend. He is an unending source of knowledge and has the ability to stimulate his students to reach for high goals and achieve them. Much of the information in this book is a direct or indirect result of his lectures. Daisy Belin deserves and has my unending affection. She read the manuscript and supported me with praise and much-needed constructive criticism. I thank her for her time, her interest, her patience, her suggestions, her corrections, and her advice.

In this age of woman's liberation it pains me to admit that I needed my husband's help. He provided it above and beyond the call of duty. Not to my "better half" but to my "other half" I dedicate this book. Though his name does not appear as coauthor—it should.

One more name belongs here, though he did not contribute to the material in the book. Thank you, Bob, for being.

Van Nostrand Reinhold Company Regional Offices:
New York Cincinnati Chicago Millbrae Dallas
Van Nostrand Reinhold Company International Offices:
London Toronto Melbourne

Copyright © 1975 by Litton Educational Publishing, Inc.
Library of Congress Catalog Card Number 75-2819

Designed by Loudan Enterprises

Published in 1975 by Van Nostrand Reinhold Company
A Division of Litton Educational Publishing, Inc.
450 West 33rd Street
New York, NY 10001

Van Nostrand Reinhold Limited
1410 Birchmount Road
Scarborough, Ontario M1P 2E7, Canada

Van Nostrand Reinhold Australia Pty. Ltd.
17 Queen Street
Mitcham, Victoria 3132, Australia

Van Nostrand Reinhold Company Ltd.
Molly Millars Lane
Wokingham, Berkshire, England

16 15 14 13 12 11 10 9 8 7 6 5 4 3 2 1

Library of Congress Cataloging in Publication Data

Buchsbaum, Ann.
 Practical guide to print collecting.

 Bibliography: p.
 Includes index.
 1. Prints—Collectors and collecting. I. Title.
NE885.B77 760'.75 75-2819
ISBN 0-442-21138-4

Illustrations

Connoisseurs of Prints, John Sloan, 7

1-1. Relief method, 9

1-2. Intaglio method, 9

1-3. Planograph method, 9

1-4. *Saint Hieronymus*, 11

1-5. Wood block for *Samson and the Lion*, 12

1-6. *Samson and the Lion*, Albrecht Dürer, 13

1-7. *Te Faruru*, Paul Gauguin, 15

1-8. *Joachim and Anna at the Golden Gate*, Albrecht Dürer, 16

1-9. Detail of 1-8, 16

1-10. *Male Nude Seated in a Landscape*, Antonio da Trento, 19

1-11. Wood engraving for *Reynard the Fox*, Fritz Eichenberg, 20

1-12. Drawing of hatching, 22

1-13. *La Torre di Malghera*, Antonio Canale, 22

1-14. Detail of 1-13, 22

1-15. *Le Champ de Choux*, Camille Pissarro, 24

1-16. *Good Advice*, Francisco Goya, 26

1-17. Detail of 1-16, 26

1-18. *Clump of Trees with a Vista*, Rembrandt van Rijn, 28

1-19. Detail of 1-18, 28

1-20. *The Knight, Death and the Devil*, Albrecht Dürer, 30

1-21. Detail of 1-20, 31

1-22. *Passing Storm*, Martin Lewis, 32

1-23. *Mlle. Lender*, Henri de Toulouse-Lautrec, 35

1-24. Detail of 1-23, 35

1-25. *Souvenir d'Italie*, Jean-Baptiste-Camille Corot, 37

1-26. *Homage to Frederick Kiesler*, Robert Rauschenberg, 38

1-27. *Double Gray Scramble*, Frank Stella, 40

1-28. *Untitled*, Chris Keith, 41

1-29. *The Milk Maid*, Lucas van Leyden, 45

1-30. *Three Girls*, Suzuki Harunobu, 45

1-31. *Adoration of the Magi*, anonymous, 46

1-32. *Edmond Picard*, Odilon Redon, 46

1-33. *Self-Portrait*, Edgar H. G. Degas, 47

1-34. *Portrait of Dostoievski I*, Max Beckmann, 48

1-35. Illustration for Molière, L. Cars, 49

1-36. *Polypheme*, Henri Matisse, 50

1-37. *Femme au Bain*, Aristide Maillol, 51

1-38. *The Old Painter's Studio*, Pablo Picasso, 51

1-39. *Christ before the City*, Georges Rouault, 52

1-40. *Hinged Canvas*, Jasper Johns, 53

1-41. *Still Life With Picasso*, Roy Lichtenstein, 54

1-42. *Embossed Linear Construction 2A*, Josef Albers, 55

2-1. *Girl with Parted Lips*, Raphael Soyer, 58

2-2. *Untitled*, Joe Goode, 59

2-3a. *L'Apside de Notre Dame*, Charles Meryon, 60

2-3b. *L'Apside de Notre Dame*, Charles Meryon, 60

2-4. *La Mort du Vagabond*, fourth state, Alphonse Legros, 61

2-5. *La Mort du Vagabond,* tenth state, Alphonse Legros, 62

2-6. *La Mort du Vagabond,* sixth state, Alphonse Legros, 63

2-7. *The Violinist,* D. C. Sturges, 67

2-8. Oxhead watermark, 70

2-9. Collector's mark, 70

2-10. Provenance, 72

3-1. Mold and deckle, 76

3-2. Laid mold with watermark, 77

3-3. *The paper maker,* Jost Amman, 77

3-4. French paper mill, book illustration, 78

3-5. Paper drying loft, book illustration, 78

3-6. Watermark design in the mold, 80

3-7. A 15th-century watermark, 80

4-1. *Marriage at Cana,* lectern cloth, 85

4-2. *Madonna and Child in a Glory with an Indulgence and a Prayer,* 87

4-3. *Saint Valentine,* 88

4-4. An Easter calendar beginning with the year 1466, 89

4-5. Map of Mexico City, Giovanni Batista Ramusio, 90

4-6. Illustration from an emblem book, Christopher von Sichem, 92

4-7. *Les Grandes Misères de la Guerre,* plate 8, Jacques Callot, 93

4-8. *Rue Transnonain, le 15 avril 1834,* Honoré Daumier, 93

5-1. *Les Drames de la Mer; Une Descente dans le Maelstrom,* Paul Gauguin, 101

5-2. *The Prophet Joel,* 103

5-3. Verso of 5-2, 103

5-4. Detail of 5-2, 105

6-1. *Jan Lutma the Elder,* second state, Rembrandt van Rijn, 109

6-2. *Jan Lutma the Elder,* first state, 111

6-3. *Jan Lutma the Elder,* third state, 112

6-4. Detail of second state, 113

6-5. Detail of window from third state, 113

6-6. Details of 6-2 and 6-3, 114

6-7. *The Rialto,* James McNeill Whistler, 118

6-7a. A Whistler butterfly, 118

7-1. *19.9.68,* Pablo Picasso, 127

8-1. Drawing of print properly mounted, 134

8-2. *Le Graveur Joseph Tourney,* Edgar Degas, 136

Contents

Introduction 6

1 A Print is a Print is a Print 8

2 There is More to It than Meets the Eye 57

3 If Paper Had Never Been Invented . . . 73

4 Once Upon a Time . . . 84

5 The Discerning Eye 97

6 The Moment of Truth—Authenticating a Print 107

7 Art Dealers 120

8 Tender Loving Care 132

9 Let's Talk Printese: A Glossary 139

10 Read, Read, Read: A Bibliography 144

Index 154

Introduction

It is obvious you are already interested in art. You share this interest with the growing number of people who visit art museums and galleries. This interest in art brings with it an awareness and appreciation of original works of art—those made by the artist—rather than reproductions.

Few of us can afford two million dollars for an oil by Rembrandt, but a great many can afford to own a print by this great artist. Prints are original art and are available in a wide price range. This is only one reason for the increasing popularity of graphic art. Each print from an edition is an original, provided it was made by the artist or at his request. The fact that prints are multiple originals makes it possible for a greater number of people to own them and brings their price into realistic proportions. The steadily rising popularity and appreciation of prints has also made them an excellent source for investment. A look at the stock market page will show that even a blue-chip stock like A.T.&T. has not gone up in value sufficiently to keep in step with inflation. In real estate a house that cost $30,000 ten years ago will have at least doubled in value. The story of the print market is quite different. Like all print lovers and collectors, I regret not having bought *that* Picasso lithograph, signed and numbered, edition 150, for $325 (now valued at upwards of $3,000) or *that* Rembrandt etching, an early authenticated work at a reliable gallery, for $450 (today worth about eight times as much).

By learning to understand and evaluate prints, you will be in a position to protect your investment, make sound decisions, and, most importantly, enjoy the work of art more than ever. Establishing a rapport with a work of art is a beautiful experience that might be compared to meeting another person on a close, intimate level. It has the aura of a charismatic, magical happening. You may want to own it, get to know about it, and find out why this particular work captured you, where it was before you found it, what the artist's greatness was. Ultimately the true work of art becomes a living thing, and it can be viewed just like a person—with respect, admiration, understanding, and love.

This book concentrates on the most practical as well as some aesthetic aspects of "print learning." It will capitalize on your interests and intelligence—without driving you to boredom. Whatever knowledge you already have in the field of the humanities will be helpful. If you are inclined to pursue an area of interest further, you will be well rewarded with the knowledge gained.

At the outset you will be shown the differences in printmaking media and their unique possibilities. The next chapter deals with states, signatures, editions, paper, and watermarks. Chapter 3 delves deeper into the subject of paper, the common denominator of almost all prints. Chapter 4 places printmaking in perspective, locating artists in their historical settings and showing the impact of the times on their styles and thought. Andy Warhol, for example, simply could not have painted a can of tomato soup in the seventeenth century, since cans did not exist then. The next two sections will show you how to look at prints with greater skill to distinguish quality. At this point you can put your knowledge to use, gain experience, and—in the process—possibly discover a treasure. The essential tools of practical research are explained to help you in your detective work. A discussion about galleries and auctions follows. You will, of course, want to give your collection the care it deserves; the information in Chapter 8 will be valuable to you in this respect. The remaining two chapters include handy reference material, a glossary and a bibliography.

The secret in the understanding of graphic art is an interaction of three things; knowledge of the artist's work and time, knowledge of the technical possibilities in a medium, and a trained eye. You can acquire them all and enjoy the result.

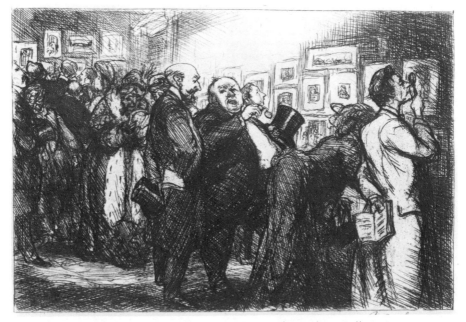

Connoisseurs of Prints by John Sloan. (Courtesy of Kraushaar Galleries)

1. A Print is a Print is a Print

In order to become an astute print collector, you will want first to become familiar with the various methods of producing graphic art so that you can recognize them easily. Admittedly this is not always very simple, especially with the contemporary works that employ mechanical methods. It takes experience to recognize an aquatint or to tell a soft-ground etching from a lithograph. This chapter explains the different print media that are used in fine-art prints and includes typical examples.

Graphic-art processes can be divided into four groups: relief, intaglio, planograph, and—for lack of an official name—mechanical "now" methods. In the relief method we are mainly concerned with the woodcut. The line to be printed is *raised*—or in relief—on the wood block, as seen in Fig. 1-1.

Intaglio is a term applied to incised or "cut in" methods, such as etching, aquatint, drypoint, engraving, and mezzotint. Here the line to be printed is cut into the matrix, etched into the plate, or gouged out from the surface of the plate. The matrix is frequently metal, but it may be of any suitable material, such as lucite. At any rate, the line to be printed is *below* the surface, as shown in Fig. 1-2. This is exactly the opposite of the relief line.

A planographic line is *neither* above nor below, but level with the surface, as shown in Fig. 1-3. A lithograph employs this method. The drawing is made on the prepared stone with a crayon.

Contemporary graphics, in addition to using the above media, also involve the use of the latest automatic machinery. Offset lithography, computer prints, and screen and stencil processes belong in this group.

The following pages contain explanations of these four general types of printmaking methods. For even more detailed information, you will find a large quantity of literature written by specialists in each medium. Refer to Chapter 10 or look at the listings in most libraries under Graphic art.

Usually the artist has good reason for his choice of method. Either it allows him to experiment to get new effects or the medium is particularly suitable to his style of working and personality. A good work of art is the

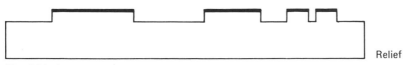

Relief

Wood Block

Fig. 1-1. Drawing showing relief method, as in woodcut. In this process only the raised surface gets inked and is printed. The undesired parts are cut away and thus leave a raised design.

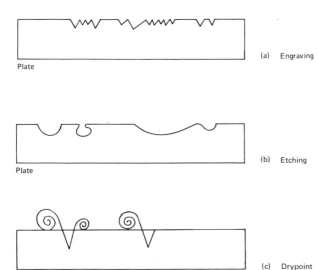

Plate

(a) Engraving

Plate

(b) Etching

Plate

(c) Drypoint

Fig. 1-2. Drawing showing intaglio method. (A) Engraving, (B) etching, (C) drypoint. Lines are below the surface; grooves hold ink for printing. In drypoint, ink is also retained above the surface, in the burr. Width and depth of lines relate to the tool or mordant used. Some variations are indicated.

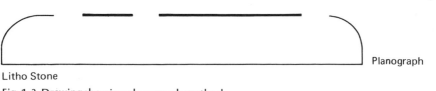

Planograph

Litho Stone

Fig. 1-3. Drawing showing planograph method, as in lithography. This process is neither below nor above the surface; printing is done *on* the surface.

result not only of the creative effort but also of craftsmanship, thorough understanding, and proper use of the processes involved. A lack of craftsmanship will prevent the artist from expressing himself freely.

Through the centuries of printmaking, different approaches have been used to obtain the finished impression. In the time of Albrecht Dürer, the fifteenth and sixteenth centuries, a powerful guild system—somewhat comparable to present-day labor unions—prevailed. Dürer himself was trained as a goldsmith. Belonging to this guild permitted him to do the metal engraving for his prints himself. The woodcuts were a different story, and the law of the land required him to have the block cut by a woodcutter, or *Formschneider,* as he was called. Unfortunately there were no sophisticated cutters available. There is much debate among scholars as to just who did the cutting of the Dürer wood blocks. Possibly he trained cutters to the excellence he required; possibly he cut some blocks himself. At that time printing usually was done only by printers who had served their apprenticeship and were members of their guild. The same applies to paper makers and all other craftsmen. Yet, it is known that Dürer owned his own press and workshop, and we must assume that this unusual condition was not only for possible financial gain, but—more importantly —for the artistic advantage it offered. Rembrandt did some printing himself, and those prints are at a premium today. These works differ in choice of paper, in color of ink, and in the wiping of the plate after inking. Very likely he did not pull a whole edition himself, but had it done by skilled printers. Unquestionably, both Dürer and Rembrandt thoroughly understood the whole printmaking process.

As a greater variety of techniques and equipment became available in printmaking, the artist was less and less involved in the total process. At the present time, artists both accept and reject our age of science. On the one hand, some are purists in the sense that they use handmade paper and their own presses and execute a graphic work from start to finish by themselves. On the other hand, the latest in technical know-how is applied, including automation and computerization. Plastic materials are used, colors are mixed by industrial and chemical formulas, aluminum foil replaces paper, photo-offset is used to print, and Fortran (a computer language) is the means toward a visual end called computer graphics.

The art collector, print lover, or investor must decide whether to accept all these new creative efforts as original and valuable art. Much controversy and discussion rages on the topic—on the validity of the use of industrial processes and on the frequent lack of direct contact of the artist with his work. Do not come to your own decision without having considered seriously the advantages and the drawbacks. Inform yourself and keep an open mind; accept or reject on the basis of knowledge rather than on emotional impulse.

As mentioned earlier, knowledge of this field requires initial familiarity with the printmaking processes. The descriptions below will serve to clarify the terms as they are used throughout the book.

RELIEF PROCESSES
Woodcut

The earliest form of printmaking on paper is the woodcut. This relief method dates back certainly to the fifteenth century, probably earlier. The first woodcut bearing a date is a German work from 1423: Saint Christopher crossing a stream with the Christchild on his shoulder. At the outset the woodcut had a crude and simple appearance. Figures and shapes were only outlined, and the line itself was rather crude. Fig. 1-4 is an illustration from an Italian book dated 1497. Many of the early woodcuts appeared in books. More about that in Chapter 4.

The woodcut process became more and more refined in a relatively short time and culminated in the work of Albrecht Dürer (1471–1528). Most experts agree that no one has as yet surpassed him in the art of the woodcut. The wood block in Fig. 1-5 and the impression taken from it in Fig. 1-6 give a good idea of Dürer's talent. Early prints were made by hand rubbing the paper on the wood block. By the time this block was printed, hand presses were used. In northern Europe a strong guild of woodcutters had been formed, and they had refined the craft of preparing the block according to the artist's/designer's instructions.

Fig. 1-4. *Saint Hieronymus (Saint Jerome)*. Early woodcut illustration, 1497. (Courtesy of Lucien Goldschmidt.)

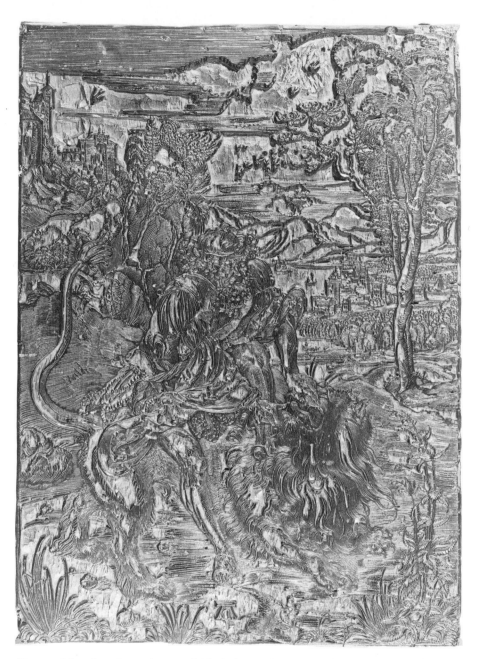

Fig. 1-5. Albrecht Dürer. The wood block from which the impression shown in Fig. 1-6 (*Samson and the Lion*) was taken. (Courtesy of The Metropolitan Museum of Art, Gift of Junius S. Morgan, 1919.)

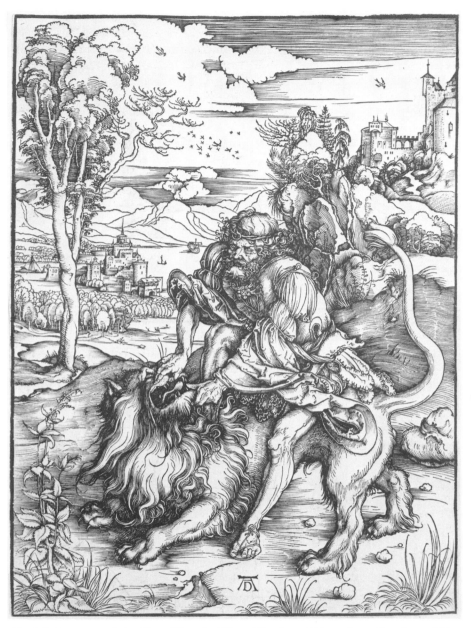

Fig. 1-6. *Samson and the Lion*, Albrecht Dürer. Woodcut, 15th century. (Courtesy of The Metropolitan Museum of Art, Gift of Junius S. Morgan, 1919.)

The medium became less useful in the ensuing years, but it came into its own again in modern and contemporary art. The modern woodcut differs considerably in appearance from its predecessor. Now the emphasis is placed more on the wood-grain texture—as may be seen in Fig. 1-7—and on the color woodcut.

The ultimate result in a woodcut depends not only on the ability of the artist and/or the cutter, but also on the material used. (There are, as you are undoubtedly aware, soft woods and hard woods, long-grained and short-grained ones. The best craftsman cannot accomplish thin, fine, close lines in a long-grained, soft wood. See Chapter 3 for a further explanation of wood types.) The wood is cut away from both sides of the desired black line, as shown in Fig. 1-1. Ink is applied to the raised surfaces that remain after the cutting is done, the block is placed in the press, paper is placed on it, and a print results. The pressure of the press is fairly strong, and it should be as even as possible. The platemark of a woodcut is not a very deep one, since it is a relief print. Consider how the printing process affects the wood block. The whole block can crack; some lines may break off; some lines may break in the middle, crack somewhere, or simply show signs of wearing down. The latter is frequently noticed on the older prints, where the lines become shorter and thinner. In other words, the print becomes whiter, since there is less relief surface available to be inked. The condition of the block is of great importance to the print collector. Being able to distinguish and detect these damages or signs of wear allows you to recognize good-quality impressions (and often determine their authenticity) as well as make a valid judgment regarding their price.

Fig. 1-8 serves as an example of a good woodcut. It shows fine craftsmanship in the cutting of the block, combined with good printing on fine paper. This Dürer impression has very few flaws, the lines are clear, the block is still fresh and not worn. If you look at the female figure in the foreground you will notice an interruption of line along the contour of her lower back, as well as on the line across her shoulder. This might have been done on purpose, but more likely the wood broke in those spots, either while the block was cut or in the earliest stages of printing. In an impression taken later in the edition, some of the fine line endings would be worn down or have disappeared—creating white spaces. The heavier lines would be less sharp and less crisp, since the edges would be worn down. As mentioned above, the wood wears away or splits off, less surface is available to be inked, and a generally lighter impression results.

The cutting of the blocks requires a great deal of skill. Fig. 1-9, a detail of Fig. 1-8, shows the swelling and tapering of the line in the Dürer woodcut. The undulation causes more or less shading—i.e., darker effects where the lines are thicker, and vice versa. They may be closer together or farther apart to create dark and light areas. Cross-hatching is possible. Consider that all unwanted parts must be cut away in order to remain with the tiny squares of the hatching. Crossing of lines is another difficulty in the cutting, especially when the already cut part consists of fine (thin) lines.

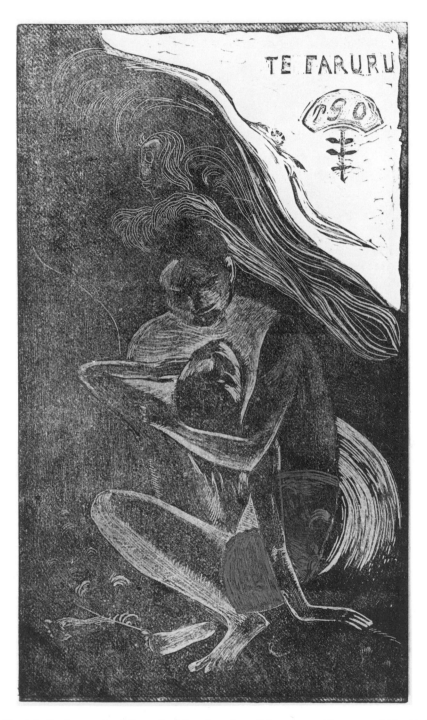

Fig. 1-7. *Te Faruru*, Paul Gauguin. Woodcut, late 19th century. (Courtesy of The National Gallery of Art, Rosenwald Collection.)

Fig. 1-8. *Joachim and Anna at the Golden Gate*, Albrecht Dürer. Woodcut, 1504. (Photo by M. Horowitz.)

Fig. 1-9. Detail of Fig. 1-8.

The choice of wood and its grain are considerations that will affect the end result as well. The thickness, absorbency, and color of the paper, and the type of ink used, are of great importance to the finished print.

As many as 500 impressions can be pulled from a hardwood, end-grain block. Certainly the first and the last will not be of equal quality or crispness in line. Not all prints in an edition will be equally good, particularly if they are done by hand rubbing or hand press. The variations of pressure, of lighter or uneven inking, of paper within the edition, produce differences in quality. The collector may find that the better impression costs a lot more. Often impressions are offered for sale or auction with more than one example from the same edition, and the prices may vary considerably. The difference in quality is reflected in the price. My personal view on this matter is that one should buy the best possible quality of a work for investment as well as for aesthetic pleasure. Even if the print market were depressed, the top-quality works would always retain their value, much like a pure white, flawless diamond. In the rising print market the top-quality impressions are the ones that set the pace.

Woodcuts need not be only black and white. If color is desired, the artist makes the complete design and then cuts a block for each color. Let us assume that it is a figure outlined in black, with a red hat, purple blouse, and blue pants. The key block would be the black one, another block would be red, and another blue. Purple is the result of blue and red, so it does not require a separate block. In order to print the color exactly where it is needed, a mark is placed on the key block and then transferred to all the others. This is called the register. If the blocks are off register (not properly aligned), the color will print sloppily, spill across other color areas or lines, and generally spoil the total effect. To print a color woodcut, each sheet of paper is run through the press with each color block. In the above example, the paper would be printed three times. Each time the paper is dampened, perhaps slightly stretched, and then dried. The larger the number of blocks, the more complicated the printing and aligning. During the printing and drying, the order in which the impressions are produced might be mixed up. When the edition is finished, the artist signs and numbers each impression. Thus, low or high numbers are really not of much consequence.

When you have an opportunity to examine a nineteenth-century Japanese master print, look at the clarity of line, the perfect alignment of color, and the intricate design. Bear in mind that each color is printed from a different block—sometimes ten or more—each of which must register correctly. In the Orient the color woodcut has reached a high level of craftsmanship, in printing and in the cutting of the blocks.

Chiaroscuro Woodcut

In the sixteenth century, particularly in Italy but also in Germany, chiaroscuro woodcuts were very popular. They provided a way to introduce color, achieving three-dimensionality and highlights in printmaking. *Chiaroscuro* is an Italian word meaning light and dark (*chiaro* = light, *oscuro* = dark). It is a term applied to paintings that make use of strong light contrast to get a sense of volume and dramatic effects. A woodcut made in the chiaroscuro manner is shown in Fig. 1-10. It is easily recognizable by its white highlights, which are saved out (i.e., the white of the paper); all else is printed. The method requires two or more wood blocks, which must be very carefully aligned to each other. Just as in the color woodcut, each color has its own block (called a tone block in the chiaroscuro technique). The key block is the one that carries the total design. It is not absolutely necessary to print it in black, nor does every chiaroscuro or color woodcut have a key block. Whether or not the design requires a key block, all the blocks of the color design must be in perfect register. Since this may involve as many as fifteen and even more, this process is quite difficult. The background is generally rather softly tinted and often has a tone-on-tone color design. This is accomplished with layers of translucent ink in graduated tones. Each tonality requires a separate block. All the white lines are left untouched—they are not done in white ink.

In spite of the fact that a chiaroscuro woodcut may appear a little crude at first glance, this art form is one that requires great skill in the preparation of the blocks and in the printing, and, on closer examination, it is really quite delicate. A well-executed design has a sense of volume and depth that is rarely found in a black-and-white woodcut.

Chiaroscuro effects may also be obtained by using tinted paper and printing one of the color blocks in white. This, however, is not true chiaroscuro in its traditional sense.

Wood Engraving

Wood engraving, like the woodcut, is a relief process. It differs in that the engraving can be made only on very hard wood with short grain. Usually the end grain rather than the wide grain is used, and boxwood is a preferred material (cross grain). The engraving tool used is the same as that used for metal engraving.

Wood engravings were very useful as book illustrations because the hard wood block made it possible to print as many as 500 good impressions before it wore down. For reproductive printing, such as books, where there is a need for large quantities, a metal cast may be made of the final wood engraving and it, rather than the wood block, is used in the press.

This method was particularly popular in the nineteenth century, but it is still in use, as seen in Fig. 1-11. Dürer's work is often referred to as wood engraving, since he used fine tools and end-grain wood blocks.

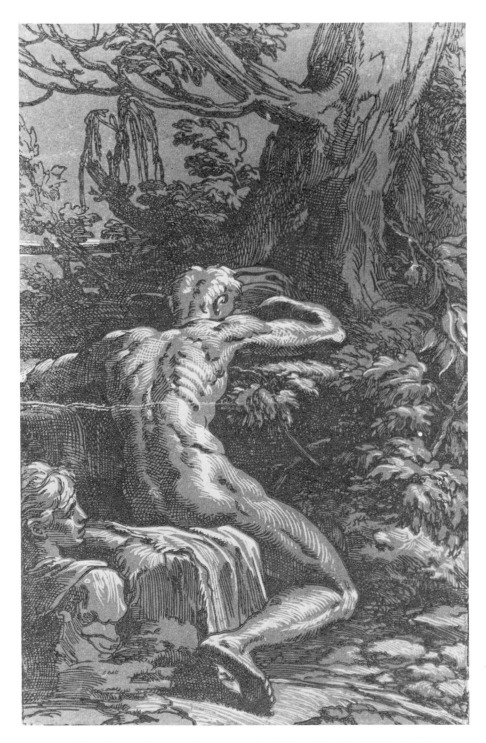

Fig. 1-10. *Male Nude Seated in a Landscape,* Antonio da Trento (after Parmigianino). Chiaroscuro woodcut, 16th century. (Courtesy of Lucien Goldschmidt.)

Fig. 1-11. Fritz Eichenberg. Wood engraving
for J. W. von Goethe's *Reynard the Fox*, 1954.
(Courtesy of the artist.)

INTAGLIO PROCESSES
Etching
The origin of etching is somewhat obscure. It may be an outgrowth of etched glass or of metal etching done by goldsmiths. Etching, an intaglio technique, is a more complicated process than woodcutting. The old masters generally worked on copper plates, but zinc and iron were used too. The metal is first covered with a waxy substance, called a *ground,* and the artist draws his design into the ground with an etching needle, thus removing the covering only where the line was made. Next the plate is placed in an acid bath, called a *mordant.* The acid attacks the exposed metal—i.e., the areas from which the ground is removed. Each immersion in acid is called the *bite.* Depending on the length and strength of the acid bath, the bite will be weaker or stronger and the resulting lines will print darker or lighter.

Etching allows a wide range of tonal variation, and different means are available to the artist to achieve this. He may etch thinner or wider lines into the ground. The etched wider lines, of course, will hold more ink and appear more black. Hatching and cross-hatching, as shown in Fig. 1-12, are possible. The closer the lines, the darker they will appear. Multiple bites are possible for achieving darker and lighter effects. Assume that a design is made on the plate and bitten perhaps for thirty minutes. The ground is removed, the plate is inked, and a working proof is taken. The etcher then decides that some areas need to be darker. He then applies ground again or varnishes those areas that he finds satisfactory in order to protect them and again places the plate in the acid bath. This process is called *stopping out,* and it may be repeated as often as desired.

Another possibility would be to etch first the part of the design that must be darkest. Then remove the plate from the acid and add to the design by working into the ground and biting the plate a second time. Since the portion exposed previously is exposed a longer time to the acid, it will be bitten deeper and so print darker. In Fig. 1-13, this may well have been the procedure used. The foreground is much darker than the sky or the walls of the tower. Note the difference in line distance or closeness, as well as the difference in depth or strength of line between those in the sky and those in the bushes at the bottom of the tower (near the edge on the right). The detail (Fig. 1-14) helps accentuate the marked differences.

When possible, study graphics with a good enlarging lens in order to develop your ability to recognize good, crisp lines. Fig. 1-13 is remarkably close to a drawing, and it is precisely this similarity that has made etching such an excellent medium for the greatest draftsmen in the history of art. Until lithography, it was the only printmaking method that allowed the artist the unhampered freedom of line.

The etcher can choose a softer or harder ground. A soft-ground etching is made by applying a soft mixture like beeswax to the plate. Then a sheet of paper is laid on it and the drawing is done on the paper. When the paper is removed, the soft ground sticks to the underside of the sheet where the lines were drawn, and thus exposes the metal surface of the plate. The

Parallel Hatching

Cross-Hatching

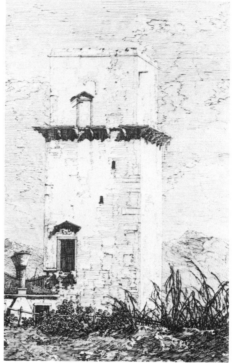

Fig. 1-12. Drawing of parallel hatching and cross-hatching.

Fig. 1-14. Detail of Fig. 1-13.

Fig. 1-13. *La Torre di Malghera*, first state, Antonio Canale, called Canaletto. Etching, 18th century. (Courtesy of Lucien Goldschmidt.)

22

biting procedure is the same as described before, but the texture of paper and pencil will remain. Some soft-ground etchings may be mistaken for lithographs, as shown in Fig. 1-15. A comparison between Fig. 1-13, a hard-ground etching by Canaletto, and Fig. 1-15 clearly indicates the differences between the two methods.

When the artist is finished with the plate, it is cleaned and all ground is removed. It is then inked carefully until all grooves are well filled, and the superfluous ink on the plate surface is wiped off. Etchings are printed with a press that uses considerable pressure to make the impression. As in all intaglio processes, the lines on the paper will be embossed, however faintly. Copper is a rather soft metal, and as the copper plate is put through the press again and again, it begins to wear. This makes a considerable difference in the quality of the impressions in the edition of an etching. The first sheets will be much crisper and sharper and have a greater color tonality than subsequent ones. After seeing a number of different impressions from the same edition, you soon learn to distinguish good and bad quality. Consider the printing process and the resulting wear of the delicate grooves. These grooves become more shallow and hold less ink, and so the impression is lighter in color. Hatched areas, especially, have wider white spaces and the rich blacks disappear. The limitation in the size of an edition from a copper plate etching necessarily changed the purpose of making a print in this medium. Rather than making illustrations for publications or reaching the masses, the etcher concerned himself with art and aesthetics, in the same way as he did with a painting.

If you look at any etched line with considerable magnification, you will find that it neither swells nor tapers but is equally wide throughout. Edges of an etched line are smooth, and the line is not thinner at its beginning or ending. The explanation for this is the manner in which the etched line is formed. The acid attacks the metal equally in all exposed areas, so that neither thick nor thin effects can be expected to occur. This is quite the opposite of the woodcut line, and also of the engraved and drypoint ones (see below).

As you can see, etching requires considerable knowledge of technique on the artist's part, in addition to his capabilities as a draftsman. It is only possible to achieve a beautiful end result if the printmaker excels in creative ability and the understanding of the technique. Apparently Rembrandt had this ideal combination, and he was aware that the medium of etching was as yet unexplored in his time. He experimented with ground as well as mordant. He realized that inks and paper made considerable difference in the results he could achieve. He lovingly did much of the printing himself, using even this stage of printmaking to experiment with inking and wiping the plate in different ways. Whistler and Rembrandt often did not wipe the plate completely but deliberately left ink film on some areas. The impressions made in this fashion are highly prized and usually very soft and beautiful in tonal gradation. Rembrandt is the undisputed master of etching, but certainly Callot and Whistler do not lag far behind.

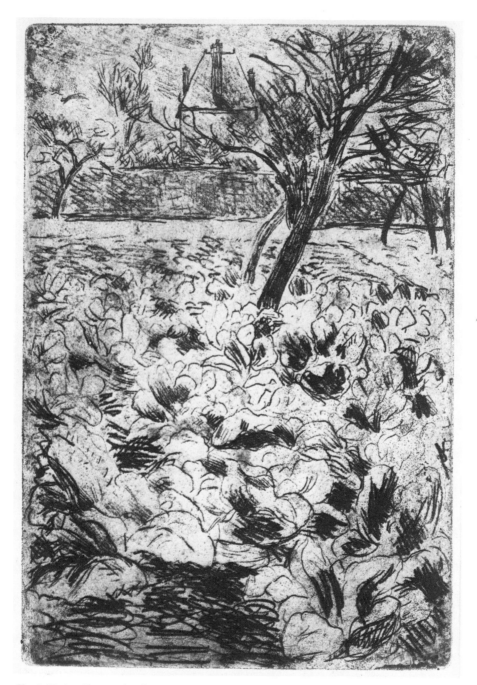

Fig. 1-15. *Le Champ de Choux* (*The Cabbage Field*), Camille Pissarro. Soft-ground etching, about 1880. (Courtesy of The National Gallery of Art, Rosenwald Collection.)

For the print collector it is advisable to study the work of Rembrandt, even if it may be financially out of reach for most, because so much can be learned from his methods and experiments. There is a large body of literature on this artist's etchings that will assist you in learning about any of his etched works. You will also come across many impressions labeled "Rembrandt" that are fakes or misrepresentations and not originals. Recently an acquaintance told me of a wonderful buy he made. It was the *Hundred Guilder* print by Rembrandt, and he found it in an antique store for $145. When asked if it was a restrike (a new print from an old plate, block, or stone), he insisted that it was a Rembrandt. This misinterpretation will not happen to you if you familiarize yourself with the process and look at good and bad impressions, as well as at restrikes. You should look at the best examples by the best artist to learn the most, and that is the prime reason for studying Rembrandt etchings. Chapter 6 will assist you in that regard.

Relief Etching

Perhaps the easiest way to visualize a relief etching is to compare it to a woodcut block. The plate is covered with ground (sometimes tar is used) and the part that the artist wishes to print is left covered. The ground around the desired lines is removed and a fairly long acid bath and strong chemicals are used. This removes the material in the same way that the woodcutter cuts away from the lines. The similarity to the woodcut ends with the printing process, since the relief etching either may be inked and its surfaces embossed onto the paper or it may be printed without ink. The latter is frequently practiced in modern prints, often with lovely, thick handmade papers and a very deep relief. The result is an embossed impression without color.

Aquatint

Aquatint is another intaglio method and Fig. 1-16 illustrates this process well. The basic difference between the "classical" etching and the aquatint lies in the manner in which shading is achieved. Instead of hatching and cross-hatching to attain dark areas, the plate is heated and rosin or fine powder is sprinkled on it. The warmth makes the tiny powder particles adhere to the plate. The acid will attack the areas between the particles. If they are very dense, a lighter shade will result, while areas that have a lesser density will appear darker. It is possible to get a tonal gradation from white to black. Aquatint is used frequently in combination with drypoint and etched lines, but it may be used by itself. The term *mixed media* usually refers to such a combination. Those portions of the design that will not contain aquatint must first be stopped out so that they are not touched by rosin. This can be done with varnish or ground.

The aquatint method has numerous variations, many of which are used by contemporary printmakers. Sometimes particles of sand or sugar are added to the ground to get texture and tonality.

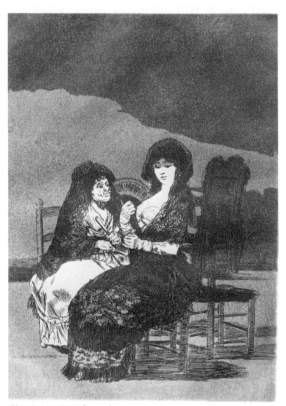

Fig. 1-16. *Good Advice* (*Bellos consejos*), Francisco Goya. Etching and aquatint, 18th century. (Courtesy of The Metropolitan Museum of Art, Gift of Walter E. Sachs, 1916.)

Fig. 1-17. Detail of Fig. 1-16.

Drypoint

Another intaglio method is drypoint. The line is made on the metal plate with a sharp tool. This produces a groove that will hold ink, and it also throws up a burr, a ragged metal curl (Fig. 1-2), on the edge of the line that was engraved. It is this burr that adds the most velvety and beautiful rich tones to a graphic work. Alas, its beauty is elusive. The burr, during the inking of the plate, fills and holds the ink, as does the shallow groove. Since it is raised above the surface of the plate, however, it does not last for more than ten impressions, at most, under the pressure exerted by the press. Rembrandt's work shown in Fig. 1-18 is a lovely example of a fresh and vibrant drypoint; the detail (Fig. 1-19) shows the rich, soft effect of the as-yet-unspoiled burr. An impression of this quality is rare, and in the case of Rembrandt it is nearly priceless. Drypoint is a very useful method, since it can be used in combination with all other intaglio processes; indeed, it is rarely used by itself. It may be used, too, for strengthening worn engraved or etched lines, and it may be added to a finished metal intaglio plate to make changes or additions in the design. For the artist it is desirable, since it allows much freedom of line, is quickly accomplished, and has, as the added bonus, the rich color resulting from the burr.

You will not have much difficulty recognizing drypoint when the impression is one of the first few printed. After the burr has worn down, the shallow and rather wide groove remains. It does not hold too much ink and is light in color. Any print that has drypoint work in its design should be scrutinized by the collector to determine the condition of the burr in the impression. Naturally, the better the quality (i.e., the earlier the impression within the edition) the higher will be the cost.

This method, like etching, is particularly suited to great draftsmen, and fine examples may be found in the oeuvre of Dürer and Picasso. With a magnifying lens, look at Fig. 1-18 closely and see if you can determine which lines are made by drypoint and which by etching. A photographic reproduction, of course, in no way compares to the original. To really study drypoint it is necessary to see the original. (The tree on the left has the soft, rich effect from the burr.)

Engraving

Artisans have engraved symbols and pictures in clay, stone, and metal since antiquity. Most closely allied to the engraved print is the work of the medieval and Renaissance goldsmiths, who were highly skilled in engraving metal designs. With the availability of paper, engraved prints began to appear in the middle of the fifteenth century. Some of the great names in the early history of engraving are Martin Schongauer, Albrecht Dürer, and Andrea Mantegna.

Engravings were widely used as illustrations in the seventeenth and eighteenth centuries. You will find those easily when visiting a used-book store that also sells prints. (A further discussion of this topic is found in Chapter 5.) Other applications for this medium in the fifteenth century included devotional images for religious purposes, and playing cards. In

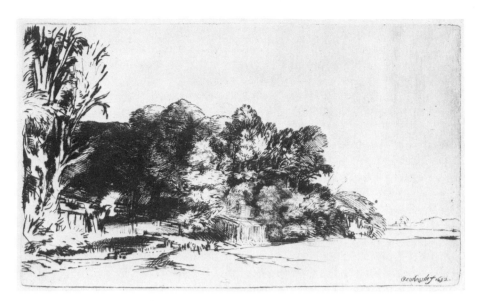

Fig. 1-18. *Clump of Trees with a Vista*, Rembrandt van Rijn. Etching and drypoint, 1652. (Courtesy of The Metropolitan Museum of Art, Gift of George Coe Graves, 1920.)

Fig. 1-19. Detail of Fig. 1-18.

modern art, engraving is less popular, possibly because it has been super-seded by newer mass-printing methods and because of the tedious work involved in the making of the plate. The artist today requires more freedom and spontaneity than this medium allows—freedom that can be found with other techniques.

To work on the design, the engraver places the metal plate on a "pillow" (a small cushion) and then moves it on this pillow while firmly applying the engraving tool—i.e., he moves the plate rather than the tool to form the line. This method is a very exacting one that requires not only great skill but also physical strength. The finished plate is inked and printed in a press, though it is possible to print it by hand. One of the most famous engravings is shown in Fig. 1-20; Fig. 1-21 is a detail of it. Consider the workmanship involved in the creation of the fine lines, and the steadiness of hand required. Color tonality is achieved through the spacing and thickness of the lines. The engraved line swells and tapers, depending on the pressure exerted on the tool by the engraver. Incidentally, in the process of cutting the metal a small burr is formed. But this burr is always removed in an engraved plate and is not considered desirable as it is in drypoint. In an engraving the lines are usually close together, be they parallel or hatched. If the burr were to remain, the impression would be deep black and the lines undistinguishable. The whole delicacy of line which is so typical of engraving would be lost, or in the case of a work that has a silvery tone, as in Fig. 1-20, that rich shimmer would not be possible. If the artist aims for deep, velvety blacks, he could leave the burr on the plate, but he would have to take this into consideration when making the design. In addition, much would depend on the purpose of the plate, i.e., if it is meant for a large edition (as in book illustrations), the engraved lines would long outlast the burr; the burr is worn down in the printing press after about ten impressions. This subject is discussed in more detail in the section of this chapter covering drypoint.

Engravings are made on copper or other metals, and editions of a few hundred are frequent. The groove formed by the tool is not too deep, and it has a rather uneven edge after the burr is removed.

For the collector it is important that an engraving have clear, sharp lines. As the plate wears down in larger editions, the incised groove becomes shallower and narrower, since it is cut in a **V** shape, as shown in Fig. 1-2; it will hold less ink and will have wider spaces between the lines. Dürer achieved a color tonality best described as silvery; it is completely lost in those impressions taken later in the edition. Examples of this delicately shimmering type are rarely available for sale, but they can be seen in museum print rooms. They are a real feast for the eyes.

The term *engraving* is often applied inaccurately to etchings in literature. Do not let it confuse you. The error probably stems from the French word *peintre-graveur,* which was used in connection with prints made from metal plates. As has been shown, the differences in technique and execution of line are considerable.

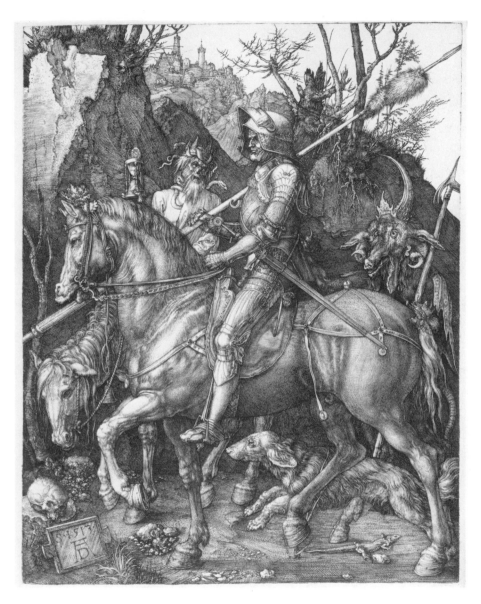

Fig. 1-20. *The Knight, Death and the Devil,*
Albrecht Dürer. Engraving, 1513. (Courtesy of
The Metropolitan Museum of Art, Harris
Brisbane Dick Fund, 1943.)

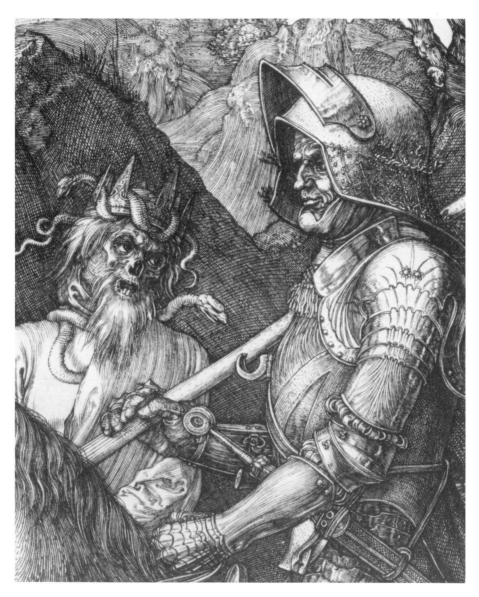

Fig. 1-21. Detail of Fig. 1-20.

Mezzotint

Mezzotint has been used mainly for book illustrations; it was particularly popular during the eighteenth and nineteenth centuries. The process lends itself to large editions of good quality, and it makes the reproduction of paintings possible. It is executed on a metal plate and printed like other intaglio methods, but it differs from these in the preparation of the design on the plate. Actually, the process is reversed. The whole surface is first treated with a spiked rocker, which makes tiny and closely spaced holes over the whole plate. (If printed in this condition a black sheet would result.) Next, the design is made by shaving and scraping away the dotted parts to get light areas. Mezzotint—the French word for it is *manière noir* ("black manner")—has a very painterly quality and allows a wide range of gray color tones, which are controlled by the amount of scraping. The tiny holes have a burr and, once again, the first few impressions have a soft, rich, and velvety black not found in sheets taken later in the edition.

Mezzotint was not used by the great printmakers, possibly because the process did not readily lend itself to spontaneous and creative designs. Most of the great masters were also great painters, and when they wanted to get a painterly result they may have turned to their oils and canvas. Some lovely examples in this medium may be found, however, and one such is illustrated in Fig. 1-22.

Fig. 1-22. *Passing Storm*, Martin Lewis. Mezzotint, 1919. (Courtesy of Kennedy Galleries, Inc.)

PLANOGRAPHIC PROCESSES
Lithography
Some of the greatest prints have been made by this method in modern times. Artists like Goya, Daumier, Toulouse-Lautrec, Vlaminck, and Picasso have drawn on the stone and experimented with color and variations of the technique. Lithography's use extends from fine art to poster art to advertising material and other commercial printings. Artists like the freedom it offers in the execution of the stone, and publishers like the large editions that are possible.

A good lithograph requires not only a talented artist but also a highly skilled printer. The printer's skill is probably as important as the artist's. The artist generally does not carry out the whole process of preparing the stone for printing and printing itself. Sadly, some artists remove themselves even farther than that and do not even draw directly on the stone. If you collect lithographs seriously, try to get acquainted with the working habits of the artist you are interested in through books, discussion, and art publications. Some familiarity with outstanding printers' names or workshops is helpful. Sometimes the printer's blindstamp appears on the impression. This uninked, embossed symbol means the same as the artist's signature on his work. In contemporary graphics you will come across the names of Tamarind Workshop, Gemini G. E. L., U. L. A. E., and others as printers with high standards of excellence. In France the best-known names are Mourlot and Vollard.

Lithography was invented by Aloys Senefelder, a German, who patented the process in 1801 and wrote a book about it. The technique is based on the principle that grease and water do not mix . . . at least this is how every explanation of lithography begins. Following is a brief description of the process, but this medium is rather complex and truly requires a book of explanation by itself. Since so many graphics are made in various lithographic techniques, it will be worthwhile for you to look more closely into this subject. An understanding of it will also enable you to decide whether you find all versions of lithography acceptable as "original graphics." This is particularly true for the offshoots, such as transfer lithography and photo-offset. (The topic of "originals" is discussed at some length in Chapter 2.) Since lithography was invented at the very end of the eighteenth century, it coincided with the modern-art movement. The impressionists and post-impressionists were very interested in this method and experimented with it.

A lithograph is made by the planographic method (see Fig. 1-3). Using a grease pencil, the artist draws directly on the surface of a porous stone, preferably Bavarian limestone. First the stone is cleaned and ground smooth, then the design is drawn on it. The design is set or fixed by an etching process. This etching, however, differs completely from the etching medium discussed above. Here the mordant does not bite into the stone but merely serves to protect the design. It is a chemical separation between the areas that should accept the ink and the others that should not. The stone is then washed, etched a second time, and washed again.

When the technical preparation is finished, the stone is soaked in water and ink is rolled on it. The stone is then placed in the press bed, a sheet of paper is placed on it, and the two are moved through the press. Ink will adhere only to the areas that have the greasy crayon on them and not to those that are saturated with water. The ink has a grease base and is called *tusche*.

Black-and-white lithographs can attain lovely color gradations if handled properly and with understanding by the artist. The example in Fig. 1-23 ranges from the richest blacks to dry-looking grays. In other lithographs, sharp contrast of black and white may be desirable. Lines may be fine or thick, white may be scratched into black areas, washes may be used, areas can be scraped—there are many creative possibilities.

Fig. 1-24 (a detail of Fig. 1-23) gives an indication of the color tonality and pencillike texture of the line that is typical for lithography. The grain of the stone, too, is noticeable.

A good impression has a luminosity of color, sharp blacks, and soft grays. If the stone is overworked, the pores will be filled with too much ink and the impression will be pasty and overly dark. Also, the grain of the stone will not show up clearly. There may be harsh contrasts in color tone. Look for the stone's texture and its irregular grain. If the grain is too regular and perfect, it may be due to the metal grid used to make reproductions by halftone cut, a photomechanical process.

Colored inks may be used in addition to the black tusche. Color lithography is a complicated process that involves color separations and usually a separate stone for each color.

When the stone has been completely processed, one print is pulled for the artist's approval. If it is found to be satisfactory the artist marks it *bon à tirer* ("good to be printed") and leaves it with the printer as a sample. The edition should be printed exactly like this proof. This *bon à tirer* impression usually becomes the property of the printer and is, of course, a collector's item. Editions of up to 500 can be taken from one stone. The image can be transferred to a second stone for larger quantities. Transfer lithography is discussed below.

CONTEMPORARY TECHNIQUES
Transfer Lithography
With transfer lithography the controversy concerning original versus mechanical process begins. All definitions that apply to the classical concept of original graphics must be redefined, or else transfer lithographs and photolithographs cannot be considered "original" graphics. This topic is discussed in more detail in Chapter 2.

The lithograph stone is large, bulky, and heavy. Transfer paper, on the other hand, is simply a sheet of paper treated on one side with a greasy substance. The artist draws on the untreated side. He can execute it in his studio in the south of France and mail it to his printer in Paris. And this is precisely where the problem lies. The printer will place the transfer paper on a prepared stone, run it through the press, and presto . . . he is ready

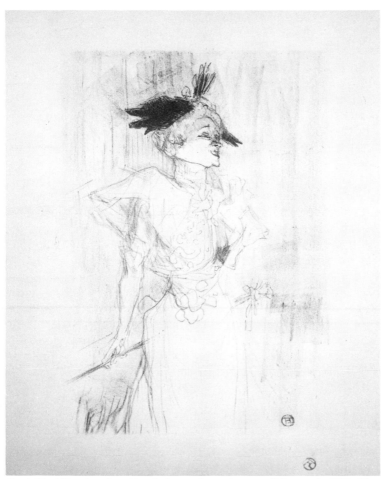

Fig. 1-23. *Mlle. Lender*, Henri de Toulouse-Lautrec. Lithograph, 1859. (Courtesy of Lucien Goldschmidt.)

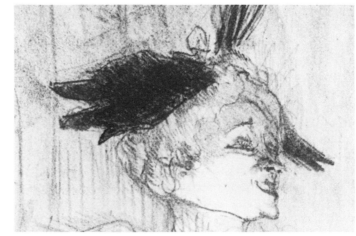

Fig. 1-24. Detail of Fig. 1-23.

to print an edition without the artist having been anywhere near the stone. After some time, the edition of finished prints will be sent to their creator for his signature.

As mentioned before, the transfer method is also used when a large edition of a lithograph is anticipated. In that case, more than one stone may be prepared at the beginning. If the artist has placed his drawing on the stone, the transfers to the second and subsequent stones are made by printing the design on transfer paper directly from the stone. Such a transfer must be done very skillfully, so that nothing of the original drawing on the stone is lost.

When the artist draws on transfer paper, the final impression will not be a mirror image; it will be directionally the same as the drawing. If he draws on the stone directly and signs his name, the impression taken will show the signature to be reversed. In the case of stone-to-stone transfer, the signature will be in reverse twice and therefore not show any change in direction from the first stone. Recognizing a transfer lithograph is not always simple. Sometimes the above-mentioned mirror image is an indication, but this is not proof in itself. Sometimes the pencil lines show the texture of the paper—but not always.

Transfer lithography is a convenience and maybe even a shortcut for the artist. It does, however, function also as a technique for accomplishing effects of a special nature. To make good use of that, the artist must be familiar with the technical advantages of the process. Fig. 1-25 shows a transfer lithograph.

Offset Lithography

Offset lithography is an outgrowth of the lithographic process. Its printing surface is made by mechanical means, but its beginning is an original composition or design. One procedure, often called the direct method, requires the artist to draw his design on a stone or plate. This matrix is inked and the design is then printed on a roller, which is in turn used to print on the paper. In traditional lithography the print is pulled directly from the stone; offset has an additional step between the stone or plate and the finished print, i.e., the roller. Thus the name offset.

The other method involves a photographic process. The design is photographed and the negative image is transferred to a treated surface: the plate or stone covered with a light-sensitive, water-soluble solution, such as albumin. The solution will harden on exposure to light. Those areas that were dark on the negative and did not permit light to penetrate remain unaffected. Since the solution is water-soluble, the unaffected parts will simply wash out. Those areas where light penetrated become the design. They are inked and printed by offset.

The design in photo offset is assembled by the artist and transferred to the plate by means of a negative. It may consist of textured materials, photographs, drawings, paintings, lettering, etc. Examples of contemporary prints in the offset process are found in most galleries that handle graphics by Robert Rauschenberg, Roy Lichtenstein, and others.

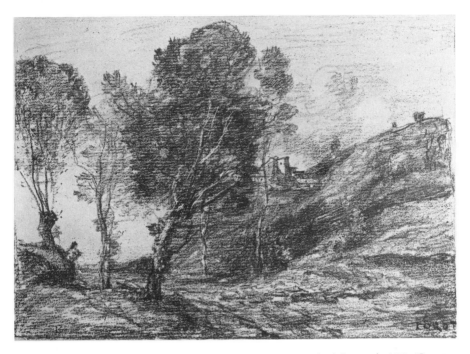

Fig. 1-25. *Souvenir d'Italie*, Jean-Baptiste-Camille Corot. Transfer lithograph, 1871. (Courtesy of The National Gallery of Art, Rosenwald Collection.)

Fig. 1-26 illustrates an "original" offset lithograph. This is an even more controversial method than transfer lithography. Contemporary artists make much use of it, and large editions are possible. Andy Warhol, and many others whose work is quite expensive, make prints in this fashion, often signed and numbered. Frequently a limited edition is printed, numbered, and signed and then sold for fairly high prices. Sometimes another, later edition of much greater number follows, not numbered but sometimes signed.

Unfortunately, offset lithography has also been used in the reproduction of copies from original works of all media. Under very large-power magnification it is possible to see the difference between an original print and a reproduction, and placing the offset beside a good original will help as well. In very general terms, the original will be "alive" and crisp compared to its copy. The print collector who looks at many, many prints in all media will react with a measure of uncertainty when looking at copies; things just will not look right. It is not absolutely necessary to know how the copy is made, but if there is a doubt, trust yourself and check it out.

Stencil (Silk Screen, Serigraph, Screen Print)
The heading already indicates that this approach to printmaking has many variations. All of them, however, have as a common denominator the means of putting the image on paper (or other material) and the fact that it is a direct image rather than a reversed one.

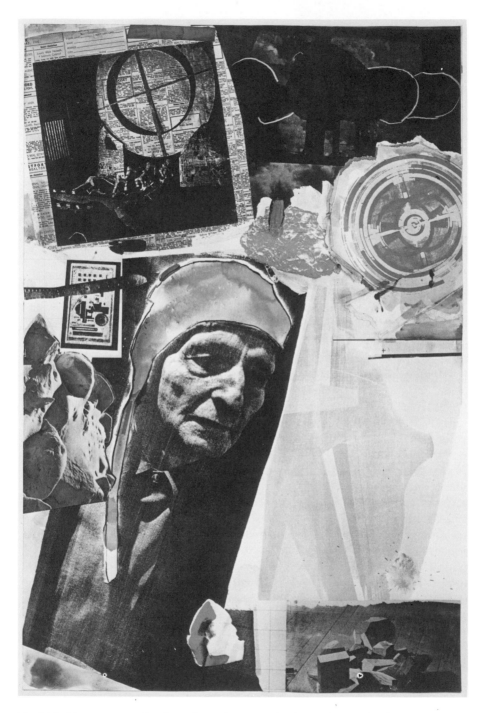

Fig. 1-26. *Homage to Frederick Kiesler*, Robert Rauschenberg. Photo-offset lithograph, 1967. (Courtesy of Leo Castelli Gallery.)

There is no plate, block, or stone in this technique. Fabric is stretched over a frame, which may be any size. The fabric most often used is silk, but cotton or wire mesh may be substituted. This assembly is called the screen and the name silk screen is, of course, derived from the most frequently used material. Serigraph is a more elegant term for silk screen, and it is usually applied to fine-art impressions. Screen print means a print made on a screen, but not necessarily a silk screen.

The making of a screen print requires the use of a stencil. This stencil may be made of paper, glue, stop-out material, or anything that fills the holes in the screen and prevents the ink from passing through. Liquids are brushed on the screen fabric itself. Paper stencils are fastened to the underside of the screen. The areas not blocked out will be the design printed on paper, i.e., the impression. To print, ink is forced through the open spaces with the aid of a squeegee—a device similar to that used for washing windows. The ink cannot pass through the stencil. If the stencil wears out from prolonged use, it can be replaced with a new one. For very large printings, this may be necessary. The screen itself is washable and can be reused. Printing may be done on paper or any other surface—like glass, canvas, metal, cloth. For color prints, several stencils are used, and they must be in perfect register. Generally that is not too great a problem in this method. Large editions are possible, although "fine-art prints" made by the stencil method often appear in limited editions. These limits are set mostly for financial reasons and not by the medium. As discussed in the section on posters, there is sometimes a limited edition, signed and numbered, and then an identical larger printing.

There are intricate variations in the making of screen prints. The paper stencil may be replaced by a mimeographic or photographic one. It is also possible to place the design directly on the screen with the use of glue, lacquer, or other stop-out liquids. The stencil paper can be replaced by plastic, wood, glass, or canvas. This wide variety of materials and techniques means almost unlimited freedom of choice for the artist. Even size is not a problem, since it is dictated only by the frame, which is made of four pieces of lumber fitted together and hinged to a baseboard on which the paper is placed for printing. Different media combine easily with screen prints. Lovely painterly results have been achieved by making use of textures, brushstrokes, and build-up of color. Combinations of paintings, photographs, drawings, etc., produced with the aid of a photo stencil, have been made by contemporary artists such as Warhol and Rauschenberg. The photo stencil makes use of a light-sensitive gelatin to apply the design on the screen (which functions as a stencil). One type of screen print is shown in Fig. 1-27. It is not possible to illustrate all the techniques or to describe them in detail. Some very fine books are available dealing exclusively with the screen print.

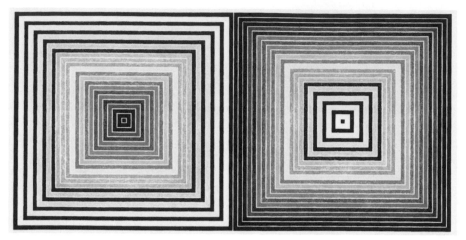

Fig. 1-27. *Double Gray Scramble*, Frank Stella. Silk-screen printed in 150 colors. (Courtesy of Gemini G.E.L., Los Angeles.)

Computer Graphics

We have come a long way from the time when woodcuts were crude and served religious purposes, or from the—probably overly romantic— vision of Rembrandt sitting by the window as the sun sets, drawing on a copper plate. How would he have responded to the computer?

The computer, without a doubt, has become an integral force in our lives, and it was probably unavoidable that the creative mind would feel its impact. For many print collectors computer art may be just another wave of "Future Shock." The temptation is great to cast it aside and label it copy, printout, or an attention-getting device. I was once called to task by a teacher for rejecting the creative effort of a contemporary artist. His objection was my lack of flexibility in not seeing the painting in its own right and not giving it a bit of time and thought. I looked into the matter with considerable effort and found that I really was prejudiced by tradition. Perhaps most of us are, and a confrontation with computer graphics can provoke a conscious effort to be flexible. The example in Fig. 1-28 was made by a talented artist who does not limit his graphic output to computer prints.

The printmaker who decides to use the computer as his medium must understand its function and possibilities. He must learn a computer language, such as Fortran, which is required to write the program. He is, in effect, a programmer. For the input to the computer he may use other equipment, calculators, magnetic tape, teletype, etc., and he must choose between analog and digital computers. To obtain the result of his labors, he requires additional equipment. A fastprinter, an oscilloscope, or a plotter may be used. The computer program for the illustration in Fig. 1-28 by Christopher Keith—or Newwave, as he is called in BASIC (a computer language)—is shown on the following page.

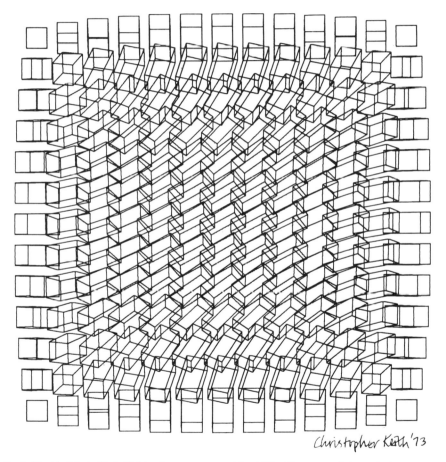

Fig. 1-28. *Untitled*, Chris Keith. Computer graphic, 1973. (Courtesy of the artist.)

NEWWAVE (Chris Keith's computer "name")

```
 80 LET S1=6
 90 LET S2=18
100 DIM A(3, 3)
110 DIM V(3)
120 DIM D(3)
130 DIM E(3)
140 DIM W(3)
150 LIBRARY "PLOTLIB***:CAL"
160 DIM C(150)
170 LET P=3. 1416
180 CALL "3SPHERE": C(), 0, 0, 0, 4
190 CALL "3EYEPOLR": C(), 40, 0, 0
200 FOR P1=-2*P TO 2*P STEP P/S1
210 FOR P2=-P TO P STEP P/S1
220 LET T=SIN((P1+P)/2)
230 LET Q=SIN((P2+P)/2)
240 LET A(1, 1)=COS(T)*SIN(Q)
250 LET A(1, 2)=-COS(T)*SIN(Q)
260 LET A(1, 3)=SIN(T)
270 LET A(2, 1)=SIN(Q)
280 LET A(2, 2)=COS(Q)
290 LET A(2, 3)=O
300 LET A(3, 1)=SIN(T)*COS(Q)
310 LET A(3, 2)=-SIN(T)*SIN(Q)
320 LET A(3, 3)=COS(T)
330 RESET
340 FOR I=1 TO 10
350 MAT READ V
360 MAT D=A*V
370 MAT D=(P/S2)*D
380 CALL "3LINE":C(), D(1), D(2)+P, D(3)+P2
390 NEXT I
400 CALL "LIFT": C()
410 FOR J=1 TO 3
420 MAT READ V
430 MAT D=A*V
440 MAT D=(P/S2)*D
450 MAT READ W
460 MAT E=A*W
470 MAT E=(P/S2)*E
480 CALL "3CONNECT": C(), D(1), D(2)+P1, D(3)+P2, E(1), E(2)+P1, E(3)+P2
490 CALL "LIFT": C()
500 NEXT J
510 NEXT P2
520 NEXT P1
530 CALL "FINISH": C()
540 DATA 2, 1, 1, 2, 1, -1, 2, -1, -1, 2, -!, I, 2, 1, 1
550 DATA -2, 1, 1, -2, 1, -1, -2, -1, -1, -2, -1, 1, -2, 1, 1
560 DATA 2, 1, -1, -2, 1, -1, 2, -1, -1, -2, -1, -1, 2, -1, 1, -2, -1, 1
570 END
```

Once this program has been determined, it is fed into the computer and then, with the aid of a plotter, the design is drawn on paper by the stylus of this plotter. It may take the computer ten minutes to do this, and computer time is very expensive. Therefore the artist then takes this "original" (or we might call it the matrix) and makes a silk screen by photomechanical means. The edition is printed from this screen and, as a general rule, it will be a limited edition. Color may be introduced if desired.

CHINE APPLIQUÉ
This is really a printing rather than a printmaking technique, and it can be applied to all media. The lithograph, woodcut, or etching is printed on a very thin China or India paper (see Chapter 3), which is glued to a heavier backing paper simultaneously while going through the press. The result is very lovely, since it has the delicacy the fine paper affords and a depth supplied by the backing. Usually there is a difference in the color of the two papers, and this further enhances the appliqué.

MONOPRINT
This is not a true print process, because only one impression is possible. Remember that the raison d'être of printmaking lies in the possibility of the multiple original. A monoprint is a drawing or painting done on a smooth surface. While the drawing is still wet, a piece of paper is placed on it and the printing is usually done by hand rubbing. The ink or paint is transferred from the surface to the paper, and no further print can be taken. Monoprint relates to other printmaking processes in that it is a mirror image of the design.

GLASS PRINTS OR CLICHÉ VERRE
In French, *verre* means glass and *cliché* means a plate, block, or photographic exposure. That describes the method almost completely. The glass plate is covered with paint and the design is scratched into the paint. A photosensitive paper is then placed under the glass, and the scratched lines will appear on the paper. Cliché verre was used in the nineteenth century, mostly by Camille Corot.

POSTERS
Posters are an outgrowth of lithography, and they are executed frequently in that medium. Any other process suitable for printing very large quantities may also be used. The poster's fame originates with Toulouse-Lautrec. He used lithography as the medium, and the original editions were small in number. There is a considerable difference in method as well as philosophy from his work to the present commercial advertising posters. Today the methods are screen and offset, or other mechanized procedures, and the aim now is to reach the viewer visually and psychologically in order to sell a product.

It is a frequent practice in modern art that the artist prepare a poster for his exhibits. Picasso, Miró, Chagall, and many others have made them.

They may be a new composition or make use of a painting or other work that will be on exhibit. Sometimes a small signed and numbered edition is made first, and then a larger number of posters is printed. Sometimes the second run is identical to the edition—especially if the medium is offset or screen. They may even be printed together and then a small quantity will be signed and numbered. Another group may be signed only and not bear a number. The rest are all unsigned. Sometimes there is a difference between the original edition and the subsequent one. In one instance of prints by Jasper Johns, for example, the paper of the first printing was better, the prints were signed and numbered, and the image was larger than in the subsequent ones. In contemporary prints there is simply no definite rule, and the best way to protect yourself against a mistake is to be informed about the artist's habit, and the edition of the particular print you are considering. New York galleries such as Castelli and Brooke Alexander are very willing to answer questions about their artists. If you expect to buy at auction, though, inform yourself before you bid. The difference in price between the small and large editions, even if the impressions are identical, is considerable. An unnumbered poster will fall into the under-$35 range and the "fine-art print" (i.e., numbered and signed) may be $1,000—and more.

To make things even more confusing, especially with the early posters, many reproductions may have been made. A Toulouse-Lautrec lithograph poster from the original edition is sometimes sold for an astronomical price. Such a poster is rare and very much in demand. A reproduction of the original poster, usually made commercially, may be bought for a few dollars. While pretty, it is no collector's item.

In the following section of photographs you will have an opportunity to make good use of the information in this chapter. Admittedly a photoreproduction is not as good as an original, but this selection of photographs emphasizes the basic and typical features of each medium. In addition to this, try to see as many originals as possible. Ask yourself the following questions.

What is the medium?

Why do you think so?

What is particularly characteristic of the medium in this print?

Can you identify the artist?

Can you approximate the date of the print?

Do you like it or dislike it—and why?

If you can answer all the questions, fine—but don't be discouraged if you can't. It takes time to develop a discerning eye. Experts and scholars disagree and make errors too. Reread the description of the medium you could not identify and find out what misled you.

The captions for Figs. 1-29 through 1-42 appear on page 56.

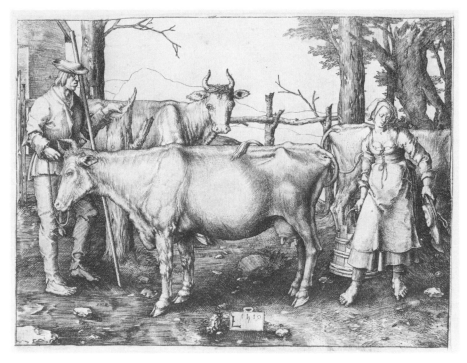

Fig. 1-29.

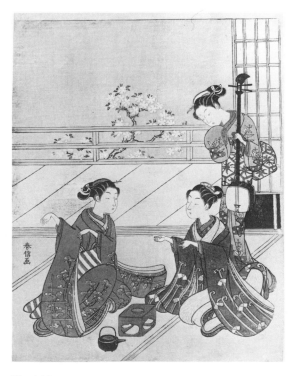

Fig. 1-30.

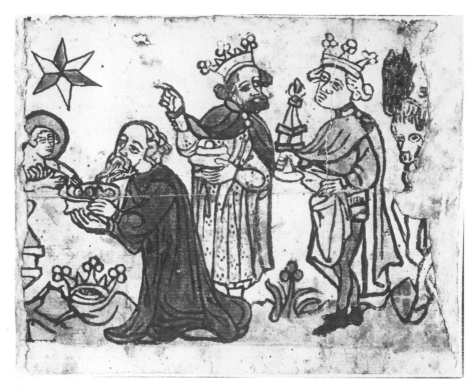

Fig. 1-31.

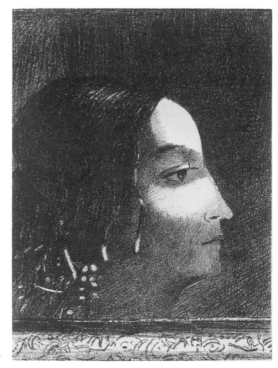

Fig. 1-32.

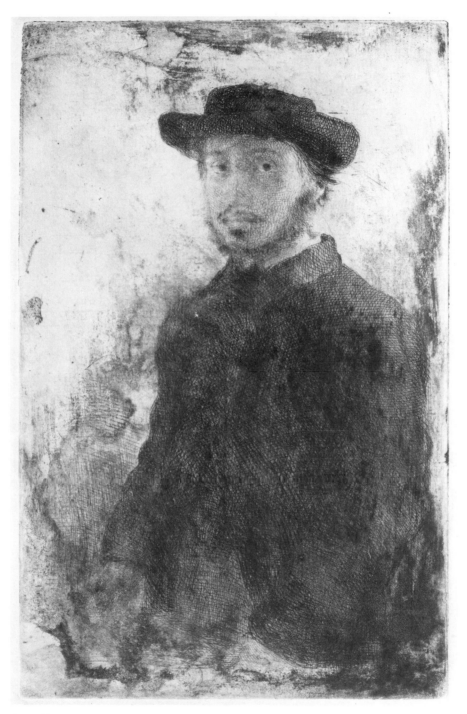

Fig. 1-33.

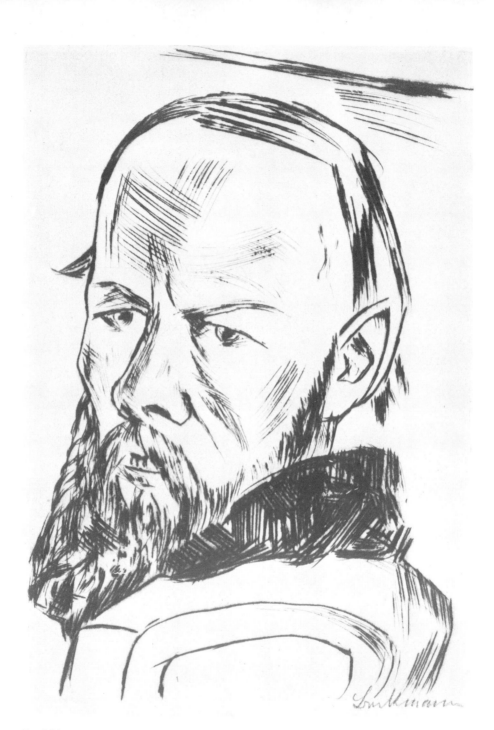

Fig. 1-34.

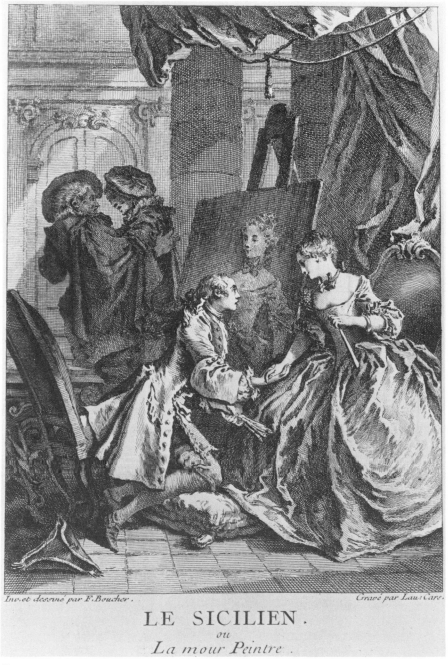

Inv. et dessiné par F. Boucher.　　　　　　　Gravé par Lau: Cars.

LE SICILIEN.
ou
La mour Peintre.

Fig. 1-35.

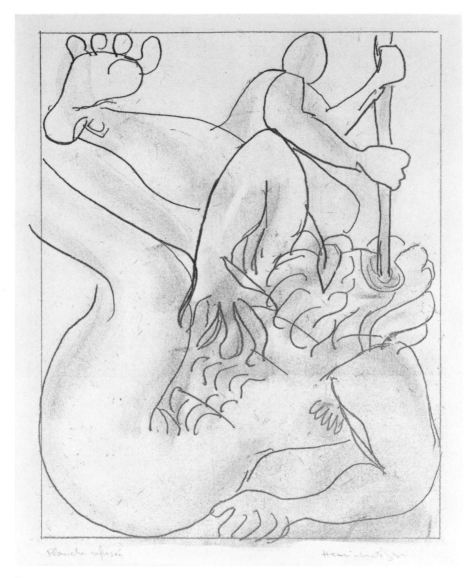

Fig. 1-36.

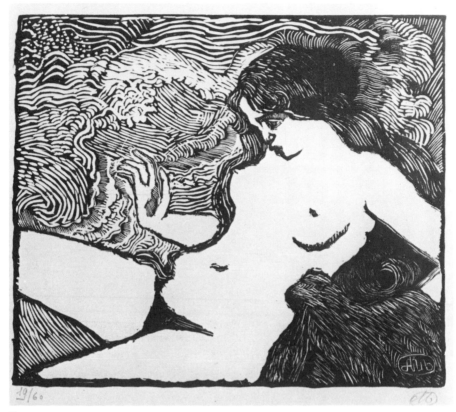

Fig. 1-37.

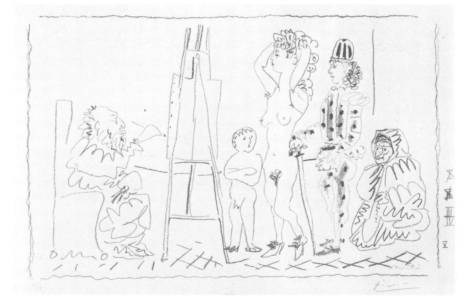

Fig. 1-38.

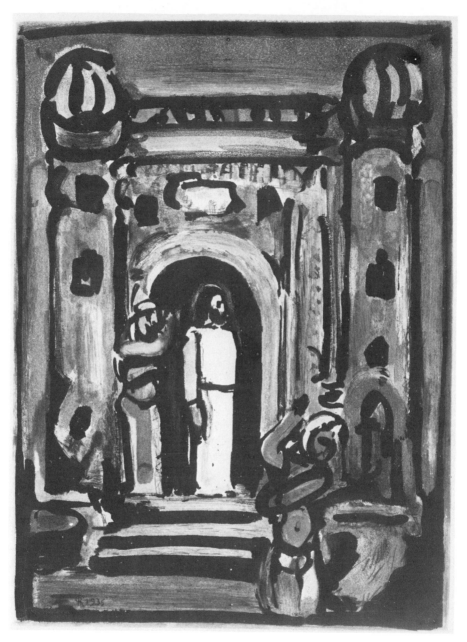

Fig. 1-39.

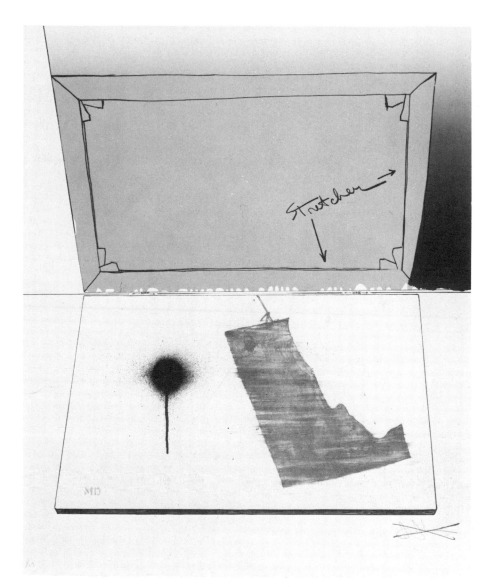

Fig. 1-40.

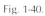

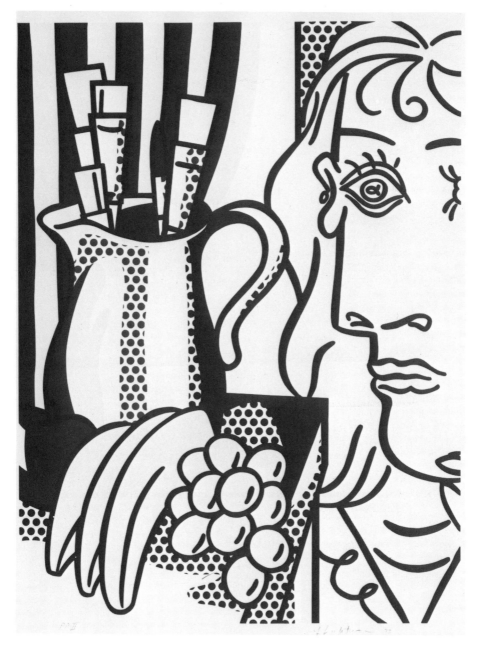

Fig. 1-41.

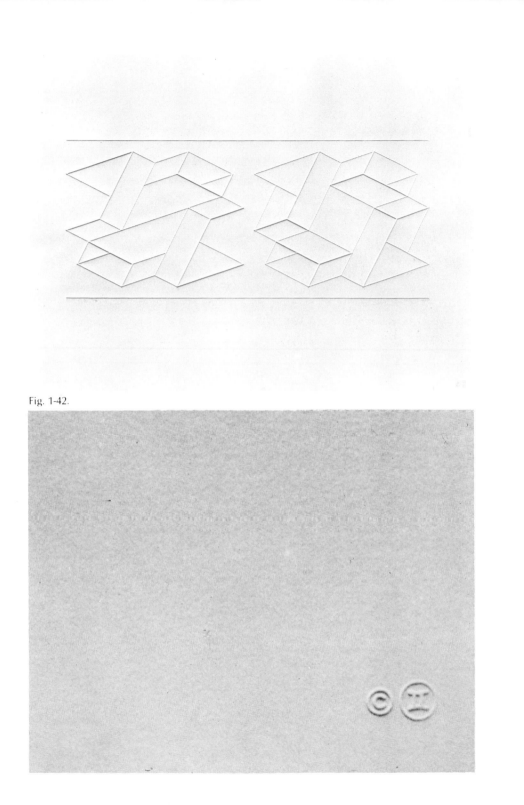

Fig. 1-42.

Fig. 1-29. *The Milk Maid*, Lucas van Leyden. Engraving, early 16th century. (Courtesy of The Metropolitan Museum of Art, Harris Brisbane Dick Fund, 1926.)

Fig. 1-30. *Three Girls* (one holding a samisen), Suzuki Harunobu. Woodcut (Japanese), 18th century. (Courtesy of The Metropolitan Museum of Art, Bequest of Henry L. Phillips, 1940.)

Fig. 1-31. *Adoration of the Magi*, anonymous German. Woodcut, hand colored, 1400 to 1430. (Courtesy of The National Gallery of Art, Rosenwald Collection. This is the earliest woodcut in the above collection. Note the crude lines and lack of shading.)

Fig. 1-32. *Edmond Picard*, Odilon Redon. Lithograph, 1887. (Courtesy of Lucien Goldschmidt.)

Fig. 1-33. *Self-Portrait*, Edgar H. G. Degas (1834–1917). Etching and aquatint, undated. (Courtesy of The Metropolitan Museum of Art, Bequest of Mrs. H. O. Havemeyer, 1929.)

Fig. 1-34. *Portrait of Dostoievski I*, Max Beckmann. Drypoint, 1921. (Courtesy of The Museum of Modern Art, New York, Larry Aldrich Fund.)

Fig. 1-35. Illustration for Molière, L. Cars (after Boucher). Engraving, 1734. (Courtesy of Lucien Goldschmidt.)

Fig. 1-36. *Polypheme* (*The Cyclops*), Henri Matisse. Soft-ground etching, 1935. (Courtesy of The Museum of Modern Art, New York, Derald and Janet Ruttenberg Foundation Fund.)

Fig. 1-37. *Femme au Bain*, Aristide Maillol (1861–1944). Woodcut, signed and numbered, undated. (Courtesy of Lucien Goldschmidt.)

Fig. 1-38. *The Old Painter's Studio*, Pablo Picasso. Lithograph, 1954. (Courtesy of The Museum of Modern Art, New York, Curt Valentin Bequest.)

Fig. 1-39. *Christ before the City*, Georges Rouault. Etching and aquatint, 1935. (Courtesy of The Museum of Modern Art, New York, Gift of the artist.)

Fig. 1-40. *Hinged Canvas* from Fragments—According to What series, Jasper Johns. Lithograph. (Courtesy of Gemini G.E.L., Los Angeles.)

Fig. 1-41. *Still Life With Picasso*, Roy Lichtenstein. Screen print. (Courtesy of Gemini G.E.L., Los Angeles.)

Fig. 1-42. *Embossed Linear Construction 2A*, Josef Albers. Embossment. (Courtesy of Gemini G.E.L., Los Angeles.) Note the Gemini chop mark with the copyright symbol in the lower right corner.

2. There is More to It than Meets the Eye

When you go to buy a car, you may look at the lines and be impressed with the appearance, but you will not buy it unless you know what its features are, how much horsepower it has, what the gas mileage is, whether it has air-conditioning, etc. Now compare this to buying a work of art. Here, too, the visual impact is the first consideration, but there are a number of other important aspects. When you buy a car, you get a printed booklet describing its features and giving its specifications. The print collector, on the other hand, has to get some or all of the facts himself. When these facts are not available, you have to rely on your knowledge and judgment. A print has to be evaluated from an aesthetic point of view, as well as from a practical one. The "technical" aspects that have to be weighed include paper, watermark, size of edition, inking, signs of wear, margin, and condition. The freshness and crispness of line certainly will be of great importance. Chapter 1 discussed the differences in media and their visual characteristics. This chapter covers the technical aspects that compose the total graphic work.

It is one of the challenges of print collecting that there are so many facets to consider, and this is one of the reasons why expertise is required. Graphic media have common traits, and knowing about such things as paper, watermarks, edition, etc., enables the collector and the scholar to form valid opinions with regard to the authenticity of a print and its value. If you intend to buy a print in a gallery, this information is usually available from the dealer, but you may want to do your own research as well. It is possible for the gallery to be mistaken and, unfortunately, there have been cases of dishonesty. If a large sum of money is involved, you would be well advised to investigate the print's authenticity. If you find an inexpensive print in an antique shop or at an old-book store and think that you have made a real "find," the research may pay off. This is a rare situation, but it does happen. This part of the book, then, deals with the underpinnings of knowledge that make a connoisseur and expert. It will be put to good use in Chapters 5 and 6.

EDITION

Perhaps the first thing to consider in the printing process is the size of the edition. The artist and/or the publisher make a commitment to print no more than the stated number of impressions from the plate, stone, or block. This is a contemporary custom and did not concern the old masters, who printed as many sheets as were needed or could be produced from their matrix. For example, a contemporary printmaker might decide to have an edition of eighty-five sheets of a particular work, as is the case in *Girl with Parted Lips,* Raphael Soyer's etching shown in Fig. 2-1. On the bottom are the numerals 59/85. This means it is the fifty-ninth impression in

Fig. 2-1. *Girl with Parted Lips*, Raphael Soyer. Etching, 1967. (Photo by M. Horowitz.)

an edition of eighty-five. From this we know that no more than eighty-five prints should be made, and that at least fifty-nine are already in existence. An edition need not be completely printed. It may happen that the total number (i.e., eighty-five in this case) is never reached.

In old-master prints we rarely, if ever, know what the size of an edition was, how many were printed, and how many have survived. If a large number of prints is taken from the plate or block, the difference in quality between the first few to those printed when the matrix is worn down is very distinct. Modern technology has made it possible to get a more even result in the total edition through methods such as steelfacing a plate or a block, or using harder materials than copper for the plate. The characteristic burr in drypoint, however, still suffers the most wear under the pressure of the press.

In addition to the predetermined number, the artist receives six to ten so-called artist's proofs, or *épreuves d'artiste*, for his personal use. These are so designated, as seen in Fig. 2-2 (in this case, A.P. #1), on the paper under the printed part on the left side. As a general rule these artist's proofs are more valuable because they are the choice examples of the edition and were the property of the artist. This numbering of prints in an edition started in the nineteenth century and applies only to modern artists. Old masters did not hand-sign their work, nor did they indicate edition sequence.

The artist's name often is found in the plate or block in old- and new-master prints. In descriptive literature this is mentioned as "signed in the plate" (or stone or block) and is not necessarily of great consequence.

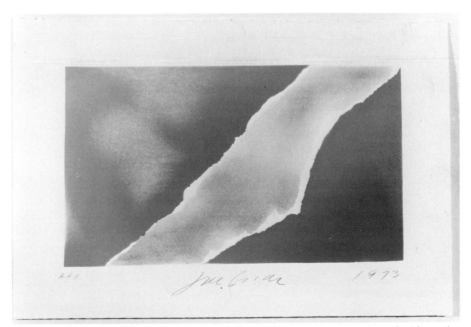

Fig. 2-2. *Untitled*, Joe Goode. Lithograph with pastel, 1973. (Courtesy of Brooks Alexander, Inc. Photo by Eric Pollitzer.)

STATES

We speak of a state when an alteration or variation exists within the edition. During the process of making the plate, stone, or block, the artist may wish to see what he has done so far. He can ink the matrix and pull an impression (see Fig. 2-3a). This is called a trial proof or a working proof, but it is considered by some as a state. Or, as is often the case, the artist has carried out the design as planned and prints a quantity. In looking at it he feels that he would like to make some changes, and he does so.

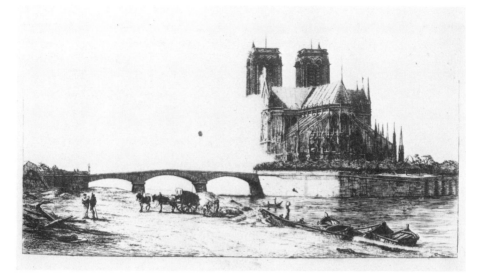

Fig. 2-3a. *L'Apside de Notre Dame*, Charles Meryon. Etching (unfinished trial proof), 1854. (Courtesy of The National Gallery of Art, Rosenwald Collection.)

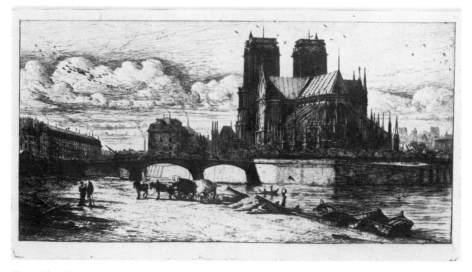

Fig. 2-3b. *L'Apside de Notre Dame*, Charles Meryon. Etching (finished state), 1854. (Courtesy of The National Gallery of Art, Rosenwald Collection.)

Collectors may be interested in obtaining all possible states of a print. For scholars it is of great interest to study the changes made, especially those that show how the work progressed and developed. The symbols used to indicate a state either on the print itself or in reference works are Roman numerals. If, for example, you come across an entry II/II, this means second state of two states, or 14/V/VI means it is the fourteenth print of the fifth state of six states known to exist of this print. The other states may consist of one or more impressions.

Figs. 2-4 and 2-5 are the same work, *La Mort du Vagabond,* an etching by Alphonse Legros. Fig. 2-4 is the fourth state (IV) and Fig. 2-5 is the tenth state (X). Apparently Legros decided to add to the background after he had proofed some states. Fig. 2-6 is a counterproof. Such an impression is made by the artist during the preparatory stages of his work. It is made by inking the plate, taking an impression, and placing a sheet of paper on the wet impression. It is this second sheet that is the counterproof. It is directionally the same as the design on the plate and *not* in mirror image.

Fig. 2-4. *La Mort du Vagabond,* Alphonse Legros (19th century). Etching (fourth state), undated. (Courtesy of Lucien Goldschmidt.)

This is an asset to the printmaker, since he can alter the design or add to it on the paper and then easily transfer the changes to the plate. The illustration shown has been used in this manner, and Legros has made additions in the sky, on the background, and on the figure in sepia wash (ink wash applied by brush). Fig. 2-5, which is a later state than the counterproof, shows that the changes were carried out on the plate, and they subsequently appear in the impressions.

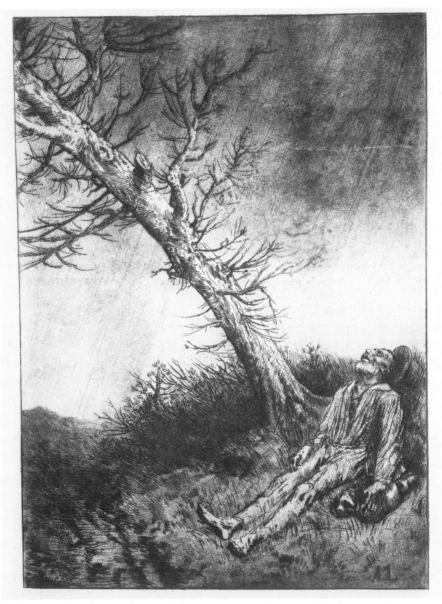

Fig. 2-5. *La Mort du Vagabond*, Alphonse Legros (19th century). Etching (tenth state), undated. (Courtesy of Lucien Goldschmidt.)

Fig. 2-6. *La Mort du Vagabond*, Alphonse Legros (19th century). Etching and sepia wash (counterproof of the sixth state), undated. (Courtesy of Lucien Goldschmidt.)

ORIGINAL

This is probably as good a time as any to emphasize that *a print is a multiple original*. There is no one original in the sense that we apply the meaning to an oil painting. The plate, stone, or block is the working surface from which the edition is pulled, and each sheet in this edition is an original. Because the question of original art, especially in graphics, has become problematic through excellent photographic, xerographic, and other modern techniques, international art dealers have tried to set up rules.

In 1960, the Print Council of America attempted to define an original print. Subsequently a resolution was passed and published in a number of books and magazines. It stated that the printmaker has the right to set the size of the edition in the particular technique he chooses, that an original print should be signed and numbered by the artist, and that he should indicate if he printed it himself. (This is generally done by writing *imp* — an abbreviation for *impressit* — next to the signature.) After the edition is finished, the matrix should be cancelled by the artist. The matrix must be executed by the artist or, the Print Council Resolution states, the work must be considered a reproduction. Unfortunately this rule was already outmoded when it was made, and it certainly is not applicable to many contemporary graphics. It further emphasizes that reproductions — even if signed by the artist — should be acknowledged as such.

This resolution was somewhat modified, since it could not be enforced, morally or otherwise, in view of the many new methods that have come into use. The requirement that the artist execute the matrix remained. It was stated that the print had to be made from the matrix that was the work of the artist himself and that the finished print had to have the artist's approval. Incidentally, the resolution does not apply to prints made before 1930.

In spite of a very necessary attempt to set up some standards for original graphics, neither the first resolution nor its modification is practical or easily applied to transfer lithographs, photo-offset, photo-screen, or computer graphics. Perhaps the conditions set forth were too confining for the artists. Certainly prints made by the new processes would not qualify as originals, yet they are originally conceived and created by the artist. If we take photo-offset lithography as an example, the artist assembles or in other ways prepares the materials that will be photographed and then mechanically reproduced. These materials may include existing drawings and paintings that are reproduced by the artist in his graphic work. Even more confusing, the design may consist of previous graphic works combined now to make a new one by photomechanical means. These reproduced works, however, are very purposefully and intentionally used in the creative process. Perhaps it becomes necessary to define anew not only what is acceptable as an original, but also what is acceptable as art. Can the creative act alone be sufficiently important so that we can ignore the manner in which the image is produced? If the result is art, does it matter if it is handmade or machine made?

I am not suggesting that you should reach a quick decision on this

question, but as a collector you will be faced with the need to take a position. It is a very personal matter and little advice, if any, can be given you. The answer is simple enough when you are dealing with old masters. If the artist made the plate, block, or stone himself; if it was printed under his supervision or by himself; or if it was done in his lifetime with his approval, there is no question that it is an original. If, on the other hand, you are confronted with a contemporary work of which 2,000 examples were printed mechanically, and of which a limited edition of perhaps fifty was signed and numbered, are not all of the 2,000 to be recognized as originals? The only real difference concerns the material value of the impression. The limited edition is just as mechanically or impersonally produced. As a matter of fact, limiting an edition really defeats the true purpose of the print—to enable a large group of people to have access to a work of art. Most of the old masters did not do their own printing, not all of them did the cutting of the block, most of them never worried about limited editions but made use of the matrix for as long as it was usable and there was a demand.

Consider all this, look at contemporary graphics, learn about the methods and the artist's aims. Being a connoisseur requires an open mind and a willingness to grow mentally.

DOCUMENTATION

For contemporary prints, the size of edition may be ascertained if the impression carries a chop mark from the printer, or if this information is available otherwise. For example, Gemini G. E. L. possesses complete documentation for every print made by them. They are willing and able to furnish this information on request. Such a documentation sheet gives the date, title, size, medium and artist's name. It tells you about signature, exact size of edition including the number of trial proofs, artist's proofs, and cancellation proof. It illustrates the design and lists the printing order. It bears the signature of the artist and the printer/publisher.

RESTRIKES AND REPRODUCTIONS

Restrikes are best described by their own name—the plate, block, or stone is struck again (i.e., it is printed again). In Chapter 6, you will find a discussion of posthumous prints made from Rembrandt's plates, but in more recent years restrikes unfortunately have occurred with the artist's knowledge. Let me give you some examples. A limited edition of perhaps 100 impressions is printed, signed, and numbered. The demand for more exists, and so another edition is printed and signed—but now designated in a different way. This may be done either by using Roman numerals or letters or by calling them artist's proofs. Another situation concerns the already controversial photo-offset lithographs or silk prints that come out in a limited, signed, and numbered edition, which is followed by a second—unsigned (or unnumbered)—quantity. Are such impressions restrikes, reproductions, originals, reprints, or copies?

A typical restrike is made from the original matrix. Most often it is a metal plate that has been steelfaced—i.e., it has been plated with a hard metal so that the plate does not wear out easily in a large printing. Steelfacing can be recognized easily because of its hard and sharp edge in the lines. This change becomes particularly apparent when a restrike is placed next to a known original. Sometimes, as in the case or Rembrandt's plates, the matrix is reworked, the existing lines are strengthened, and the print is made without steelfacing. The lines may be worked with a tool or bitten again, and new lines may even be added. If the matrix is cancelled (presumably by two diagonal lines crossing the whole design) and another printing is made, there is no problem about giving this a name. It is a restrike of a cancelled plate and may be of interest to the collector.

Reproductions differ from restrikes, since they are not printed from the original matrix (plate, stone, block, etc.) but are photomechanical copies. Restrikes of Rembrandt plates, as discussed in Chapter 6, have been made from the original copper plates made by Rembrandt. A reproduction would be made from an impression. Reproductions can, of course, be made of paintings and watercolors as well. Depending on the process used, they will vary in quality, price, and fidelity to the original. If color is involved, it is frequently distorted. In the case of black and white, the tonal gradations may be missing. There are some techniques available, however, that produce such fine reproductions that they are very difficult to distinguish from the originals.

SIGNATURE
Most artists have exceptionally high standards for their work. When they sign their work by hand, usually on the bottom right side below the printed part, as in Fig. 2-1, it may be taken as a sign of their approval and satisfaction with the finished impression. As in all other fields, the art world has to contend with misuse, and misrepresentation, and even outright fraud. At its worst, signatures are forged in order to give an unsigned original, or even a very good reproduction, a greater value. Some artists who do not do their own printing, or sometimes not even their own transfer of the design, have even been known to sign the blank paper. They may never see the finished edition. Some have found it financially advantageous to have additional editions printed. While this is a gain for the artist or the publisher, it is the collector's loss. The best protection is to be on guard, to be informed of these malpractices, and to be as familiar as possible with the methods used by the artist whose work you wish to collect.

CANCELLATION OF PLATE
The matrix should be defaced or destroyed after the edition is printed. This is done by cutting or scratching lines across the whole surface, or in other ways clearly indicating a cancellation, as shown in Fig. 2-7. Plates and blocks, of course, are very valuable collector's items and, with luck, wind up in museums or other large and responsible holdings. Unfortunately,

Rembrandt's copper plates of his etchings did not fare so well. Their history has been the topic of much study and controversy. A large group of them is now safe in the North Carolina Museum in Raleigh, North Carolina. These plates were sold after Rembrandt's death and have been reworked, reprinted, and again reworked. Printings were still made from them less than 100 years ago. Sometimes the printer even had seventeenth-century paper available. In such cases the collector must only trust his own knowledge and ability to distinguish the signs of reworking and wear on the plate.

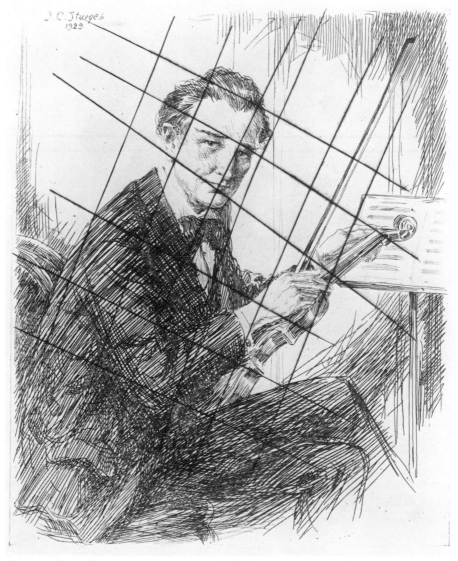

Fig. 2-7. *The Violinist*, D. C. Sturges. Cancelled plate. (Courtesy of The National Gallery of Art, Rosenwald Collection.)

EDITION SEQUENCE AND NUMBER

The artist or publisher should, in modern prints, indicate the size and edition and possibly the sequence of the print within the edition. Many collectors are interested in obtaining the lowest possible number. In general this is very sound thinking, but is not a rule to obey blindly. Only the quality of the print itself is the decisive factor, though it is true that in some processes the first few impressions are sharper, richer, and, therefore, more desirable. This may be particularly true in drypoint, but it is not at all the case in some modern methods, such as lithography or silk screen: the lithograph stone and silk screen do not suffer from use so quickly.

In the printing process of an edition of 100, all sheets may be printed and then hung up to dry the ink. When they are taken down and are ready for the artist's signature, their place in the printing sequence may well have been mixed up. This is especially true of prints in color, which use more than one plate or block and therefore are inked more than once. It also could be possible that the inking of one or the other is better, that the absorbency of the paper or the pressure of the press influenced the final result for better or worse. For this reason, some contemporary artists do not number their work in the conventional manner, but simply write "ed. 100" or "100 imp." (edition of 100 or 100 impressions).

The size of the edition itself has a great influence on the value of a print. For example, a signed work by Picasso, in an edition of 100, may sell for about $2,500 or more. One without a signature and in an edition of 1,000—if an original—will cost closer to $500.

PAPER

Chapter 3 discusses how paper is made and gives more details on its history, but here our concern is the effect of paper on the finished print.

Paper is made of various materials, such as rags, rice hulls, wood, etc., by hand in a mold, or by machine. It can be thick or very thin, more or less absorbent, have a glazed finish or a very roughly textured one, and its color can vary from pure, bleached white to medium brown tones. In addition, there are papers with color tints added, and they may be used by artists to get color variation within the same state and/or edition. The choice of paper is made with great deliberation. In the time of the old masters, paper was a very costly item and we find that different qualities were used within a single edition. The first few impressions were made on the best grades and sometimes even on vellum (animal hides). Subsequent imprints were on paper of inferior quality.

Modern prints are often done on machine-made paper, but some contemporary artists have also returned to hand-made material. The reason lies in the printmaking processes in use today. Very thick, hand-made paper lends itself perfectly to blind printing (without ink) and to some of the other contemporary creative expressions. The absorbency of hand-made, unsized paper—possibly with its own texture—has its own effect on the final product. You may notice a frayed edge on a full sheet of paper.

This is called a deckle edge and is a sign of good-quality, usually hand-made, paper.

For the collector it is worthwhile to look into the subject of paper, since it leads to a better understanding of graphic art and, by itself, is a fascinating topic with a most interesting history.

WATERMARKS

The old paper makers, as a sign of identification and pride, made use of watermarks in bond writing paper or in currency. The watermark is created during the process of papermaking. The design, symbol, or initial is made of wire and affixed to a wire screen in the mold. It is then reproduced on every sheet made in that mold.

To see the watermark, the paper must be held up against a strong light. Here I would like to introduce a word of caution. Never, never buy a print unless you can take it out of its frame. Certainly the watermark cannot be seen in any other way. (This subject will be discussed in greater detail in Chapter 3.)

Fig. 2-8 shows the oxhead watermark as an example of sixteenth-century symbols. In this instance we know that from about 1500 to about 1520 Dürer used paper with the oxhead or a high crown for the first few impressions taken from a block. Such a watermark helps to authenticate the work and makes it more valuable, since it probably is a very early impression.

If a print does not have a watermark, it does not mean that it is inferior. Since paper was very costly in the time of the old masters, the artist cut the sheet carefully so it could be used completely. Some part of the paper area, therefore, will not have the watermark on it. On the other hand, just because an old-master print has a watermark, it is not necessarily authentic. We know that paper from the seventeenth century with the same watermarks as paper used by Rembrandt was still available in the nineteenth century— and that it was used. Furthermore, old books made use of paper with watermarks, and some contained unprinted pages. Unfortunately, such sheets occasionally have been put to fraudulent use.

COLLECTOR'S MARKS

In studying prints, you may come across a small, stamped mark near the bottom or on the back of an impression (Fig. 2-9). This is a collector's mark, indicating that this print was in a museum or a large private collection. The fact that a particular print was in an important collection, however, does not necessarily mean that it is valuable, authentic, or of excellent quality. Listings in catalogs may state: duplicate from Albertina, collector's mark on verso. This should be interpreted as: the museum had two impressions and kept the better one, In other words, it is nice to know where the print comes from, but in itself this is not a decisive piece of information.

Fig. 2-8. Oxhead watermark used in the 16th century.

1760^b 1760^c

noir, verso

Fig. 2-9. Collector's mark. The printed numbers below the initials indicate the listing in Frits Lugt, *Les Marques de Collections de Dessins et D'Estampes.* (Courtesy of Lessing J. Rosenwald.)

CATALOGUE RAISONNÉ

A scholarly compilation of the total known work of an artist is called a catalogue raisonné, catalogue illustré, or definitive catalog. It lists all available information, such as medium, states, watermark, edition, printer, size, date, signature, and posthumous impressions.

Most important artists have been the subject of scholarly study. This study may have been done as a doctoral dissertation in the academic field of art history or it may be the outcome of a scholar's lifelong interest. A print curator, for example, if he is also an art historian, is in an ideal position to compile a catalog of the total oeuvre of a particular artist. Not only might his museum's print collection have a considerable number of impressions, but he is in contact with collectors and dealers and, therefore, is able to see and compare many prints.

MARGINS AND PRINTER'S STAMP

The margin of a print is the area of paper outside the platemark—i.e., the paper not required for the print. If an impression has a complete margin all around, however narrow, you can be sure that the print is complete and nothing is missing or has been cut off. Since old masters paid dearly for paper, their margins were very small. Contemporary printmakers, for the most part, make use of a full sheet, which is usually left intact.

Often the embossed printer's blindstamp can be seen below the printed portion. This printer's stamp may be of great aid in the authentication of a work, since it may be known that a certain printer published only the first edition, or that he did a posthumous one. The blindstamp may also be of help in dating a print. For example, it may be that the artist in question worked with a certain printshop only in his early period.

Contemporary prints made by U.L.A.E. have this workshop's chop mark—the letters *LAE* within a *U*. The astrological symbol for Gemini, which looks somewhat like the Roman numeral II, is the chop mark of the Gemini G.E.L. workshop. Both of these chop marks indicate good-quality printing, but there are of course many others.

DAMAGES AND REPAIR

One good reason for examining a print out of its frame is the possibility that you may detect damage or repairs. Careful scanning, while holding the print against a good light source, may show up thin spots and skillful repairs. Look carefully on the front and the back of the sheet. If a print is pasted onto a supporting backing, you should be suspicious. It may be that the paper is crumbling or it might hide damage, and restoration of such a condition is very difficult and sometimes impossible. Consult a good restorer for advice. At any rate, a pasted-down impression is of less value.

PROVENANCE

The history of previous ownership of a work of art is called its provenance. Fig. 2-10 will serve as an example. As a general rule, the whereabouts of prints are very difficult to trace, because they are multiple originals and no records were kept regarding the location of most of the graphic works through the centuries. It is rare to find documentation that is specific enough to identify a particular impression. A collector's mark, of course, provides some information, as does a dedication written on the sheet itself. Auction catalogs or inventories of collectors' estates are helpful. If a provenance is available, it aids in establishing authentication and value. For the collector it is an intimate piece of information on a print's history.

To understand Fig. 2-10, it may help you to know that "Lehrs" is a catalogue raisonné of *Fifteenth-Century Engravings in Germany, the Netherlands, and France,* written by Max Lehrs. It consists of nine volumes and is a very reliable compilation. "Lehrs ix. 197. 198" means "volume 9, page 197, item no. 198." Measurements in print listings are usually given in millimeters for accuracy. "Lehrs 10" refers to an illustration of the watermark in Figure 10 of the Lehrs catalogue. "Lugt 724": Frits Lugt has compiled a catalog of collector's marks called *Les Marques des Collections de Dessins et d'Estampes,* and "Lugt 724" is the collector's mark listed under number 724 in that book. B-19,762 is the accession number, which catalogs the acquisition of this impression at The National Gallery of Art.

Ca. 1490-1500
Lehrs IX.197.198
262 x 182 mm.
Watermark: Hand with flower, Lehrs 10

Provenance: Paelinck Collection; A. Donnadieu, London, Lugt 724; Dukes of Arenberg, Bonn, Lugt 567; purchased from William Schab, 1951
B-19,762

References: Geisberg, *Verzeichnis,* no. 172

229

THE MADONNA AND CHILD ON THE CRESCENT
SUPPORTED BY FOUR ANGELS

Fig. 2-10. Provenance for a 15th-century engraving. This provenance is item number 229 in the catalog written for the exhibit *Fifteenth Century Engravings of Northern Europe* by Allen Shestack, The National Gallery of Art, Washington, D.C., Dec. 3, 1967, to January 7, 1968. (Courtesy of The National Gallery of Art, Rosenwald Collection.)

3. If Paper Had Never Been Invented . . .

Paper is a common denominator of most prints. Therefore, it is valuable for the collector to have some familiarity with this topic. This chapter covers a brief history of paper making and watermarks. Other print materials are also described.

PAPER

Paper as we know it today was invented in the Orient. Most experts agree on the date as A.D. 103, but it is possible that paper existed earlier. As early as 2,000 B.C. the ancient Egyptians had their own version of paper: papyrus.

Papyrus is a plant that contains inside its stem thin sheets that are peeled off and laminated to one another to form a larger sheet. Linguistically our word *paper* is derived from the Greek *papyros*, and this is where the relationship ends. Paper is not found in nature but is a man-made product. Before it came into general use in western civilizations, animal hides were prepared for use as a writing surface. Called vellum, they are sometimes also referred to as parchment. Today, according to Labarre's Dictionary of Paper, these terms are still in use but have acquired other definitions. Vellum is a white paper with an appearance similar to animal skin, and parchment denotes an unsized paper. If you see these words in a catalog, more likely than not vellum is paper, but it could refer to animal hide. As an example, the Pierpont Morgan Library in New York owns an impression of *Jan Lutma* by Rembrandt, printed on vellum, and in this case vellum really is animal skin.

Comparatively few tools are required to make paper; a vat for the pulp, a mold for forming the sheet, an apparatus for squeezing the water out of the formed sheets (usually a press), and a place to dry them. The first paper mill in Europe was established in Spain in A.D. 950, but paper did not come into general use at that time. The Fabriano paper mill in Italy began to operate about A.D. 1276. Apparently a number of others were established in Italy and Germany soon thereafter.

In 1390 a man by the name of Ulman Stromer built a paper mill in Nuremberg, Germany. He was a merchant with no knowledge of paper making, but he employed Italian artisans who were experienced paper makers. Stromer drew up elaborate contracts with them to the effect that they must not divulge the secret of the process to anyone but himself and his heirs, that they would protect his interests and be loyal. Eventually they staged a minor revolt and attempted to take control of the mill. Stromer had them confined to a tower for a brief period and then made them swear under oath that they would be loyal and productive. Apparently they lived happily ever after. This incident is documented because Stromer kept a diary in which he recorded the events of his business. In addition, a picture of the Stromer paper mill is included in the *Nuremberg Chronicle,* printed in 1493. This book, published by Koberger (who was Dürer's godfather and did some of Dürer's printing), is set in movable type and illustrated with woodcuts. Many libraries have facsimile editions of this or other early books that are of interest to the print collector.

Paper production increased during the fifteenth century, the demand for books grew, and movable type was invented by Gutenberg (in Germany) about 1450. Printing, illustrating, and printmaking flourished. It was the time of re-awakening—the Renaissance. Through the next three centuries more mills came into existence, more paper was produced, and some mechanical innovations were made or became refined, but essentially handmade paper is produced today in the same manner as it was in the beginning. In the nineteenth century the industrialization and mechanization processes that affected production of all goods also affected the making of paper. Not only was paper made by machine rather than by hand, but new materials were put to use. Wood was probably introduced to paper production as early as 1802. As the mold was abandoned and machinery took over, it was possible to make much larger-sized sheets, and this coincided approximately with the invention of lithography. For some contemporary artists the paper is an important ingredient of the creative effort; some even make paper themselves, or have it made to their specifications by a paper maker. Papers were produced in Europe, but many artists used imported material from the East. Oriental papers differ from the European ones in their ingredients to make the pulp. Rice hulls, mulberry bark and other vegetation not rag, flax or linen were used. If this matter remained unbleached, the resulting paper sheets were in shades of tan or brown. Oriental paper is generally thinner than the European one. Frequently it is also unsized. Rembrandt, especially, experimented with oriental paper. Designations such as Japan, China, India or Holland were added to the different types of paper to indicate thickness and color. Each type comes in many variations, but usually China and Japan papers are thin and white, Japan is often more textured than China, and India paper is perhaps more likely to have a darker color. Holland refers to good quality white rag. These are generalizations that may not be satisfactory, however, the important thing is not the name of the paper, but the effect it affords the artist.

PULP

Paper (this discussion concerns only handmade paper) can be made from flax, linen, vegetable fiber, and rags. The ingredients are cleaned, cut into a small size, and put in water to ferment. Then they are pounded or mashed to a pulp. Originally this was done by hand, but soon mechanical appliances were used. The device for this might be a stone roller, a trip-hammer, or a wheel-driven stamper. The object was to reduce the fermented material to fiber. When this was accomplished, the fibrous liquid was transferred to the vat. To prevent the fibers from settling to the bottom, constant stirring was necessary. The forming of the sheet was done by skilled craftsmen called the vatman and the coucher.

MOLD

By tradition the mold is rectangular in shape. It consists of a frame and a deckle. The frame has to be very sturdy. It is usually made of wood or bamboo and the wire mesh is fastened to it. The deckle fits over the frame and looks somewhat like a simple wooden picture frame. It forms the "deckle edge."

Depending on the wire arrangement in the frame, we speak of laid paper or wove paper. Fig. 3-1 shows some rather heavy lines, the ribs, which are spaced apart. The finer lines across them at right angles are laid lines, closely spaced. The laid lines are fastened to the ribs in a chainlike manner—the chain or chain lines. Wove paper is made on a mold that has a woven wire mesh like wire window screens. It came into use around 1750 in England. The pattern of the wire lines, either laid or wove, gives the sheets of paper their name. A laid paper mold is shown in Fig. 3-2. As you can see, it has the watermark of the Van Gelder Zonen paper mill.

To form the sheet, the vatman dips the mold into the vat at an angle, scoops up some of the fibrous pulp material, and shakes the mold as he lifts it, as shown in Fig. 3-3. This action forms the sheet, i.e., distributes the fiber on the wire portion of the mold. The shaking expels excess water. A good vatman succeeds in an even distribution of the pulp over the entire area, and so produces a sheet of paper of equal thickness and strength, as well as of the desired shape. This requires considerable skill and the good judgment to estimate the quantity of pulp required for the achievement of uniformity. Next, the deckle is placed on the mold. This presses the edges of the sheets between mold and deckle and results in the ragged or frayed appearance of the deckle edge. It has been imitated in machine-made paper, but it lacks the natural, uneven appearance of handmade deckle edges. Next, the water is allowed to draw from the mold, and then the coucher takes over. He flips the mold onto a felt pad, thereby removing the wet sheet from the mold. Couching requires considerable skill, since the freshly formed paper is wet and the fibers do not firmly adhere to each other yet. The coucher alternates sheets and felt pads on top of each other until a "post" (equal to 144 sheets) is accumulated. Then the post is placed in a press and the remaining water is squeezed out. The sheets are then removed from the pads and placed on one another and returned to

the press. This is done by the layman, whose job it is to layer the sheets carefully and make them as smooth as possible through the additional pressings. Fig. 3-4 illustrates all the steps involved in making paper by hand. The post now gets separated and hung to dry in the drying loft. The middle crease on some old paper is quite likely due to the line on which the damp sheet is hung, as illustrated in Fig. 3-5.

Paper may be bleached or colored, and the appropriate ingredients are added to the pulp before the sheet is formed. The whiteness and purity of paper is determined by the materials used to make the pulp. Certainly pure linen or flax will give a different color and texture than rice hulls or tree bark.

Fig. 3-1. Mold and deckle of the 17th century. An engraving of a partially finished paper mold of the 17th century. (A) Note the watermark. (B) The wormlike lines are the wires used to lace the ribs and laid lines together and form the chain lines. (C) The deckle. (D) The frame is made of sturdy wooden bars like this. (E) A rib. The darker portion of (A) and (B) shows the part of the mold that already has the laid lines fastened to it. (Courtesy of Dard Hunter Paper Museum at the Institute of Paper Chemistry.)

Fig. 3-2. Laid mold with watermark of the Van Gelder Zonen paper mill. (Courtesy of Dard Hunter Paper Museum at the Institute of Paper Chemistry.)

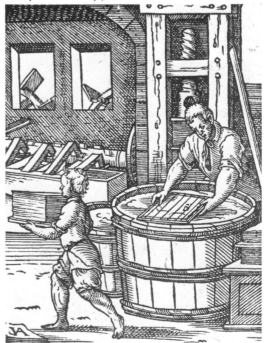

Fig. 3-3. *The paper maker*, Jost Amman. Woodcut, 1568. (Courtesy of The Library of Congress, Washington, D.C.)

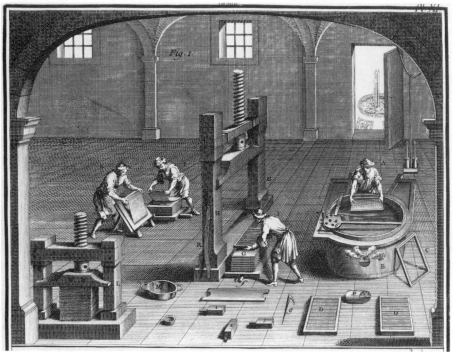

Fig. 3-4. French paper mill. Engraved book illustration, 1761. (Courtesy of The Library of Congress, Washington, D.C.)

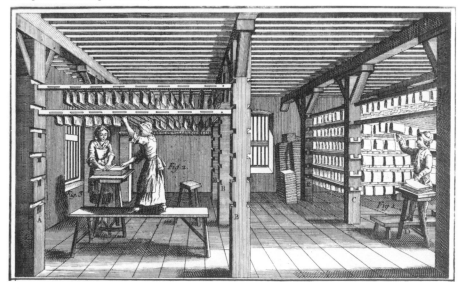

Fig. 3-5. A paper drying loft. Engraved French book illustration, 1767. (Courtesy of The Library of Congress, Washington, D.C.)

78

SIZE

The sheet finally goes through a finishing process. It may be hand polished, sized, or unsized. Much depends on its intended use. Size is used to make paper less absorbent and more durable. Animal or vegetable sizing has this latter effect, but chemical size unfortunately can destroy the paper rather than protecting it by making it brittle, flaky, and discolored. This is especially true of some nineteenth-century paper, and it affects the book collector perhaps even more than the print collector.

An unsized sheet of paper, such as a blotter, makes ink diffuse. If it is desirable to have a clear, sharp line, as required for engravings, sized paper is used. Oriental paper is frequently made without sizing, which lends a softness to the artist's brushwork. The diffusion also depends on the fineness of the fiber used and of the material from which the fiber is made. The finer the particles in the pulp, the denser will be the sheet; the longer fibers result in stronger pulp.

Sizing is generally made of a gelatin derived from processing animal hides. The dried sheet is dipped into the size vat, once more pressed, and hung to dry.

Inks influence the appearance of a print. Printer's ink is heavier than writing ink, and less size is required when heavier inks are used. A printer can therefore adjust his inks to the type of paper he is printing—to some extent. Newsprint is unsized paper, and thick ink is used to print on it. The unsized sheet absorbs the ink very quickly.

"Progress" made in the production of handmade paper since its invention concerns mostly bleaching agents, better presses, mechanical pulp makers, and sizing. The secret of beautiful paper still lies in the craftsmanship and knowledge of the artisans.

Mechanization of paper making brought notable changes in quality (inferior), supply (plentiful), and cost (lower). Paper mills today are completely automated, from pulp to sizing, with cylinders and moving belts acting as molds. Wood replaced the meager supply of rag and linen when the demand exceeded the supply. For coarser papers, even straw and some grasses are used. Much experimentation preceded the mechanization, many inventors worked on the problem, and all of it is rather recent. The patent for the process of making wood pulp was granted in 1852 in England, but it was put to use in the United States a few years later.

During the printing, when the sheets are usually dampened, paper stretches and shrinks. This is a particular problem when producing color graphics, since the paper has to go through the press more than once and must be in perfect register every time. Paper, hand- or machine made, must be produced with forethought for its intended use.

WATERMARK

A watermark design, made of wire and attached to the mold, is shown in Fig. 3-6. An example can be seen in a good-quality writing paper that might have a watermark such as Bond, Rag Content, or a trademark. The watermark design (see Fig. 3-7), like the laid and chain lines, leaves its imprint

when the sheet is formed on the mold; the area where the wires touch the fibers are slightly thinner.

In modern paper production the fiber passes a cylinder called the dandyroll, to which the watermark design is attached. As this dandyroll moves across the material, it impresses its mark. It can also produce the laid or wove design.

The first watermark was probably made when the need arose for repair of a mold. Someone may have realized that the new wires showed in the paper and began to make more fanciful designs, until it became a means of identification and particular pride, since paper making was for so long a secret process. Ulman Stromer, who was mentioned before, used a watermark in the form of the letter S, and the papers with such a design are recognized as coming from his mill.

A large variety of subjects were used for the watermark design—from religious symbols to animals, crowns, flowers, letters, tools, fruits, weapons, etc. The well-known oxhead watermark shown in Fig. 2-8 was in use for 200 years. It exists with a cross, with a flower, without either, and in hundreds of other variations. If the wires of the design wore out, they were fixed or replaced and frequently differed slightly from the previous design. One compilation of pre-seventeenth-century European watermarks contains nearly 16,000 designs, including numerous variations of some designs.

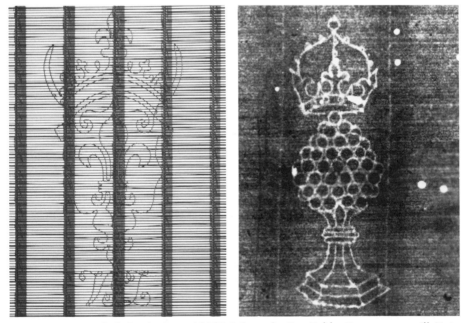

Fig. 3-6. Watermark design in the mold. This is from the Van Gelder Zonen paper mill. Note the chain line in this detail. (Courtesy of Dard Hunter Paper Museum at the Institute of Paper Chemistry.)

Fig. 3-7. A 15th-century watermark showing the arms of Augsburg in the laid paper. (Courtesy of The Library of Congress, Washington, D.C.)

For the collector of old books or old prints, the watermark is an important means of identification. We know that the more expensive papers were used for the earliest impressions by many artists, and in the case of most old-master graphics, a variety of papers was used in the total edition. In modern graphics, part of an edition may be printed on watermarked paper and the rest on unmarked sheets. This may indicate that some impressions are more desirable. Usually a reference is found in the catalogue raisonné. Oriental papers can have watermarks, but generally they do not.

MATERIALS USED IN PRINTMAKING
Wood Blocks

All woods are suitable for cutting the block, but the results depend on the type of wood chosen. As was pointed out in Chapter 1, we differentiate between hard and soft woods and between short and long grains. Boxwood is the hardest and finest-grained wood and was used to prepare the blocks for most of Dürer's prints as early as the fifteenth century (see Fig. 1-5). It is still considered the best for fine line work, as was pointed out to me by the contemporary artist whose work is shown in Fig. 1-11. Other hardwoods like rosewood or oak are also used for fine line, but they are not as desirable. Boxwood, unfortunately, is a slow-growing plant with a rather thin stem, and it does not yield an abundant supply. It is not possible to derive large planks from it, so small squares must be pieced together in order to form a block of suitable size. Since the cut or engraved block must withstand the pressure of the press, this piecing requires excellent craftsmanship. In addition, the block is inked, and eventually the liquid soaks into the wood. This could cause swelling in some areas and would result in separation of the pieces if the seams were not perfect.

Soft woods like pine or maple are used if more chunky lines are desired, or if the wood grain itself is to be part of the design. Not as many impressions can be taken from a soft wood block as from a hard one because it wears much quicker and absorbs the ink faster. Damp wood tends to buckle. If run through the press in that condition, it will crack or break.

The short grain, also called the end or cross grain, allows much finer cutting or engraving than does the long grain. Boxwood is almost always cut across the grain to obtain pieces that will be more durable.

Lithograph Stones

Bavarian limestone seems to have most of the attributes required for lithography. In the recent past, because it has been less readily available, substitutes have been used, i.e., other stones with similar characteristics. Lithographs are also made from aluminum or zinc plates, which differ in their properties from stone but offer new effects and easier handling. They are particularly suitable when lithography and photo-offset are combined in the same print, since these metal plates can be used for both processes.

Mordant

This is the acid bath used in etching (see Chapter 1). The ingredients and strength of the solution determine the length of submersion (bite) and also the width and depth of the etched line. Dutch mordant, which is made of water, hydrochloric acid, and potassium chlorate, bites a rounded, straight groove, whereas nitric acid results in a shallower, wider groove. The mordant was made up according to recipes until it became commerically produced. Some old recipes are available that were used by Callot, Bosse, Hollar, Haden, and Whistler.

Ground

There is a considerable range of possibilities open to the artist, and his choice of ground must be made with care. It is made according to recipes or may be purchased commercially. Jacques Callot, whose aim in etching was the imitation of the engraved line, used a hard ground. This produced a clean, sharp line. In addition to this, Callot developed a tool called the échoppe, which enabled him to make an undulating line into the ground, more closely related to engraving. Rembrandt, for the most part, seems to have used a softer ground, which allowed more freedom in drawing. This freedom of line we associate with Rembrandt's work is due to both his choice of ground and his style. This is mentioned here only to emphasize the need for technical understanding on the part of the artist for his materials, methods, and processes. The Pissarro etching shown in Fig. 1-15 required even softer ground for the artist to accomplish the effect he desired.

COLOR IN PRINTS

Some printmaking media lend themselves better to color than others. Woodcut and lithography are preferred by artists who are colorists, while etching traditionally is carried out in black and white, with few exceptions.

Originally color was applied to the early woodcuts by hand. Since the figures were represented in outline without any shading, it was a simple matter to fill the spaces. As the techniques in woodcuts and engravings became more sophisticated, shades of gray were achieved and figures were modeled in three dimensions with parallel and cross-hatching.

The chiaroscuro woodcut probably was introduced in the sixteenth century as a technique for the reproduction of paintings; therefore, it required color. This was accomplished by using more than one block, but it was not the first use of multiple blocks. Apparently the practice existed earlier in that century in the Nuremberg area. A frequently cited example is the color woodcut by Albrecht Altdorfer, dated 1519, which employed six different color blocks. The ukiyo-e color woodcuts made by seventeenth- and eighteenth-century Japanese artists are examples of the finest craftsmanship and technique of cutter, printer, and artist. Teamwork was also employed in the field of color lithography. When there is a real rapport and respect between the artist and the printer, the end product is the superior accomplishment of both.

Registration in Color Printing

If a print has more than one color, it is necessary to separate the colored areas so that each color can be printed separately. First the artist creates his design and either colors it by hand or works out exact written instructions of his plan. The coloring may be done with crayon, washes, oils, or any other material the artist finds suitable. Artists who do their own printing may even prefer to use the trial-and-error method, but if there is to be a collaboration with a printer, it is necessary to develop preliminary sketches.

To separate the areas of color, acetate or tracing paper overlays are made. By tracing all areas of one color on each overlay, a so-called color separation results. Each one of these overlays is then transferred to a matrix: a stone, plate, or block. If the final print is to have three colors, then three color matrixes are required, each containing that part of the design that should be printed in the designated color. If the final impression should consist of a red square inside a green circle, the circle would be separated from the square by tracing the outlines, and each portion of this design would then be transferred to the plate or stone separately. In the printing process all the stones (or plates) are used in succession, until all the colors are included.

The purpose of registration is to line up all the colored areas perfectly in each impression. The above-mentioned circle must print exactly within the area allowed for it. If it is slightly off register, it will overprint into the green square and look not only sloppy but also discolored. In this misalignment some areas will remain white, since the circle shifted. Some contemporary artists like this effect of being slightly off register and do it on purpose (Andy Warhol, for example). But proper registry is critical in hard-edge designs (Josef Albers, for example) and other exact art work.

Sometimes it is desirable to have one color overprint on another in order to get a third color as a result. Purple, for instance, is a mixture of red and blue. If one color (red) is printed over the other (blue), this third color (purple) may be achieved by using only two plates.

The register mark is placed on the key stone outside the design and is then transferred to the other plates, stones, or blocks to line up perfectly and accurately. Since each sheet goes through the press numerous times, it is essential that it be lined up carefully and in register every time it is printed. Problems arise as the paper shrinks and stretches when pressure is exerted on it. Minor shrinking or stretching can be adjusted, but if the change in the paper is too great, the solution may lie in the choice of different paper.

4. Once Upon a Time . . .

Recognition of a masterpiece is possible for most of us. Reaching intellectual awareness and a true understanding of a work of art is a learned reaction—at least in the twentieth century. We are not born with the required knowledge or even the trained eye that truly sees. It *can* be learned, and the relatively young discipline called art history provides the tools.

Professor Erwin Panofsky, the eminent art historian, in his book *The Meaning of the Visual Arts,* discusses the relationship and difference between the collector and the scholar. The collector's concern is with the more practical aspects of a work of art; when it was done, by whom it was done, what its quality and condition are. He calls the connoisseur a "laconic art historian" (and the art historian a "loquacious connoisseur") who evaluates works of art subjectively, according to his taste. The art historian should be objective in his judgment and evaluate in terms of style, artistic intention, and past history.

The preceding chapters of this book have concerned themselves with the basic ingredients you need to be a collector of graphic works. Now I would like to round out the picture with a general discussion of art history.

The history of graphics is, of course, a part of the history of art, and it has evolved simultaneously with all other art forms. It concerns the origin and development of prints, their use and purpose, with special consideration to "time and place." For example, the woodcut made in the Orient varies from prints made in Europe at the same time, and a print made in the fifteenth century in northern Europe will differ from one made there a century later. Historical events, scientific and industrial developments, religious and philosophical thought also exert strong influences. To introduce you to the history of graphics, I have selected some highlights. Of necessity, they are very condensed discussions; hopefully they will kindle your interest sufficiently so that you will pursue them more fully.

Printing on paper was preceded by printing on fabric. Fabric designs were carved, in relief, on a wood block, the surface of which was inked, and the design was stamped on the fabric. An example of this is shown in

Fig. 4-1; it is a rare, 500-year-old lectern cloth. Woodcuts printed on paper depended on the availability of paper, the history of which has been recounted in Chapter 3.

During the fifteenth century so-called block books were printed from wood blocks on which lettering and illustration were hand carved. When movable type was invented around 1450 by Gutenberg, paper was still very expensive. The 150 Gutenberg Bibles (thirty more were printed on parchment) required 50,000 sheets of paper at a cost of 900 gulden. This sum was translated by an expert as the equivalent of almost five large country estates. This quantity of paper could not be supplied by one paper mill but required several. The paper used in these books bears the different watermarks in use at the various mills. Each Bible sold for thirty gulden, a very respectable sum at the time.

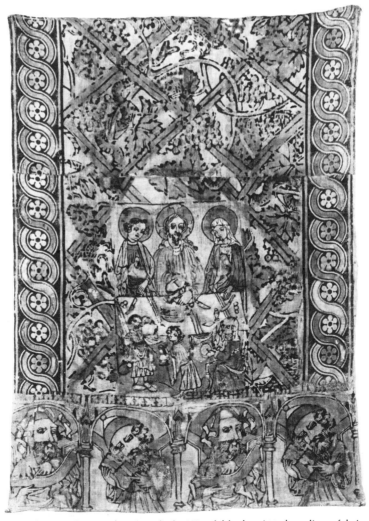

Fig. 4-1. *Marriage at Cana*, a lectern cloth. Wood block printed on linen fabric, ca. 1400. (Courtesy of the National Gallery of Art, Rosenwald Collection.)

The significance of early graphics certainly does not lie in their artistic and creative quality but in the historical presentation of religious and secular events and thought. Prints were not made to please a print collector of the fifteenth century. Their purposes differed, although their main function was a religious one.

In medieval times monks worked from morning to night, writing and copying books, mostly the Bible, by hand. Kings and members of the aristocracy had prayer books made in this way, the so-called Books of Hours. These were made on parchment and included colorful, often artistic, paintings. Illuminated manuscripts were handwritten and hand painted on animal skins. Remember that neither paper nor printing press was available. Because of this, and the long time it took to copy and illuminate them, the volumes were rare and very expensive.

Few people were literate then. The Church, eager to spread its power and its dogma, soon realized the value of presenting the Bible and other religious material in visual form without letters. In the fifteenth century famous painters worked on altarpieces, which often contained scenes from the lives of Christ and the Virgin Mary. The content of these paintings included a great deal of symbolism that was readily understood by the people and did not require any written explanation. A woman holding a baby with a circle around its head was immediately recognized as the Virgin and Child, the circle as a halo. A winged figure with a white lily in its hand was known to be the Angel Gabriel, the angel of the Annunciation. A dove with a halo represented the Holy Ghost and, together with two male figures, the Trinity. These are simple examples of iconographic symbolism. Iconography is the portion of art history that deals with symbolic content in the visual arts. Stenography is language translated into symbols that are quickly recognized and understood by anyone who has learned what these symbols mean. The meaning of stenographic symbols remains constant, but iconographic symbols have changed in meaning over the centuries. The Greeks, on painted pottery, recognized the god Bacchus by his attribute, grapevines and grape clusters. Wine, grapes, and grapevines used in religious art at around A.D. 1500 symbolized the blood of Christ, i.e., the wine used during the celebration of High Mass. Seventeenth-century northern baroque also used wine and grapes as iconographic symbols, but since patrons were of Protestant middle-class society, the meaning changed again. Artists painted allegories of the five senses. Wine, therefore, referred to the sense of taste. In the more "lusty" scenes, showing a "maiden" and a suitor, the interpretation would be closer to an attempt at seduction.

In more recent times, Georges Braque used a bird as his subject matter many times. We recognize it readily as the dove of peace, not as the dove representing the Holy Spirit, as it was used 500 years ago. These interpretations are, of course, connected with the prevailing way of thinking in a given society, and with what occupied the minds of the population. The art of any given time has relevance to its environment, and it has to be understood on this basis. Twentieth-century thinking cannot be applied to

a fifteenth-century work of art, nor to its iconographic symbols.

Early iconography became more intricate if it concerned an important altarpiece, but altarpieces were not the only form of Church-sponsored art, as can be seen in Fig. 4-2, which includes an indulgence. This is a woodcut; the Virgin and Child are hand colored, the letters are hand cut. The text is in Old German and refers to Pope Pius IV, who granted an indulgence lasting 1,000 years to all those who confessed, repented, and prayed. The lower part of the sheet is given over to a prayer addressed to the Virgin.

Fig. 4-2. *Madonna and Child in a Glory with an Indulgence and a Prayer.* Woodcut, ca. 1480. (Courtesy of The National Gallery of Art, Rosenwald Collection.)

As pointed out in Chapter 1, small prints—often pictures of saints—were sold to pilgrims. Fig. 4-3 is a good example of this type. It depicts Saint Valentine, the saint of lovers and the protector of epileptics. *San valetin bit got fur uns* ("Saint Valentine, pray to God for us") are the words inscribed. Saint Valentine is shown as a bishop with a halo. One couple is lying on the ground, apparently in an epileptic fit; the other couple may well be lovers. Above their heads are symbolic shapes that must have had healing or magic qualities; this would have been understood immediately by the people in the year 1470, the date of the illustration. In this example the lettering is hand-cut as part of the wood block on which the design appears. This is the way letters looked in the early books before movable type. Note how the letter *U* differs each of the four times it appears here. Movable type was metal cast in a mold and all four *U*'s would have been alike.

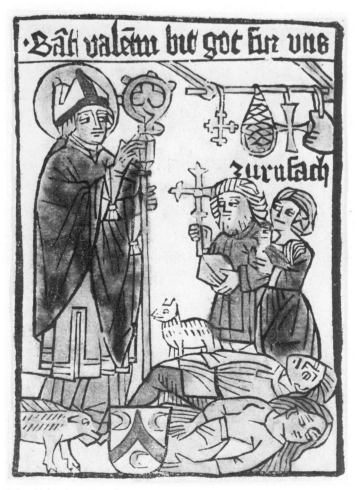

Fig. 4-3. *Saint Valentine.* Woodcut, ca. 1470–80. (Courtesy of The National Gallery of Art, Rosenwald Collection.)

Some of the more popular uses for printing on paper were playing cards, medicinal illustrations, pictures of herbs that could be used to cure illness, depictions of costumes and of everyday events. The Easter calendar shown in Fig. 4-4 was used to compute the dates of the Catholic Church's movable feasts, and it is a rather intricate table for calculating these dates over a period of twenty-eight years. It is based on the lunar month. Fig. 4-5 is another interesting early print. This map of Mexico City dates to the middle of the sixteenth century.

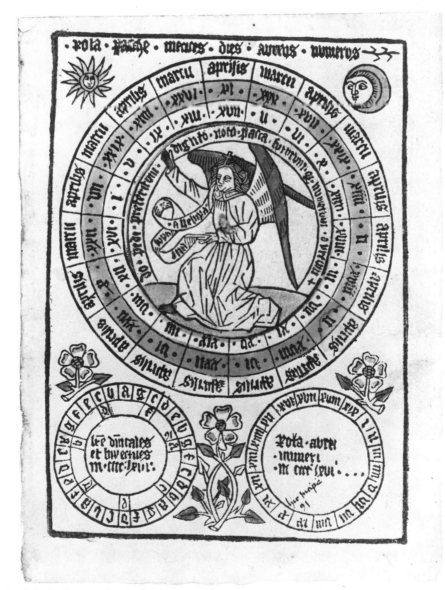

Fig. 4-4. An Easter calendar beginning with the year 1466. Woodcut. (Courtesy of The National Gallery of Art, Rosenwald Collection.)

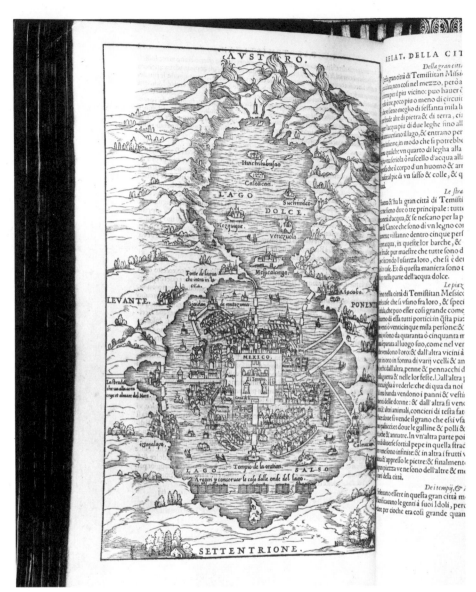

AVSTRO.

Fig. 4-5. Map of Mexico City, Giovanni Batista Ramusio. Woodcut, book illustration, ca. 1554–59. (Courtesy of Lucien Goldschmidt.)

Early prints frequently had colors painted in by hand. They resembled stained-glass windows and their designs were rather crude. Printing with more than one block came into practice later.

The Renaissance brought about changes all over Europe, and especially in Italy. These changes concerned not just the fine arts, but also literature, politics, religion, and certainly philosophy. As man became the center of the universe, the theme in all art, including prints, changed. Allegories, myths, festivals, theatrical events, and the like, replaced the tightly pre-

scribed religious scenes. The Bible still provided the subject matter in many instances, but it was expressed in a totally new manner. One of the giants of the Renaissance, Michelangelo, chiseled the *Pietà* from a marble block. It is no longer a Madonna and Child with halo, but a mother holding her dead son. Her grief is human, not godlike. Not only does the concept differ, but also the attitude. The human body was examined in detail; proportions and perspective were considered. The crowning achievement of architecture was the dome of Saint Peter's in Rome. Popes employed artists like Michelangelo and Raphael to paint frescoes. Many of the scenes were related to intellectual endeavors of the time or to Greek philosophers, and even the religious subjects were freed. These changes are reflected, of course, in the subject matter, style, technique, and medium of graphics. The very crude and simple woodcut was transformed by Dürer to an art form. Engravings, originating from the decorations of goldsmiths, were made by well-known artists like Andrea Mantegna, Antonio Pollaiuolo, Lucas van Leyden, and Albrecht Dürer.

Albrecht Dürer is credited with bringing the Renaissance to the north of Europe. Compare the illustrations of his work in Figs. 1-6 and 1-8 against the prints shown thus far in this chapter. You will notice the refinement of line and shading, plus the totally different handling of the figure, of the drapery, and even of content. Dürer's prints are rather self-sufficient; they tell a whole story. Technically they are far superior and already include perspective.

Printing presses and processes, as well as new tools and materials, contributed to the widespread production of prints. More than that, people began to appreciate and value them. New purposes evolved. Scientific illustrations, anatomical pictures, architectural designs, commemorations of important events like a coronation or the triumphal return of a general, copies of monuments, sculptures, and decorations on structures were produced in graphic media. Objects of general admiration were translated into prints. These included interiors of churches, paintings by well-known artists, and even other graphics. Prints are small, easily portable, and exist in multiples. This makes it very simple to transport them over a large geographical area, and in this way to spread information. Artists in the north of Europe learned what their colleagues were doing in the south, and vice versa. Many were print collectors themselves. Influences of style and technique from one artist to another and from one country to another were due, to a large extent, to graphic works.

Another interesting use of graphics was the so-called emblem books. These date back to the seventeenth century, mostly in the Netherlands, where the social, political, religious, and economic changes are reflected very clearly in the art. In Protestant Holland a well-to-do merchant class arose. To elevate their status they surrounded themselves with art, but their taste was not that of the sophisticated aristocrats. They liked to look at scenes from daily life (genre scenes), lusty drinkers and lovers, refined middle-class interiors, landscapes of their country, card players, children at play, women at work or at leisure, people eating, drinking, and making

merry. Yet they also understood the value of teaching their families through visual means. Households owned emblem books, which contained moralizing illustrations together with short verses about them. Many of these dealt with life and death, and all of them had symbols to express the theme they portrayed. Fig. 4-6 is from such a book, with its moralizing message. The winged figure is a putto making clay figures on a pottery wheel. A putto is not an angel, but an allegorical figure like Eros; the symbol originated in Italy and, translated from the Italian, the word means "boy". Clay is the material used to make man, according to the Bible. Note the finished clay "people" on the wall shelves, neatly divided into male and female. A girl sits nearby, blowing a soap bubble. This is symbolic of life: it is fragile and does not last long. The shovel in the corner possibly refers to burial. The moral of the story is that life is but a fleeting moment: we begin alike and we all end alike.

Fig. 4-6. Illustration from an emblem book, Christopher von Sichem. Woodcut, 1628. (Courtesy of Lucien Goldschmidt.)

Woodcuts and engravings became a popular way of illustrating books in the baroque period and the years following. The etching shown in Fig. 4-7 is from Callot's *Miseries of War,* dated 1633 and made in France. The theme is a social comment on the horrors of war. This topic was taken up later by other artists, for example, Goya. Social and political criticism really came into their own with the biting comments made by Honoré Daumier, after the invention of lithography. Fig. 4-8, showing a murder of four family members, including a baby, is one of Daumier's finest technical efforts in lithography.

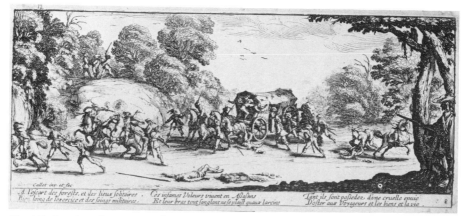

Fig. 4-7. *Les Grandes Miseres de la Guerre*, plate 8, Jacques Callot. Etching, 1633. (Courtesy of Lucien Goldschmidt.)

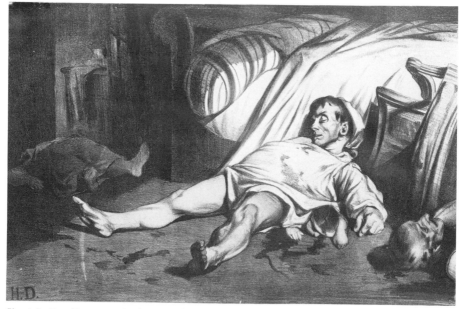

Fig. 4-8. *Rue Transnonain, le 15 avril 1834*, Honoré Daumier. Lithograph. (Courtesy of Lucien Goldschmidt.)

Artists who make prints, just like artists working in any other art form, express themselves in the characteristic way of the prevailing style, which has varied considerably through the ages. Style, according to Webster, is a "distinctive or characteristic mode of expression" or a "distinctive manner or mode of painting, sculpting, etc." It is affected by what might be called, in an oversimplified way, life or environmental change. There are, obviously, many aspects to life, and the term has been overused in our daily language.

An artist can influence his society, but he is, in turn, a product of his peers, the social events, politics, religion in his locality, and the particular time in which he lives. The work of an artist is often not understood by his peers because his vision is not of his time, but rather ahead of it. You may find yourself wondering what separates great masterpieces from the lesser ones. There is, of course, more than one answer to this, but the first consideration must be to observe the particular artist or the work of art within his or its time. Certainly the impressionistic manner of painting is still used today by some professionals and amateurs. It was Monet who was innovative both in thought and execution. It happened in a particular place and time, and it was caused, to a large extent, by the invention of photography around the middle of the nineteenth century. Some fifty years later, at the end of the nineteenth century, entirely new printing techniques came into use, including photographic processes and mechanized presses. Since the photograph could make a more exact likeness of a face, a tree, or a landscape, the artist no longer needed to do it. Impressionism may be seen as a direct result of these developments.

The artists' interests then turned to color and light. Monet painted the Notre-Dame Cathedral at different times of day, in bright sunshine as well as at dusk. While the structure certainly remained the same, his impression of it varied in color and his perception of its appearance changed in different lights. Light had also been of great concern to Rembrandt, but stylistically it had been handled in an entirely different way. Consider that he lived more than 200 years before Monet, in a different country and a different environment. His contribution, too, was innovative, but in the context of his own era.

A great master must also be a great technician, so that the handling of his medium or tools is not a problem for him. The way an artist uses his paints or the etching needle is his personal and unique style. It is likely, if he is an innovator, that he will be copied. He is great, however, because *he* is the originator. Atomic fusion is understood and used by scientists today, but it was Albert Einstein who conceived its possibility. Einstein's influence on other scientists, on our society, philosophy, politics, and progress was and is far reaching. I am not suggesting that art has quite that kind of impact, but those great masters who were innovators influenced other artists, as well as their own time and environment. An outstanding personality like Rembrandt or Picasso makes himself felt over a long time and over a wide geographical area. We speak of them as being universal. One of the great attributes of Rembrandt's work, for instance, is his apparent understand-

ing of the "inner life" with which he endowed his sitters. Sigmund Freud's impact on society and thought with regard to the "inner life" came about 250 years later.

When you are looking at prints with some concern about their artistic merit, remember that you are a twentieth-century person, so unless the print is a contemporary one, it must not be considered with twentieth-century thought. It must be seen within its own time and framework. Picasso's early, cubist works, for example, were created under different conditions than his very late ones.

Suppose that all the art, architecture, and sculpture of the world were suddenly put together in one location, without the artist's name to identify it, without any description, title, or other means of knowing where, when, and by whom the work was created. Imagine that you had the job of separating all of these paintings and buildings according to some system. How would you go about this? Certainly you would separate the paintings from the architecture, the sculpture, and the graphics. Now you would have a big accumulation that still would need to be categorized by country of origin and by the time period in which it was made. What is it, then, that would be the significant factor in determining such a separation? It is style.

Among such an accumulation of art works, as mentioned above, there would be some that would resemble each other in their distinctive characteristics or manner. If you were to separate them from the rest, you would find that they expressed an approach to the idealized figure, or to the effect of light, or were highly stylized biblical figures, etc. Stylistically, it would be expressive of historical events and philosophical trends at a particular time and in a particular place. Even a century makes a considerable difference in style.

It is the aim of art historians to bring understanding and order to this art accumulation. Art history came into being less than 200 years ago and has been pursued seriously only since the beginning of our century. In the academic world it is grouped with the humanities, not with the sciences, but it nonetheless makes frequent use of scientific methods and apparatus (X-ray, carbon dating, chemical analysis, etc.). Its main concern is to place a work of art in its proper historical time with the use of documentation and knowledge of historical data. This makes it possible to date art, and if we are to understand the artist's intent or manner, then we must understand the philosophy of his environment as well. For example, under the reign of the Byzantine Emperor Justinian, who lived from A.D. 483 to 565, tightly prescribed icons were made in mosaic tiles to grace the walls of churches and palaces. But in these works the artists did not express themselves; they were admired for their craftsmanship rather than their creativity. It would not have been permissible or possible for them to make social comments or social criticism in the manner of Goya or Daumier.

In art history we speak of periods such as the Renaissance or the Byzantine era, and we try to place them in a time segment. It is important to bear in mind that this does not mean that such dates are precise, since we cannot say that the Renaissance began, for example, on January 1, 1400.

Periods, styles, and the events that influence them flow into each other and also overlap. The dates are approximate and refer to the movements that existed at that time.

As an art-historical experiment, look at paintings and prints, either at a museum or in some comprehensive art books, for the following:

1. Ten illustrations dated approximately fifty years apart. Notice the differences of subject matter and manner of presentation.

2. Ten illustrations of the work by one artist during early, middle, and late periods in his career. Picasso would be a good choice, since changes are very apparent in his work.

3. Ten illustrations of Venetian art in the years around 1550; begin with Titian and compare these ten with a group dating around 1750, which will include Piranesi and Tiepolo, also Venetians.

4. Ten illustrations of work done by artists at the same time, but in different countries from those in number 3 above.

You may find that there are times and places far more active than others, cases of influence from time and place clearly noticeable, and some isolated styles as well. The aim is to examine art with a critical eye, not with judgment related to your personal taste, and to see stylistic differences.

The various objects in a painting or the choice of subject matter are never accidental. Their choice, by the artist, is purposeful. If he feels that the center area of a still life needs red, for example, he can place it there in the form of a bird, an apple, a box, etc. Art is a conscious effort (except for action painting). The idea the artist projects may be motivated by unconscious factors and is influenced by the way in which he perceives life and the environment around him. It is this element with which the viewer establishes a rapport, and then likes or dislikes a work of art. A great work of art is one that can establish such a rapport over a long time, with a great many people. It has a meaning that is universal—i.e., one that can be understood by many. It will deal with basic needs or instincts common to most people, like love, sorrow, youth, honor, etc. Needless to say, its execution depends on the technical skills of the artist, the means to achieve the visual image of an idea.

The concepts introduced in this chapter are of primary concern to the art historian. As a serious collector you will want to relate what your critical eye perceives to an understanding of a work of art. Some knowledge of art history is essential for this. You may know what you like, but to know why you like it requires an understanding of style, movements in art, historical changes, artistic merit, etc.

I would advise you to decide on one style, or one century, or one artist that interests you and learn as much about that as possible. If you choose impressionism, look at all art of that time, at individual painters and printmakers, read the novels and poems written then, familiarize yourself with the political and social conditions. The learning process is a very gratifying one; suddenly, one day, you will be an expert.

5. The Discerning Eye

The experience gained from looking at many graphic works is an indispensable asset for anyone who wants to become proficient in the print field. The previous four chapters have prepared the technical and cultural foundation and now it is time to *see for yourself.*

A print collector should be on the lookout for clues just like a detective. The first question in your role as Sherlock Holmes is "who done it?" Just as the criminal leaves finger prints, every artist has a particular style, a manner of drawing and handling the medium. Learn to recognize these features. Look at art books, art magazines, and originals until you are familiar with those artists and periods that interest you the most. On your next trip to a museum try to identify as many works of art as you can without looking at their captions first. Most likely, you will find that you know a great deal more than you expected, especially in those areas that are of interest to you.

Local libraries and particularly art libraries can be of great benefit. Quite a bit can be learned from studying reproductions in books. As a matter of fact, much valuable and necessary information for a collector can be found there, if there is no easy access to the original.

A good general background in history and philosophy is, obviously, an advantage for you as the print collector. It enables you to place a print in its proper frame of reference and to ask relevant questions of the experts.

LOOKING AT BOOKS

Art books are usually full of illustrations in color and/or black and white. They may be divided into so-called coffee-table books, general art books, source books for documentation and research, reference books ranging from the dictionary of art to the catalogue raisonné, and monographs. In addition, there are books dealing with specific topics pertaining to periods and styles in painting, sculpture and architecture.

Coffee-table books are large-size, heavily illustrated volumes. Generally, the written portions are not too detailed and provide only an overview. Looking at such books can help you recognize the changes in styles of

different artists and periods. It is a good way to familiarize yourself with the work of some particular artist whom you like and, perhaps, to ascertain what type of art appeals to you most. Certainly it is also a way of learning to look more closely, more deliberately, and more questioningly.

General art books, too, contain instructive information with regard to stylistic changes and influences of the time on art, and they are usually well illustrated. Look at these pictures with care.

Unfortunately, few books are put out by museum print departments. Whenever you do come across a good catalog with illustrations of graphic art, look at them carefully and read the descriptions by the experts who have compiled the material.

My recommendation would be that you concentrate on one style or period, because much of what you will observe in the narrower field will be applicable to all other art.

Make use of your eyes in a new way; look at details, look at specific lines, analyze the work of art using all the information you have gathered. Learn to *really* see when you look at something—and this is not as simple as it sounds. Our eyes are too used to being bombarded by advertisement posters and television commercials, which require little reaction from their audience.

Consider all material related to prints as an important part of being a print collector. It will broaden your background, give you self-confidence, and help develop a discerning eye!

LOOKING AT EXHIBITS

Whenever possible, you should look at the original rather than a reproduction. The color nuances, the difference in quality, the appearance of the paper, and other essential aspects cannot be reproduced. Most collectors visit galleries regularly just to look. The art dealers not only are aware of this, but encourage it. They put on exhibitions and advertise them to attract a large audience. They know that an interested browser is a potential buyer.

What do we look for? To begin with, almost all exhibits have a theme or unifying thought. It may be a one-man show. Perhaps a new talent will be introduced. Maybe new findings can be displayed and discussed. Or it can be a group show of artists who worked at a particular time. *Rembrandt, Experimental Etcher* was an excellent 1969 exhibit that commemorated the 300th anniversary of the artist's death. It dealt with Rembrandt's experimentation with paper and ink and the different effects he achieved with these materials. A great deal can be learned from such an exhibit, especially if you read the accompanying catalog. Then there are shows covering book illustrations and new photomechanical methods, and those that feature landscapes, portraits, and similar subject matter. Sometimes the medium, such as woodcut, is the theme, and the exhibition may cover a period as long as 500 years.

The most frequent arrangement for hanging a show is a chronological one. However, subject matter and size are also determining factors for the

placement of a work within the exhibit. Arranging and hanging a show is a creative act in itself, and some exhibits are exceptional in this respect.

Catalogs, with or without illustrations, are available at times. Generally there is a charge for them. Some of these catalogs are the best source of information on their particular subject. The above-mentioned show, *Rembrandt, Experimental Etcher,* had a catalog that has become a collector's item. It is an outstanding example of detailed, in-depth description. A minute aspect in printmaking (i.e., paper and ink) as used by one artist is applicable to the understanding of all others.

Usually there are catalog copies available in galleries and museums for use during the exhibit. Look at the introduction, which will give you a synopsis of the show's purpose. Compare the catalog illustrations with the original and read the description of at least a few prints in the show. This is an excellent exercise for learning the value and proper use of catalogs.

The gallery's purpose in having an exhibit is to sell prints. Those graphics that are featured hang on the wall of the exhibition space, usually with a number below them. Sometimes prints are included that are on loan for the exhibit. They may have been purchased from the gallery at one time or another, and the collector lent them to the dealer because they are especially good examples and enhance the show by their presence. Such prints are usually labeled NFS, or not for sale. If you are interested in the price of a print in the show, ask the dealer for it, giving the number that was assigned to the work for this exhibit. If there is a catalog, this number is also a means of identifying the print in the listing. Most of the time the prints are not hung consecutively as numbered, but rather to fit the arrangement.

You may notice one or more small red stickers near a print. This means that it is sold. Since a print is a multiple original, more than one sale is possible. If you are interested in a print that has such a red sticker, ask the dealer if he has more than one impression available. If it is a contemporary work, he may have a number on hand—perhaps even the whole edition. If so, you will be able to discern the variations that occur within the edition due to printing and inking.

Sometimes the price list is posted, or it may be in the catalog. More often you have to ask the dealer. Develop the habit of pricing at least three prints whenever you visit a gallery. It will give you some idea as to the price range of the gallery, your own taste, and current print values. It also breaks the barrier between you and a silent art dealer who is letting you browse without pressuring you.

Don't concentrate on all the works displayed. Your eye and your mind will be sharp for a limited time only. A way to overcome this so-called museum fatigue is to walk casually through the complete show and then return to two or three prints that particularly interested you. Study those closely, read up on them in the catalog, and think about the pertinent data. Chances are that you will sense that you have established a special rapport with them and made a giant step forward in your knowledge of prints.

In addition to the prints on exhibit, galleries invariably have a stock of other graphics. These are kept in bins (open or closed), cabinets, and

special Solander boxes. (More about these in Chapter 8.)

If you want to see prints other than those on exhibit, do not hesitate to ask the dealer for them. Mention the name of a specific artist or the period that interests you. The dealer will show you to a well-lighted table, lend you a magnifying glass, and bring the graphics you requested. You then can examine them, make notes, and ask for reference books. Of course, you are expected to handle the graphics with respect and care.

LOOKING AT MUSEUM EXHIBITS

Most museums have print collections and designated areas for displaying them. Usually the print collection is kept in the print room. The curator may periodically select a group for an exhibition. Just as in the gallery, here too a theme prevails. The rest of the print collection, incidentally, is not on view to the general public, but most print rooms make appointments for members, scholars, and collectors. (More about this in Chapter 6.)

A museum exhibit is somewhat more formal and impersonal than a gallery show. You are more likely to find outstanding examples and a more complete assemblage, as well as a greater emphasis on the scholarly approach. All prints will have descriptive labels and sometimes there is a catalog. There is usually no expert or staff member available to provide information.

To use a museum exhibit in your effort to develop the discerning eye, you should study a particular print and guess who made it, when it was made, what medium it is, etc. After you have done that, compare your results with the posted label.

On a recent visit to the Metropolitan Museum of Art in New York, I saw an exhibit of book illustrations for Edgar Allan Poe's poetry books. Poe lived in the nineteenth century, and many artists since then have made illustrations for his books. The items in the show varied from watercolors to book pages, complete books, and drawings. Fig. 5-1 is an illustration for one of Poe's poems. Look at it and guess who the artist is, in what medium it was done, when it was made, etc. Then see if you were correct. The label reads as reproduced at the bottom of the page.

It is interesting that Gauguin did lithographs, especially for Poe's poems, and that he did book illustrations. It is not the sort of thing we associate with Gauguin. Incidentally, the numbers at the end of the museum's description (22.82.2-7) are the accession numbers. The Rogers Fund is the source of the money that enabled the museum to purchase this work. We do not know anything about edition size or state, watermark, or number. There is a signature in the plate. Since the sheet is probably from a book, that would account for the lack of a hand signature. Gauguin did

Paul Gauguin, French, 1848–1903
Dramas of the Sea: A Descent into the Maelstrom
(Edgar Allan Poe)
Lithograph on zinc, 1889
Owned by the Metropolitan Museum of Art, Rogers Fund, 22.82.2-7

sign many of his graphic works, but illustrations in books are not usually hand-signed. The paper is canary yellow with black printing and has a very smooth, glazed finish. It does not seem to be handmade. The color is well suited for a book illustration, since the paper itself provides an interesting change from the black and white of the printed words. The condition was excellent, the inking even and clear, the margin even all around—as much as could be seen in the framed state.

The same exhibit contained lithographs by Manet, and wash drawings and wood engravings by a number of different artists. Perhaps in a hundred years someone will find these illustrations in a used-book shop, and if Manet and Gauguin are still popular, that someone will have a real "find!"

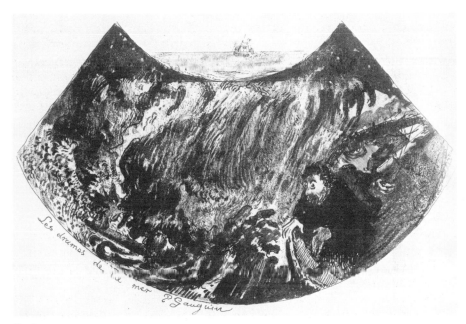

Fig. 5-1.

LEARNING FROM INEXPENSIVE PRINTS

Most cities have used-book stores. And most used-book stores have old books that have fallen apart. Some of these have illustrations or maps in them. Such book pages can be interesting and are very inexpensive. Included in a pile of such loose sheets will be prints of old costumes; herbal, flower, or fruit illustrations; portraits; landscapes; humorous or dramatic scenes; and animals. They may be black and white or color. All graphic media were used for book illustrations at some time. Well-known artists and craftsmen participated in the book industry. A typical shop will have tables outside and inside, with bins and boxes containing a wide array of subject matter, style, medium, and value. Some of them will be reproductions of objects famous in their time, but many are originals. They are printed in large editions and are not hand-signed. Prices for these prints

range anywhere from fifty cents to about five dollars. Some shops may also have a separate selection where prices are higher for prints that have been partially researched by the staff.

When going through bins and boxes, you are on your own; there is no information available except your own discerning eye. Save a visit to such a bookshop until after you have gained a little confidence in your judgment. But when you are ready, by all means try it. You will be well rewarded. There is an excitement all its own when you think you have found an interesting print. Is it a "find" or a fake? Is it indeed what you think it to be? Whether the path leads to discovery and personal satisfaction or not, the experience you can gain for so very little money is worthwhile. An error will teach you to look even more carefully the next time and thus it can save you from bigger and more expensive mistakes. As a matter of fact, such errors early in the collector's career tend to encourage caution and doubt.

It is possible to find prints by well-known artists, although the bookstore owner usually is quite an expert himself. I am not suggesting that you will come across extremely rare and valuable originals or that your dollar purchase will bloom into a fortune. A print, however, can be a work of art even if it is not by a famous artist. Some of the illustrations may be of personal value or interest, as in the case of maps, or else be used as decorative objects. It seems a lot better to have unknown original works of art on your wall than a reproduction of a famous one. The fact that a print holds a locked-in secret sometimes enhances its charm.

Figs. 5-2 and 5-3, the front and back of the same print, represent a typical experience I had. This print cost $1.50 some time ago. Look at the illustration and draw your own conclusions first.

The illustration is a woodcut. The title, *The Prophet Joel,* is immediately a great help in tracing its source to the Bible. The writing on the verso is in Old German. The style of the artist is alive and indicates an experienced hand, both in design and in the cutting of the block.

Let us now consider how to use the clues. The writing on the verso is the easiest to check out, so we will begin with that. The letters themselves are sharp and uniform. If they were hand cut, as was the practice before Gutenberg invented movable type, they would be uneven and worn. The style of the lettering resembles that used by Gutenberg, but then that type is still in use to this day. There are books and dictionaries that discuss letter-type, and these provide further information. Old German was the language used by Luther in 1522 when he translated the Bible into German, so this dates the woodcut certainly after that time.

Holding the paper against the light does not reveal a watermark, in this case, but the laid lines and irregularities within the sheet can be seen. The latter are due to the rag content and the man-made rather than machine-made process of paper manufacture. The color of the paper is slightly yellowish-tan, and it is rather old-looking. True paper experts claim they can tell the age of paper by the sound it makes. That, however, takes many years of expertise.

Der Prophet Joel.

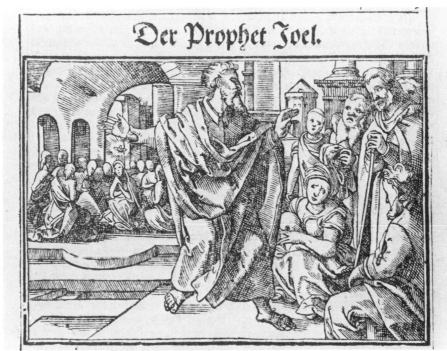

Fig. 5-2. *The Prophet Joel*, artist unknown. Woodcut illustration, front, 16th/17th century. (Photo by M. Horowitz.)

Heulet ir Diener deß Altars / Gehet hineyn vnd ligt in Säcken ir Diener meines GOttes / denn es ist beyde / Speißopffer vnnd Tranckopffer vom
14 Hause euwers Gottes weg. Heyliget eine Fasten/rufft vor Gemein zusamen/versamlet die Eltesten / vnd alle Eynwohner deß Landes / zum Hause deß HERRN euwers Gottes / vnd
15 schreyet zum HErrn. O weh deß Tages / denn der Tag deß HErrn ist nahe/vnd kommet wie ein Verderben vom
16 Allmächtigen. Da wirdt die Speise für vnsern Augen weggenomen werden / vnd vom Hause vnsers Gottes
17 Freude vnd wonne. Der Saame ist vnter der Erden verfaulet/ die Kornhäuser stehe wüste / die Scheuren zerfallen/ denn das Getreyde ist verdorben.
18 O wie seufftzet dz Vieh/die Rinder sehen kläglich / denn sie haben keine Weyde/vn die Schafe verschmach-
19 ten. HErr/ dich ruffe ich an/denn das Fewer hat die Auwen in der Wüsten verbrannt / vnnd die Flamme hat alle

in verzehrend Fewer/vnnd nach jm ein brennende Flamme. Das Landt ist für jm wie ein Lustgarte/ aber nach jm
4 wie ein wüste Eynöde/vnd niemandt wirdt ihm entgehen. Sie sind gestalt wie Roß / vnd rennen wie die Reu-
5 ter/Sie sprengen daher oben auff den Bergen/wie die Wägen rasseln / vnd wie ein Flamme lodert im Stroh / wie ein mächtig Volck / das zum Streit
6 gerüstet ist. Die Völcker werden sich für jhm entsetzen/ aller Angesicht sind
7 so bleych wie die Töpffen. Sie werden lauffen wie die Riesen / vnnd die Mawren ersteigen wie die Krieger/ ein jeglicher wirt stracks für sich daher
8 ziehen/vnd sich nicht seumen. Keiner wirdt den andern jrren / sondern ein jeglicher wirdt in seiner Ordnung daher fahren / vnnd werden durch die Waffen brechen / vnd nit verwundet
9 werden. Sie werden inn der Statt vmbher reiten / auff der Mawre lauffen/vnd in die Häuser steigen/vn wie ein Dieb durch die Fenster hineyn

Fig. 5-3. Verso (back) of Fig. 5-2. (Photo by M. Horowitz.)

The passage in the Book of Joel relates " . . . the day of the Lord is at hand. . . ." The subject matter is a religious one, but it is treated in a secular rather than a mystic way. The composition clearly focuses on the main and dramatic figure of Joel, who relays his message to the throng around him. This sense of drama, of religious realism, and of emotional expressiveness is typical of the early baroque. To strengthen this opinion we might note that the inclusion of architecture, stairs, and the handling of the draped fabrics, as well as the sense of movement throughout, are also baroque features. Furthermore, there is a figure in the right forefront moving into the viewer's field or, as this is called, coming out of the frame. This is a mannerist-baroque device especially typical since the time of the Italian painter Caravaggio (1573–1610).

The wood block is not part of the plate on which the letters are set. This makes the printing process cumbersome. However, woodcuts were used for all the early book illustrations—before and after the invention of the metal-cast movable type. Later publishers made use of the longer-lasting metal engraved plates, which permitted larger editions.

For a small book illustration the medium is handled well. There is cross-hatching in the arch and on some of the figures, and the outlines of forms are sharp. Light and shadow are well indicated through the spacing of lines and good use of the white areas. The cutting is nicely done, the lines are spaced deliberately and evenly. The cross-hatching, if you consider the tedious process of cutting the tiny squares, is admirable. With the magnifying glass you can see where the wood has worn or broken off. Fig. 5-4 is a detail of Fig. 5-2; note that the ink fills the tiny square and appears as deep black spots. While you are studying the lines with the magnifying lens, look for the unevenness and the swelling of the lines and their soft, fuzzy endings. Look for signs of wear on the thin lines, see if parts are missing because they have broken off the block. These are some ways to be certain you are not dealing with an engraving or etching.

Iconographically we become aware of two interesting figures, which are cleverly placed in the composition under the two outstretched arms of the prophet. In the foreground is the Madonna with her Child. In the background, among the faceless figures, is one woman with facial features. Over her head is a bird with a halo—the dove representing the Holy Ghost. For the reader of the Bible in olden days, such pictorial symbolism was easily understood.

All roads, then, lead to the years of early baroque, from the beginning to the middle of the seventeenth century. Historically this makes sense too, since this is the time of the Counter-Reformation in northern Europe, when the Church made much use of artistic illustrations.

Early Bibles might reveal more information about the example given above. It is not very likely that we could determine the artist, but it is usually possible to find books illustrated by the same person. With some luck and diligence it might be feasible to find a complete book that contains this particular illustration. This might enable us to come to better conclusions regarding the date and place of origin.

It is impressive to see how much information we have uncovered. The main ingredient was common sense, combined with a discerning eye and an inquiring mind.

Fig. 5-4. Detail of Fig. 5-2. (Photo by M. Horowitz.)

PERSONAL EXPERIENCE IN THE PRINTMAKING PROCESS
If you learn to make prints, not only will you recognize the medium better but you will also gain a new respect for a well-done print. You will appreciate the difficulties and possibilities that an artist encounters.

Getting involved in printmaking is really simple enough, since it is widely taught. The Fine Arts Department in most colleges offers printmaking in its curriculum. There are studios, printing facilities, supplies, and teachers. You may be able to sign up for the regular courses as a nonmatriculated student, or the college may offer adult-education classes. Most high schools have adult-education departments that make use of whatever facilities the school has. They may not have printing presses and other elaborate equipment, but a woodcut or a linoleum cut does not require extensive facilities. There may even be artists living in your neighborhood who may be interested in teaching a small group or in giving individual instruction.

An excellent way to make contact with the printmaking world is in a graphic workshop such as Tamarind or the Pratt Graphics Center (not to be confused with Pratt Institute). These are centers for printmaking that draw many of the finest contemporary artists to lecture, experiment, and use the workshop's space, presses, and supplies. Often this is a place to exchange ideas, hear of new methods, meet interesting people, and partake of the creative activities. For a fee you can sign up for workshop time. Lithograph stones and other equipment can be rented, supplies purchased. Sometimes a series of lectures or demonstrations of different techniques may be given. Professionals and amateurs mingle easily. To find out about these opportunities, try your local telephone book and look in the newspaper for advertisements from colleges and art groups, especially around September and January, when the school term begins.

Above all, go ahead and dirty your hands—whether you think you are artistically talented or not. You may surprise yourself. Even if you only attempt to copy someone else's work, the benefit lies in the deeper understanding you gain for the whole printmaking process. As you try to copy a color lithograph by Toulouse-Lautrec, a woodcut by Dürer, or an etching by Piranesi, you will gain knowledge of the artistic ability and craftsmanship that contribute to a fine print. Making prints can be a means to an end; it can enable you to become more expert, more quickly.

6. The Moment of Truth—Authenticating a Print

A friend inherited a print from a relative. During his lifetime, the uncle had told her that she would be the owner of his Piranesi engraving. After he died she asked me to help her look up some information on this print, which now graced her walls. In a short time we found out quite a bit, even if we did not investigate the topic thoroughly.

We went to a library that had art-research literature. First we looked up Piranesi in an art dictionary for some general background on the artist and a few bibliographic references. Next we tried the card catalog and found a catalogue raisonné by Hyatt Mayor, the former print curator at New York's Metropolitan Museum of Art. In that book we found an illustration that looked like my friend's print, and then we read the information given on it. It turned out that the engraving was really an etching. The work belonged to a series called *Imaginary Prisons*. Piranesi made these designs in 1740. Later they were changed and an edition of the second state was printed in 1761. Mayor commented that this series was highly imaginative and symbolistic and must be considered the highest achievement of Piranesi's creative work. While this did not tell us if the impression was authentic, i.e., an original, we had found out about the artist, his manner of working, and his accomplishments. Our time investment was about two hours. For my friend the print was no longer "something she inherited," but a real work of art made 200 years ago by a famous artist.

My friend was neither a print collector not an art scholar, and she had no desire to get further involved—nor is she interested in the value of this print. Such superficial information as we gleaned may not suffice if you are a collector or if you wish to become one. This chapter will offer examples of more thorough research methods.

Some years ago my husband wanted to buy me a special print for a birthday present. I had been involved with studying, buying, and looking at art for many years, although we had not concerned ourselves seriously with the "important" prints. In retrospect, we started with much naïveté and a great deal of luck. We simply decided to buy a great print at a gallery, although our funds were limited. At that time prints were not the status

symbols they are today, and that was reflected in the prices. Fortunately we dealt with a reliable gallery. It was not until many years later that I researched the print, Rembrandt's *Jan Lutma,* second state, illustrated in Fig. 6-1. I realized then how little I knew when we bought it, and how much one can find out about a small piece of paper. No collector should miss the opportunity to learn about his own prints or to make sure that they are authentic.

When I went to galleries and asked for Rembrandt etchings, I found quite a few. Some cost a few hundred dollars, others a few thousand. I could see little reason for the difference in price, except that some subject matter seemed more appealing than others. The dealer patiently explained to me about rarity and states, early and late impressions, provenance and watermark, crispness of line and rich blacks. I must admit that it confused me a lot and still did not explain the differences in price. Finally I was shown a book called the catalogue raisonné. There was a photograph of the print I was considering. But how could I tell if I was looking at an original or a reproduction?

Why, I asked, was one impression so much cheaper than the other? I was told it was "Basan"—to which I replied with embarrassment: "Oh, of course." Leaving the gallery, I decided to find out what Basan was. It turned out that Basan was not a *what* but a *who.* He lived in the eighteenth century and bought a number of Rembrandt plates. (Rembrandt, remember, died in 1669.) They were worn from usage and Basan, who was an etcher himself, reworked them by adding new lines and making deeper grooves in the existing ones. Then he printed them. These "late" impressions are Basan restrikes and are frequently available for sale at reasonable prices. They are not reproductions and they *do* come from Rembrandt's original plates.

Let us suppose, now, that we were interested in buying the print illustrated in Fig. 6-1. How much information can we find?

First we would look in the catalogue raisonné. The preparation of such a book requires a great amount of expertise and familiarity with the artist's work, and often the catalogers are curators or scholars of renown. But in some cases there is more than one definitive volume available, and the information in one may disagree with another. For Rembrandt the most widely accepted catalogue raisonné is A. M. Hind, *Rembrandt's Etchings,* originally published in 1923. Later and also reliable information can be found in G. Biörklund's *Rembrandt's Etchings; True and False,* published in 1968. Catalogers assign a number to each work of the artist, and this is a widely used means of identification and reference. Sometimes catalogers will also differ in their numbering system, and you might come upon a reference to *Jan Lutma* that reads something like this: B. 276, H. 290, B.B. 56. Translated, this means: Bartsch catalog number 276, Hind number 290, Biörklund, Barnard, number BB 56 C. If you look up all the entries, different information may be given in each book, but all will discuss the same subject matter. The definitive catalogs are available in libraries, print study rooms, at galleries, and at some auction houses. Never hesitate to ask for

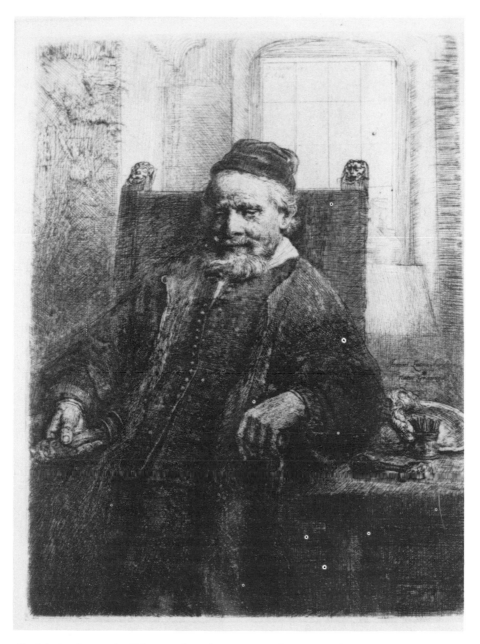

Fig.6-1. *Jan Lutma the Elder*, Rembrandt van Rijn. Etching (second state), 1656.

them when making a selection at a gallery; the dealer also considers it one of his most important tools.

For *Jan Lutma* the entry in Hind 290 has reproductions of the first and the second state (Figs. 6-2 and 6-1) and a description. The size is 197 by 148 millimeters. The plate was executed in 1656; the second state has a signature in the plate as well as the date. Three states are listed. The first one is described as "before window and signature," the second one with the signature and window added and the inscription, which is located near the table. The third state has hatching added in the upper right-hand corner. No indication is given regarding edition size or paper. Hind adds that the additions made for the third state are probably not done by Rembrandt himself. That is precisely the kind of information to watch for. Fig. 6-4 shows a detail of the upper right-hand corner, which does not have added hatching. Compare this to Fig. 6-5, a drawing of the same area in the third state with the additional lines added. From the above we can come to the conclusion that the "original" Rembrandt ends at the second state, and that we must look for reworked areas.

The next step leads us into a good art library. A museum or public library that has such a book collection would be a good source. Some universities, too, make their collection of art books available to the public. Look in the card catalog under Rembrandt for one-sentence descriptions of books' contents. Look for definitive catalogs, books that concern themselves with the artist's graphic work, books that list bibliographic material. Begin with the most recent publications in a language with which you are familiar. In addition to this, look at the reference book section, which will carry the code of "NE" in libraries using the Library of Congress system. The *Art Index* and any other book that lists art bibliographies for reference will be helpful, as will Chapter 10.

Our bibliographical search has turned up a number of interesting books. The Biörklund catalogue raisonné is fairly recent and very informative. Under BB 56 C the first and second states are listed as in Hind, and then this catalogue raisonné offers a closer examination of posthumous impressions. Incidentally, these latter prints also are divided into states, so do not be misled into thinking that the term *state* refers only to additions or deletions made by the artist. They need not be. Biörklund lists the third state as a modern edition by Basan and others. In another part of the book is the information about Basan. Pierre François Basan (1723–97) published in the year 1790 a *Recueil de Basan,* after having purchased at least seventy-eight of the original Rembrandt plates at an auction. Sometime later he added the plate of *Jan Lutma* and began to print that too.

We have now discovered a very important piece of information. To use this information, let us return to Figs. 6-1 and 6-2. Checking the upper right-hand corner, we see that the description of the second state fits our print, since it has a window, so this state is part of the original edition. So far so good.

We cannot find information regarding the size of the edition. You may recall from Chapter 2 that prints were not hand-signed or numbered in

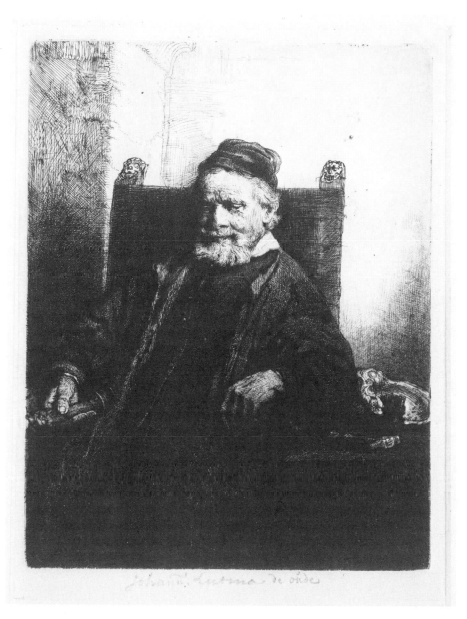

Fig. 6-2. *Jan Lutma the Elder*, Rembrandt van Rijn. Etching (first state), 1656. (Courtesy of the Rijksmuseum, Amsterdam.)

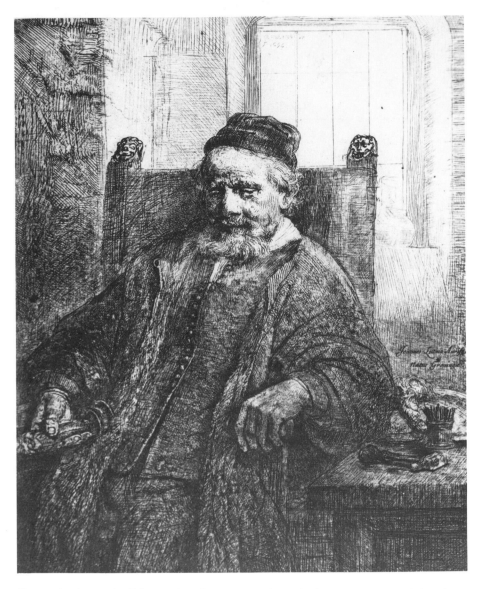

Fig. 6-3. *Jan Lutma the Elder,* Rembrandt van Rijn. Etching (third state). (Courtesy of the Library of Congress, Washington, D.C.)

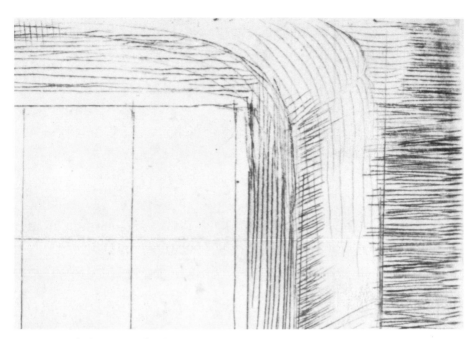

Fig. 6-4. Detail of corner window from second state.

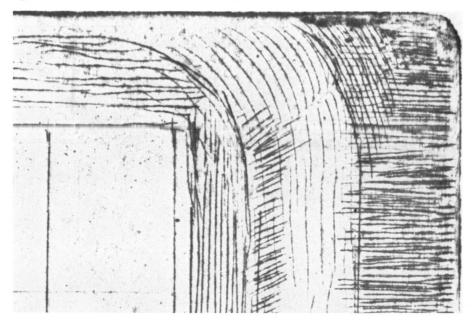

Fig. 6-5. Same corner as Fig. 6-4 but from a third state (restrike).

Rembrandt's time. How, then, can we find out if this impression was made early in the edition or when the plate had begun to wear down? If we compare Fig. 6-2 and Fig. 6-3 we can see not only the difference in content (i.e. the window and the Basan rework) but a considerable difference in quality. Fig. 6-3, the Basan impression, is an excellent example of a worn plate. Note the large, white spaces in the hatching compared to the rich black in Fig. 6-2. Note also the vitality of line in Fig. 6-2 which is quite lacking in the Basan restrike. Fig. 6-6 shows the sleeve area with the fresh drypoint of the first state and the very worn and tired lines of the restrike.

Sometimes the difference in quality is clearly discernible, but often it is a matter of developing a sixth sense. Looking at lots of originals with a good magnifying lens develops this faculty best, as does comparing two impressions from the same edition.

Paper or watermark would offer additional information. Rembrandt presents a problem because we know that he experimented a great deal with paper, and no pattern has become apparent. Within a given edition he may have used a large number of different papers and it is best to learn to judge paper quality before coming to a conclusion. We know that Rembrandt printed on parchment (animal skin), oriental paper, watermarked paper, as well as on cheaper and more ordinary types. As a very general rule we can say that these latter types were used for the later prints in larger editions. Some information regarding this topic can be found in the Biörklund catalogue raisonné.

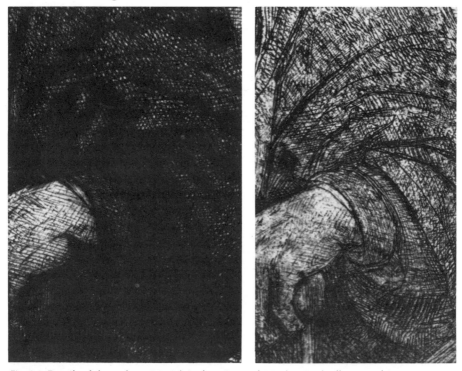

Fig. 6-6. Details of sleeve from 6-2, rich in drypoint, and 6-3, showing badly worn plate.

The time has come to visit a print room. Some art dealers will permit you to borrow a print you are considering for purchase on approval for a few hours so that you may compare it with others from the same edition, or to show it to an expert you may know or hire. If the gallery does not know you and the print is valuable, they will understandably be hesitant. They may suggest another arrangement that still enables you to examine the impression in a print room.

I have mentioned before that most museums and some large libraries have print rooms for use of students, scholars, collectors, and members, usually by appointment. Suppose that you have an appointment at the Metropolitan Museum of Art, and that the art dealer gave you the *Jan Lutma,* II, on consignment. Entering the museum, you will have to obtain a pass for the print you need to take in with you. The museum's print room is located on the second floor. You ring the bell and the door is unlocked. You will be seated at a large table, and an assistant curator will be assigned to you and ask the purpose of your visit. The staff is very knowledgeable and helpful, but they cannot be expected to do more than put books and prints at your disposal. They do not advise, authenticate, appraise, or even give opinions. If you wish to take notes, you must write with a pencil, not a pen. You must not touch their prints, which will be placed on a stand in front of you. If you want to know about the watermark, the staff will handle the impression. One, at most two, prints at a time will be brought to you. If all this seems a little formal, consider the value of the collection and the possibility of damage and theft.

Comparing your print to the museum's will indicate the difference in quality and tell you something about the desirability of yours. The museum does not always have the best impression, though often they do. Look at their paper and compare it to yours, ask if there is a watermark, ask if they consider theirs to be of outstanding quality (and if not, why not). See if the lines are as sharp and crisp on both prints, if the spaces in hatched areas are wider (i.e., if there is more white because the plate is worn), if the drypoint areas are rich and fresh. (The Metropolitan's print room has its own library and reference material, which you can request.) Examine the platemark, if there is one. Visualize the process of making the impression. When the artist has finished his work, he will smooth the edges of the plate, perhaps round the corners slightly. The platemark is at first very straight, neat, and clean looking. As it is printed again and again, that edge wears down. Ink can get into it more easily. The platemark is only another clue. A dirty and rounded platemark, together with a lack of crispness of line or lack of rich color, indicates that you are dealing with an impression that was taken late in the edition.

Examining the etching we are considering, we find that it does not show a watermark, nor is the platemark particularly revealing. It is there, not too deep and perhaps a little rounded, but the fact that it lacks a sharp edge indicates that it has flattened some from usage. The paper looks slightly yellowed as aged paper often does, and when held up to the light, it shows the design of the laid lines, as old paper should. The general condition of

the impression does indicate a wearing of the plate. The drypoint in the elbow area of the sleeve in Fig. 6-1, for instance, is no longer velvety, and the spacing of the hatched lines seems wider on our print than on the very fine second state the museum owns. Seeing the impressions side by side gives you an instant understanding of the differences. This is one of the best ways to learn to develop an eye for quality.

Perhaps you are now in a better position to make a decision. If your impression turns out not to be as good as the museum's, don't reject the idea of buying it. Old masters are almost impossible to find, and the finest ones are usually in collections. Those that do reach the market are sometimes of inferior quality but still very rare and expensive. Both museums and collectors often buy impressions knowing that they are not the best but that they are the best available. If, at a later time, a better one is found, it can always be exchanged. This, by the way, is why you sometimes will find prints marked "from the collection of . . ." or "duplicate from the . . . museum." Such a statement in the catalog or provenance is not necessarily an endorsement.

To determine whether the price quoted is appropriate, you might consider a professional appraisal. A museum may be able to recommend experts to you. Another source is the latest yearly volume of *Art at Auction*, which lists prices paid for some prints. Some exhibition or auction catalogs include prices and they may be helpful. Better than all of these, however, is your own knowledge and judgment. If you have spent some time looking at prints in galleries and auction houses, you will not only develop a good eye for the quality but also get a very good idea of prevailing prices.

Let us now assume that the *Jan Lutma*, II, has passed the test. You know that it is indeed a second state, that its quality is acceptable to you—though it is not as fine as the one you compared it to. There are many more interesting things you can discover. The print is dated, signed, and is a portrait. Who was this Jan Lutma, and what was Rembrandt's life and work like in 1656? The information we are seeking now is a little more difficult to retrieve. Some of it is in reference books and other material will be found in magazines and scholarly research works. A very valuable reference book is the *Künstlerlexikon* by Thieme-Becker. Though it is in German, it should not be too difficult to get a translation for the brief entries. You will find that Jan Lutma is listed as a goldsmith, born 1588 and died 1669, the same year as Rembrandt. The book mentions his friendship with Rembrandt.

Maybe you have looked at the other books by Hind, one of which is *A History of Engraving and Etching*, and found out that there was a Jan Lutma the Younger, who was an etcher and also made a portrait of his father. If you follow this reference, it will lead you to the Hollstein series, *Dutch and Flemish Etchings, Engravings and Woodcuts*, which has an illustration of the work. It is interesting to note that the sitter's position is very similar to the one by Rembrandt, but the son saw his father as a much older man than did his friend. It illustrates the very personal approach of two artists, who were probably working next to one another, and the difference in their vision, expression, and ability. From here on, what you learn depends on

116

how much time you want to devote to finding out more about the life of Rembrandt. Look at the bibliographies in the backs of books on prints or on Rembrandt and read about his life, his ideas, and what it was that makes his work so outstanding.

The information you will find in the catalogue raisonné for the work of another artist may differ considerably. If it is a more modern work, such as one by Aristide Maillol, the sculptor, printmaker, and book illustrator, you will notice that the catalogue raisonné lists a number of different editions on many prints. There may be thirty impressions in black, unsigned, then twenty-five in red ink, which are signed, and still further editions that may have been printed with the artist's permission but not under his tutelage or signature.

Researching a print in depth is a somewhat time-consuming occupation, but the rewards are great. Not only do you widen your horizon intellectually, but you come in touch with interesting people and places. They, together with the knowledge you gain, will be immensely helpful. The print in question will almost become a member of the family. Many people think they will tire of a picture if they study it a lot. I have never found this to be so. As I become familiar with the print, a sense of intimacy develops that goes far beyond the pride of ownership.

There are many different approaches to authentication, and those outlined here are given as an example of the kind of information that may be retrieved. Since no artist is typical, no typical formula can be derived for the procedure. When you come up against an unexpected clue, follow it up. If you are unfamiliar with the description given at the gallery or auction or in a catalog, follow it up. If you are doubtful of "facts" you may be right. Do not be intimidated by the experts or the written word. Even experts change their minds. Be sure you are getting the latest and most competent information. Not everyone is honest, and errors are possible.

The time has come for you to apply the information in this chapter to a practical example: Fig. 6-7 illustrates a graphic work by James McNeill Whistler, an American painter and printmaker who was born in 1834 and died in 1903. He was a great etcher and a fine craftsman, and he also made lithographs. Whistler's life is full of controversies and extravagances, friends and many enemies. He was a colorful personality. Whistler graphics can be found frequently at galleries and auctions. There are considerable differences in quality and value among them. You might see a Venetian scene for $4,000 or more, or a landscape with a bridge for $200. To inform yourself about this it is not enough to go to the catalogue raisonné. You need to know a little about Whistler's working methods. From the extensive biographical material available, and from reading auction catalog descriptions, estimates and prices attained, checking galleries and their impressions and prices and the catalogue raisonné, you will soon gain enough knowledge to form a judgment. Work from the whole to its parts and then to the whole again. Choose one print at a time and find as many impressions of the edition either physically or in catalogs. To find magazine articles, consult the *Art Index*. Select the most recent material. It,

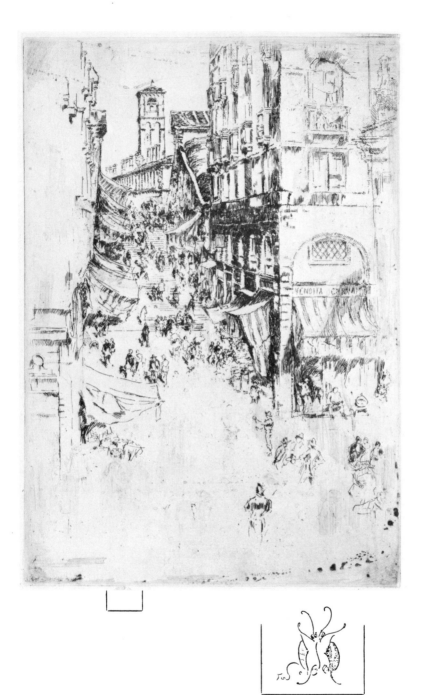

Fig. 6-7. *The Rialto*, James McNeill Whistler. Etching, ca. 1880. (Courtesy of The Metropolitan Museum of Art, Harris Brisbane Dick Fund, 1917.)

Fig. 6-7a. A Whistler butterfly. (Reproduced from Whistler, *The Gentle Art of Making Enemies*, courtesy of Dover Publications, Inc.)

in turn, will most likely give references to further articles and books.

Collectors differ in their preference for early or late Whistler works, but most of the Venetian etchings are in great demand. The subject matter is most appealing, the style is characteristic, the execution is masterly. Since Whistler lived only a relatively short time ago—in terms of art history—we do have considerable knowledge of his manner of working. He was a prolific writer, and his letters are excellent source material and documentation. It is known that he etched the plates himself, often doing his own printing. He did much experimentation with inking, often leaving a film of ink on the plate to add to the atmospheric effect. This, if you recall, was Rembrandt's method too. Except in his early years, Whistler did not believe a print should have a margin, and he trimmed all excess paper (frequently including the platemark). In his later graphic works his signature was a butterfly, which may be found inside the printed space. In addition, he hand-signed, also with the butterfly, below the design. Since he trimmed the margin, he left a tiny tab for it on the bottom. If he did the printing himself, the letters *imp* may appear next to the butterfly. The butterfly itself is worth looking at; it always differs and almost has a personality. Although Whistler found lithography a very exciting medium, he seemed to have felt that others could better carry out the process of printing for him. Most of his lithographic work was made by the transfer method and printed by Thomas Way. Way also compiled a catalogue raisonné of Whistler's lithographic works.

Begin your homework by determining the following:

What is the medium?

What can you find out about the printing and inking?

How big was the edition?

What date would be appropriate for this work, considering his style? Why do you think so?

Why can it not be earlier or later?

What other works of his are similar?

How did other printmakers execute works in Whistler's time?

Why is his method better or worse?

Is it an original and, if so, how can you be sure?

Is it signed? Does the paper seem appropriate?

Is anything unusual about the appearance? What condition is it in?

Is anything known about the history of the impression or the subject matter?

What do you think of Whistler as an artist? Do you think he was innovative? What would you think a work of his is worth to you, and would you want to own it?

7. Art Dealers

Art dealers and auction houses operate the same way as all other commercial undertakings, and they expect to make a profit. You are the customer and it is up to you to know what you are buying. The fact that the merchandise you are choosing is a work of art should in no way affect your shrewdness or coolheadedness. Be sure to remember that if you feel somewhat intimidated by the atmosphere of sophistication or even snobbery in some galleries. There is no reason to be afraid of asking questions, and no cause to be shy or overwhelmed by the knowledge the seller appears to have. If he is indeed well informed, he will gladly share his wisdom and it will be reflected in the quality of the prints he sells. Dealers know that art is not bought quickly, and they appreciate the client who wants to learn. They will respect your opinion if it is based on knowledge and fact. Not every print is the finest or the best of an edition. Nor, for that matter, is every work from the hand of a major artist a so-called important one. Not all subject matter is appealing to everyone. Not all people who love and appreciate art will want to own a Rembrandt— although, I admit, I cannot really believe that! By going to galleries and auctions frequently, your self-confidence and knowledge will increase quickly. Developing a working relationship with art dealers can be very valuable to a collector.

WHAT MAKES A GOOD ART DEALER OR GALLERY?
The people who come in contact with you should be friendly, knowledgeable, and interested in what you want. They should allow you to browse, offer help when you need it, and give you all possible information if a work is of interest to you. Above all, they should have high moral standards, love graphic art, and make you feel free to ask questions or to disagree. A capable art dealer will soon recognize the direction and taste, as well as the seriousness, of his client, and if he can help in the formation or building of a collection he will, of course, be more than glad to do it. Many large collections have been accumulated with the assistance of gallery personnel. They maintain, after all, constant contact with the art market, curators,

and other collectors. This gives them insights into future trends and enables them to form sound judgments of the financial aspects of art collecting. If you have established a rapport and feeling of confidence with a dealer, you will both benefit.

Just as there are many levels and nuances of conducting business in mink or diamonds, there are variations in gallery practices. Reputable galleries will give you a bill and a letter of authentication with each purchase. It will contain the artist's name, title of work, medium, state, and price, and it will usually cite the reference or catalogue raisonné that lists your print. This bill, incidentally, is important in case you wish to insure the print. Many galleries will update the appraised value as the market changes. All reputable dealers will refund your money if the print they sold you turns out not to be what they claimed.

Galleries may find it desirable to buy back works that you no longer want or made an erroneous decision to buy. Inquire about this practice at the time of purchase. Some dealers will call you if they have a print they think will interest you or should be in your collection. Others may discuss this with you if come in frequently to browse, and some do not interfere with your choices at all.

Suppose you are ready to buy a print but want your spouse or a friend to see it first. Sometimes you are not sure of your choice and would like to come back a few days later to see how you really feel about it. Feel free to discuss this with the dealer; he will very likely reserve it for you for a limited time. Unless you do this, it may be sold before you have the chance to return to the gallery. Some galleries offer credit plans or extend credit to collectors known to them. Banks, as a rule, do not readily give loans for art—if at all. Inquire about the gallery's practices *before* you buy. If necessary, make a list of questions so that no misunderstanding arises. Do not buy when you are tired and rushed.

Bad gallery practices are difficult to enumerate. If no definitive catalog or authentication evidence is made available to you, be suspicious. Either the dealer may not want you to look too closely into the documentation, or else he may not have the information himself. Either case is undesirable.

If you feel that you are being pressured into a purchase, or if the price is inappropriately low, you should be especially careful. Protect yourself against fraud or misrepresentation by getting written guarantees and/or by obtaining information from reliable sources. The honest dealer will make amends for an honest error, and he will impart his findings as well as his doubts to you.

Do not be taken in by the good reputation of a dealer until you convince yourself that it is deserved. When I went browsing some time ago at a well-known gallery, I was shown, with great pride and much praise, a rather expensive impression of an old-master print. Upon examination, a spot kept catching my eye. It was darker, I thought, than the area should have been. This spot seemed to throw the whole work out of balance. I asked the dealer to handle the sheet and turn it to the back. Sure enough, it had been repaired and reinked on that spot. The dealer went through

motions of surprise and lament, but it does not seem likely that his trained eye would not have caught this fault even before he purchased the work.

Galleries differ in the quality of prints they handle, and some specialize in certain artistic periods. Some galleries are known for handling museum-quality works of art and for the highly prized and high-priced impressions they carry. Then there are dealers who handle medium-quality prints, good ones that are within reach of most collectors. The rest are not really art dealers. Mostly they will have reproductions, restrikes, decorative and colorful designs with bright mats and inexpensive price tags.

In those galleries that handle certain periods, the specialization ranges from old masters to nineteenth- and twentieth-century prints to contemporary works. In this last group there is a differentiation between trend-setting "superdealers" who popularize the work of a particular artist through shows and through their influence in the art field, and galleries that sell prints done by contemporary artists. The trend-setting is usually due to their good judgment of young and unrecognized talent to which they obtain exclusive rights of distribution. Sometimes they will subsidize an artist for many years and in return get all of his work. It can be a costly error or a very lucrative undertaking for the dealer. This is known as having a stable of artists. Sometimes the gallery also acts as an artist's publisher, which entails obtaining all rights to the edition and paying for the printing. A gallery may also commission an artist to execute a matrix and so obtain the right to determine the edition size, price, and distribution. As you might have guessed, this affords the gallery great prestige if the artist is or becomes recognized. It also places the gallery in a rather powerful position, since it does not have to sell the whole edition and can also choose the purchaser of an impression. A young, unrecognized artist may sign a long-term agreement with a well-known gallery that has entrée to museum curators and that finances him and his editions, exhibitions, and public relations.

Prints of some contemporary artists are expensive, and many feel that they are overpriced. The price is based on supply and demand, even if it is created artificially. Just because a print is expensive, was praised by the critics, or was exhibited in a museum is not necessarily a guarantee for long-lasting popularity. Unless money is no object for you, do not be guided by the taste of others; use your own judgment. Look at lesser-known artists' work and go to smaller galleries as well as to the superdealers. The former may be more interested in your inquiries and you. All artists must begin to show their work somewhere, and usually they do not start at the biggest museum, although they may wind up there.

AUCTIONS

From time to time the press criticizes some public auction practices. Of course, the public should be watchful at auction sales, and it is even better that the press makes us aware of it. Questionable practices under the guise of public auction are not uncommon. The more cautious you are, the less likely you are to be deceived.

When you deal with a major auction house you can expect them to be honest and public-spirited. However, they are in business to make a profit, and the truth is that auctions are not always unrestricted public sales. The auctioneer has the right to reject your bid if he considers it too low. That means that you are not assured of getting an item at a very low price just because yours is the only bid. The auctioneer protects the seller and the reputation of the house. The seller may also establish a "reserve" on an object he places for sale. Such a reserve determines the lowest sum he will accept. Most of the objections raised against these practices concern the lack of information given to bidders at the sale. For example, you may go to a sale expecting to buy objects for far less than the reserve, and in many auction houses you are not even informed that there is such a reserve, or how high it is. There is, of course, nothing to prevent the seller from being at the auction and participating in the bidding in order to get a higher price. Some contemporary artists attend sales that include their work, even though they no longer own it. They can participate in the bidding and may, if necessary, even buy their own art in order to maintain its price level.

Your protection is self-discipline. Decide how much you are willing to pay and do not go beyond that amount. If you cannot get the print this time, you may be luckier next time. At the sale it is necessary to make split-second decisions, and it is very easy to be carried away. Some time ago I watched two people bid for a reproduction of an old master that was clearly indicated as such. It should have cost about $100. Between them they drove the price up to almost $600. You might think that the two bidders suspected that they were buying an original. This is rather doubtful, since there were a number of experts present who were just as surprised as the auctioneer. It is more likely that the bidders got carried away and each one thought that the other knew something.

If you have a gambling nature and do not want to overpay, you can engage a dealer to act for you. He will charge for his service, but you will benefit from his experience and knowledge. You can also leave a bid with the auctioneer, free of charge. You set the highest amount you are willing to pay, and the auctioneer, acting on your behalf, will try to buy the object for as low as possible. If you want to have a bid executed in this way, contact the auctioneer before the sale and find out what you need to do. The catalog for the sale should also contain the required information for this service.

The auctioneer makes the decision, during the sale, regarding the amount by which bids can be raised. For example, the bids may go up in $50 jumps to $400, and then raises may be $100. You can raise less than the set amount, but the auctioneer is not obliged to accept it. In the case of mail bids, it is not necessarily a good idea to make a bid of an outlandish number like $519.50, since there will be no bid for $518, $518.50, etc. It would make the sale endless and boring. Part of the excitement at the auction is the momentum the auctioneer can maintain.

You should ask all your questions at the presale exhibition. Some staff members are generally available in the exhibition rooms.

Make triply sure of what you are buying and whether you indeed get the item you bid for. Guarantees, when offered, usually are considerably restricted. At best they allow you to take expensive legal steps. I think it is safe to say that most buyers get stung some time at auction sales. It is also true that most buyers will come home with a really good buy at one time or another.

Practices differ according to the size of the auction house, its integrity, its location, etc. European houses often charge a commission to both the seller and the buyer. Inquire about this practice before bidding; the added commission may be a considerable sum. In general, the more information offered, the greater the accessibility to the prints; the more regulated the sale, the greater the likelihood that you are dealing with a reliable source. On the negative side: there are more shady auctions than reliable ones. Unless you are an experienced auction-goer, begin by visiting well-known and reliable sales rooms.

The catalog for the sale is available a week or so beforehand. Look through it and consider which of the prints may be of interest to you. Perhaps you are familiar with the work of a particular artist and have been trying to buy a work by him. Read the catalog carefully, but do not rely completely on the information. Do a little research yourself. Auction houses are not required to give complete data, nor must they list the unfavorable facts.

Sotheby Parke Bernet in New York (PBNY) lists its rules in the catalog. Appraisal, mail bids, commission, terms, removal of purchase, etc., are discussed. The reserve system mentioned before is described and estimated prices are given, usually on a separate sheet. Do not feel bound to these numbers; they are based on prevailing conditions in the art market, on recent auctions, and on the appraisal made by the staff, taking the condition of the print, its rarity, and the quality into consideration. Estimates are a considerable help to the bidder, but they tend to predispose the audience as well. For an additional charge you can request that the list of prices actually paid at the sale be sent to you.

The language used to describe the prints in the catalog will differ from one auction house to another. Pay attention to the choice of catalogue raisonné if more than one exists. What one cataloger considers a second and original state by Rembrandt, for example, may be called a third and late print in a different catalogue raisonné. A "late" impression is usually an unauthorized and/or posthumous one. If a date is given for the printing, make sure that this falls within the artist's lifetime. "After Boucher" (Fig. 1-35) indicates that the original design was made by Boucher as either a painting, a drawing, or a print—and the plate was executed by someone else. This is quite acceptable if it was the artist's practice and if it was done with his knowledge. Bruegel often followed that practice.

Sometimes an auction lot contains more than one item, and this should be so indicated, usually by a number in brackets under the description. There may be mention of the margin, as in "10 mm. margin all around." Although some prints are more valuable if the margin is wider, the fact that

the information is listed does not necessarily mean that it is an asset.

Some prints were used for book illustrations and were printed in quantity. Often there are a few impressions taken "before letters," i.e., before the larger edition. Such prints are far more expensive and fresher than the ones "after letters." (Also referred to as "text on verso" if the design is on one side and the text on the back. See Chapter 5.)

The PBNY catalog can serve as an example with a rather typical entry for a Toulouse-Lautrec impression.

Lot 483, *Mlle. Marcelle Lender* (see Figs. 1-23 and 1-24 in Chapter 1). In the description, reference is made to two catalogues raisonnés, Delteil 103 and Adhémar 134; the medium is lithograph; the date is 1895, size c. (circa) 355×250 mm. It also states that "this is an impression in green ink (Delteil notes an edition of 12 in colors and 15 in black), with large margins, traces of glue stains and abrasions in the margin, framed." The estimated price was $2,500 to $3,000, and the impression was sold for $2,300.

Delteil and Adhémar should be consulted first. Some of the questions that arise from the description concern signature, watermark, how bad the stains are, quality of printing and paper, what would be found on removal of impression from frame (damages, repairs, discoloration, backing). Sometimes there is more than one impression of the same print available at the sale. Be sure to determine which one you want to bid on; there may be a considerable difference in quality.

At PBNY you may find the curatorial staff circulating in the viewing rooms, willing to discuss the prints very openly. They also have a customer service area that will assist you and try to answer your questions. Take the time to look carefully, and handle the prints carefully too. Some prints are framed on the walls, while others are in cellophane portfolios and can be removed for close examination. While you are examining the prints and finding out as much as you want to know about them, decide if and how much you will bid for those in which you are interested. Make your notes in the catalog.

You may have heard about signals used by bidders who wish to be secretive during a sale: rubbing the nose, pulling the left ear, winking the eyelid might easily change the course of a sale by thousands of dollars. There is no need for you to be concerned. All these signals are prearranged with the auctioneer, so if your nose itches, go ahead and scratch it; you will not he held responsible for what is being auctioned off at the moment! The practice does exist and might be used by curators or well-known collectors. Their involvement in the bidding may raise the price. Dealers might also make use of signals in order not to have their purchase price known.

Whether the atmosphere in the sales room during the auction is formal or relaxed, whether the audience is responsive or uninterested, whether an auctioneer tries to rattle the bidders or not—*remain calm*. Decide what you will bid before the sale begins and stay with it. Your decision was made calmly, and during the auction you may not remain so serene.

If you are the successful bidder at an auction house where you are not known or where you have not established credit, you may be asked for

identification, unless you are paying cash. You are legally liable for the bid you make, and all sales are final. That means you *must* pay the amount you bid if you are the final bidder.

The viewing preceding a special and important auction can be very exciting. When the Nowell-Usticke collection of Rembrandt etchings was sold at PBNY, and during the *Important Old Master Prints* viewing in 1973 (which brought $70,000 for lot 155, Rembrandt's *Agony in the Garden*), the room bristled with security measures. Well-known dealers and collectors from all over the world could be seen examining an impression together and exchanging opinions. The atmosphere was filled with awe and excitement. At the sale, slides were shown rather than the impressions themselves. Surprisingly, the audience was not too large, but it was certainly illustrious. When lot 155 was knocked down (sold) by the auctioneer, you could hear a pin drop in the room. The sale took about a minute. The impression was a particularly fine one with fresh drypoint and an interesting provenance. The etching is 4 ⅜ by 3 ¼ inches—rather expensive by the square inch!

If you have an opportunity to go to an important sale and viewing, you should by all means do so, even if you do not expect to bid. Watch the announcements of the better auction houses in your area. Of course, the best auctions of this type are held at the biggest name houses, such as PBNY, Sotheby in London, Kornfeld and Klipstein in Switzerland, Karl and Faber in Germany, and a few more.

At the other end of the scale are the "twilight dealers," who run auctions under rather questionable conditions. It is not my intention to list all the possible shady practices, but you must be aware of the need to be distrustful and cautious when you attend auctions at less reputable places. In this connection I would like to relate an experience I had. It began when I went to see prints that were to be sold on the following day at auction. The house was not a particularly well-known one either for the quality of prints they sold or for doing any serious research before selling them. But then they also made no claims with regard to authenticity. Fig. 7-1 is an illustration of a Picasso etching that I had decided to buy at the sale, but I was outbid and did not get the print. The time between viewing and sale was very short, and I did not have a chance to investigate the authenticity of this etching. A few weeks later I was in a print room and decided to look into this matter belatedly. The first thing I found was that the reference books can differ in important points. The second was that there is little detailed information available in the compilation of Picasso's graphics. The catalogues raisonnés that exist include all the graphic output, but for the most part there is only a listing without information regarding paper, states, etc. Third, I became convinced that there is an angel guiding my print purchases.

The print, titled *September 19, 1968,* has a Roman numeral I after the date. This usually indicates a first state, but here is the exception to the rule. The print is part of the *347* series. Picasso made 347 graphic designs in different media over a period of seven months, working almost daily in a

manner of diary entries in picture form. Some days he made more than one design, and in such cases he placed Roman numerals after the date. The Roman numeral I here indicates that it was the first design executed on that date. Picasso worked at his printer's studio in Mougins. This printer, Crommelynck, has published a beautiful book that includes all 347 prints in this series. Naturally, I proceeded to the entry for *September 19, 1968,* I and found to my surprise that the print shown here was listed in Crommelynck as *September 20, 1968,* I. The number 20 was not crossed out at all. Georges Bloch, in his catalogue raisonné *Pablo Picasso,* which is considered a reliable source, does have the print exactly as it is illustrated here. It is listed as a first state. By now you know that any change in the plate is considered a state, and this would, therefore, have to be a second state. My own thought on this is that Crommelynck as the printer of the series undoubtedly has an impression of each work in the series. It is usual that the printer keeps the *bon à tirer,* the first proof. Probably Picasso realized that he made an error in the date when he saw the first proofs, and changed the number when the edition was to be printed. Crommelynck used his unique impression in the book he wrote. There was, as mentioned before, not too much information given about the *347* series, except that the work was carried out from March 16, 1968, to October 5, 1968.

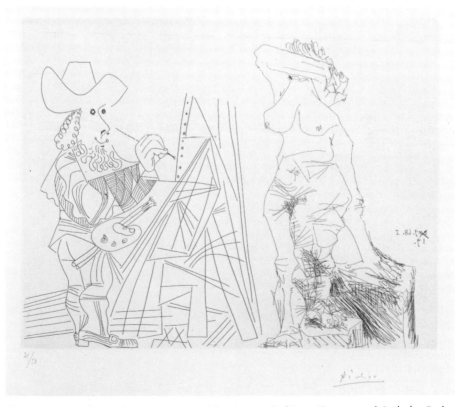

Fig. 7-1. *19.9.68,* from the *347* series, Pablo Picasso. Etching. (Courtesy of Sotheby Parke Bernet, New York.)

And now to the angel who protected me that day. In looking at the Crommelynck illustration I felt it was peculiar that the writing was in mirror image; I could not recall this to have been the case on the impression I had wanted to buy. In addition, I remembered the painter and his easel on the right side, not on the left, as in Fig. 7-1. Fortunately I had made a quick drawing at the auction, and when I compared it to the books I realized that I would have bought a fake. Had I done my homework before the auction, this would not have been possible. At any rate, I was luckier than the person who outbid me—who will have a rude awakening some day. The illustration used here is of course not the fake but an original that was sold at Sotheby Parke Bernet not long ago. My error was mostly due to clouded judgment, because I was intrigued with the subject matter, the Rembrandt-like painter etched by Picasso . . . it seemed delightful. One should not allow such romantic ideas to conflict with one's judgment. I did not examine the impression out of the frame and trusted my quick perusal without checking references. Seeing Picasso's signature made me a bit careless too. I hope my confession serves as a warning. It may be better to let a sale go by if there is no time to check the purchase before it is too late.

To find out when there are auctions or where print galleries are located, look for advertisements in your local newspapers. In addition to this, it may be a good idea to look in your library for art magazines such as *Art News, The Print Collector's Newsletter* and *Print Review*. If you visit an art gallery that has interesting prints, ask them to put you on their mailing list. Most hotels have little booklets at the front desk describing the cultural events in their locality. Any tourist information center can provide lists of galleries and museums. Other collectors are usually a very good, even if biased, source of information. You can benefit from their experience as well as from their mistakes.

FAKES

Whenever objects become valuable, misuse and imitation abound. In prints this takes the form of faked signatures, photoreproductions, re-worked matrixes, unauthorized editions, erroneous or misleading catalogue listings. An outstanding forger can fool even an outstanding expert, and this has been known to happen. It brings to mind a story that circulated for many years about Picasso. The artist was shown a drawing and asked if he could authenticate it as coming from his hand. Picasso without hesitation recognized it as his work. Years later this attribution was found to be wrong, the drawing was done by the famous forger, Elmyr de Hory. I cannot vouch for the truth of this story, but it is certainly possible. If this can happen to the artist, it can certainly also happen to a dealer, to you, and to me. It is difficult to protect yourself against such a mishap.

Photo–reproductions present a smaller problem, provided that you are sufficiently familiar with the medium of the original impression. Your understanding of materials and processes includes the development of a sixth sense that tells you that something does not look right. A reproduced

etching or engraving will have a flatter line than the original, the platemark may be absent, that crispness of line will be missing, and the total impression will lack freshness. The paper on which it is printed may differ from the type used on the original edition. Photographic methods make use of a halftone screen, which shows up clearly under magnification as tiny dots. Reworked plates tend to look too perfect. The hatched areas will be too rich and the whole print may have a rather stark appearance. Remember that a really crisp, rich impression is rare and expensive.

If you are concerned that an impression you are interested in might be a forgery, consider if it is too perfect, untypical, impossible for the medium or for the time it was made, or if the total picture lacks cohesion. A clever forger will understand the work of the artist he is imitating so well that he will make few errors in style or execution. He may give himself away because he lives in a different century and so brings to the work his anachronistic contemporary thought, objects, or mannerisms that are part of his life, not of previous times. To illustrate an anachronism: if you come across an alleged Italian print of the seventeenth century with a fire hydrant in a street scene, it might be an idea to check if there were fire hydrants then.

Restrikes are comparatively easy to recognize, especially if they come from a steelfaced plate. They are harsh and sharp. In lithographs the shaded areas lack the soft tones. Compare a suspected restrike to a known original, and you will see the considerable difference immediately.

We cannot consider all the possibilities of forged or misrepresented graphics. The creative mind of a capable forger may well be at least one step ahead of us. Perhaps the best education for a collector is a case of "mistaken identity" at the beginning of his career.

PRINT CLUBS

This idea is not a new one. Museums have formed groups of this kind for many years, and so have some art dealers. A print club usually commissions an artist to make an edition that is limited, signed, and numbered, and done exclusively for them. You, the collector, join this group by paying a yearly membership fee or sometimes just by making a minimum number of purchases within the year. Depending on the type of club you have joined, you will get more or less valuable offerings. They are quite comparable to book clubs. The prints are contemporary works, and in the better clubs they are by well-known artists. Often the prices of the graphics are lower than at a dealer, but since the print club has exclusive rights, you cannot really compare. Some of the editions sold in this way are of outstanding quality, but unfortunately not all of them. Look for the size of the edition if you plan to buy from a print club; find out if the print is returnable or can be had on consignment. Make sure you get an authentication with your print, stating that it is an original.

MAIL-ORDER GRAPHICS

There are quite a number of dealers who will send you their catalogs on request, and you can choose from their stock in this manner. These listings are illustrated and described in detail. You can usually ask to have a print on consignment so that you may decide at your leisure. Read the descriptions with care, check the references given, and try to learn something about the dealer as well. If you do not have easy access to galleries in a big city, buying art by mail is a very good solution.

TRAVELING ART SALES

Some art dealers make it a practice to visit colleges, small communities, or suburbs from time to time. Their arrival is usually advertised in advance, and it may be worth your while to look into this. For the most part the art is reasonable in price and quality. Here too, of course, you should make sure that the dealer is reliable and that he will give you a letter of authentication.

COLLEGE ART SHOWS

Most college art departments have an exhibit at the end of the school year that includes the work of their students and sometimes also of the faculty. Prices are low, the works may be really good, and you become a true patron of the arts by assisting young talent. If you are lucky, the artist whose work you buy may, some day, become one of the great names in the art world and your investment will multiply.

FLEA MARKETS AND ANTIQUE SHOPS

Flea markets may have hidden treasures, but it is more than likely that you will not find good originals there. If you are serious about your collection, be very cautious when you think you have discovered a great old-master print for a measly sum.

In most antique shops the owner will know more than the buyer. If he carries graphics, he will look for good-quality impressions himself. If the shop is not reputable, it is not the best idea to buy there unless you are very sure and very well informed.

CHARITY AUCTIONS

Art auctions for charitable purposes have become frequent events. In general such auctions are not the best source for the serious collector. The charity may be a most reputable one, but this should not mislead you into thinking that they are responsible for the art that is being sold. There are many auctioneers of rather questionable reputation who run such art sales for their own high profit. They then give a percentage to the organization in whose good name the fund raising is advertised. Rarely is there a catalog or a presale viewing—nor is there recourse after the fact. Such an auctioneer does more damage than good for the charity, since he is the one who gets most of the money, and the buyers often pay exorbitant sums for restrikes and copies. There is no staff of experts, no art expertise, nor any attempt to inform you of what you are buying. Rather, the opposite holds

true. Such auctioneers are usually operating legally, but this is only because we do not have sufficiently good laws to govern shady art dealings. The charity organization probably is not aware of the auctioneer's wrong-doings, since its staff is not made up of art experts but knows only that it needs to raise funds and that art is popular. Consider the fact that if such sales were really legitimate and valuable art were for sale, all the big collectors and art dealers would be the first to know about them and attend.

Be sure to attend sales run in or by reliable houses that have been in business for a long time and have built up a reputation for their integrity. If you want to buy a copy or a restrike, go to any museum and look at the reproductions available for very little money, and make your donation to the charity separately. That way both you and the charity will benefit without helping the unscrupulous auctioneer.

8. Tender Loving Care

While it is true that editions of early prints, from the fifteenth and sixteenth century, were quite large, very few impressions still exist. The earliest prints (for the most part woodcuts) were not made for the collector, nor were they valued as art. As mentioned earlier, they were largely religious images. The people did not frame these little pictures carefully but rather did, what seems to us today, hair-raising things with them. They folded a print or rolled it up and wore it around their necks, or carried it on their person, or pasted it on the wall of a sickroom or in books, or even buried it with its owner. When it was no longer of use, or if it was torn, it would be discarded. It seems miraculous that any prints have survived.

As the print developed through the years, collecting served an educational purpose. Artists themselves were frequently the collectors, since this was a way to study another artist's work. Rembrandt's collection is well known to us because of a document that was found listing the contents of his household that were auctioned off during his bankruptcy in 1656. This inventory sheds a great deal of light on Rembrandt's personality, it may be found in Sir Kenneth Clark's *Rembrandt and the Italian Renaissance*.

The value of works of art has fluctuated considerably according to prevailing taste and social conditions. It is hard to believe that there was a time in the eighteenth century when no one really cared who Rembrandt was. He was rediscovered by the painter Delacroix in the nineteenth century. When little value was attached to a print by an artist who had fallen out of vogue, people discarded or misused it. Wars, fires, floods, lack of understanding, and willful destruction for political reason are additional factors that contributed to the fractional amount of art that has survived.

It may seem incredible to you that even today there are those who do not care about protecting a print. Not long ago an acquaintance, hearing about my interest in art and prints, showed me a drawing her mother had kept in a trunk in the attic. It was a signed Picasso etching of the *Artist and the Model* series. It was torn, had a big fatty spot, had some crayon marks seemingly made by a child, and had foxing (moldy spots) all over it. She told me she had taken it from the attic and, not knowing what to do with it or if it was of any importance, had it "kicking around in the desk." She

thought there were more somewhere, but she had not looked for them.

The conservation and proper restoration of art work in general, and art work on paper in particular, are of growing concern to scholars, museums, and the collector. An art collector, aside from his personal reasons for being one, has a responsibility to preserve the works he owns. In discharging his moral obligation, he becomes a link—however small—in the history of art.

HANDLING A PRINT

Whenever I buy a print the true moment of ownership comes when I realize that I may now touch it. There are probably excellent psychological explanations for the desire or need people have to feel a kinship to someone or something through touch. With prints this should be kept to a minimum and, when necessary, should be done with caution.

The first rule is to wash your hands. Your skin surface is oily and moist, and that is not good for the paper. The second requirement is to have a clean surface on which to place the impression and then handle it very gently. Older paper, especially, is brittle; it can tear and be damaged very easily.

Prints at galleries, in museum print rooms, and in collections are usually placed in a mat for protection, even if they are not framed. That way they may be viewed easily and need not be touched. In a storage box the upper part of the mat also separates one impression from the next. Mats are made of matboard and have a solid sheet in the back that is hinged to the front. The front part of the mat has a window cut out, usually slightly larger than the printed surface of the impression for which it is intended. The print is attached to the back with two delicate paper hinges. The adhesive used is a vegetable paste, never an animal glue. Scotch tape must never be used. When visiting print rooms or galleries, it is best to ask before handling the print. You may wish to see the back of the paper to examine it for watermark or repair. Lift the window part of the mat at the outer edge first, and always lift the print with the edge of a piece of paper. Holding it up against a light source in this manner enables you to see whatever you are looking for, as shown in Fig. 8-1. When the print is lifted, it may come loose from the hinges, so do it slowly.

At one gallery I saw an inexperienced woman ruin a perfectly lovely Chine appliqué work. She opened the mat, took the bottom of the print firmly in hand and turned it up. The line where the platemark was located was also the line where the two papers were pressed together. Evidently it was a stress point, and the paper broke straight across the platemark. This work of art suffered a loss in value because of a lack of caution and knowledge. Watch an expert do it before you try; it is easily learned.

If a print is glued to a backing or to a matboard, do not try to separate them; leave them as they are or take them to a restorer. Do not use water or glue-solvent yourself. Handle such a sheet with more care than a loose one; the backing is often a cheap material and ages quickly; it is brittle and in breaking can damage the print.

Fig. 8-1. Drawing of a print properly mounted.

CLIMATE AND LIGHT

Ecologists have made us all aware of polluted air. Many parts of the country are humid and hot during the summer. This is not only unpleasant for people but it is also bad for any art work on paper. The sun's rays can damage a print beyond repair. Climatic conditions contribute to the growth of insects, and this may be detrimental to the print collection. To reiterate: paper requires a great deal of care.

Many museums have installed instruments and other equipment to control heat and humidity for the better preservation of art. Air-conditioning has, of course, become a way of life, but so have overheated and overly dry atmospheric conditions in most homes. Better lighting, that is to say, stronger light, enables us to see better, and when we have a lovely

work of art on the wall, a spotlight allows us to see it even better. But the heat generated from light bulbs can be almost as injurious to prints as the sunlight.

DON'TS
Don't hang a print on a wall that is either damp, warm, or very cold.

Don't allow sun to hit the print. Watch the pattern of sunlight. Direct sun will bleach the ink, whether it is black or brown or any other color. Remember that peasants used to spread their linen in bright sunlight to bleach it; the ink used in your prints will react the same way. It will oxidize, and what was once a rich, deep black will become a brownish or grayish color. This detracts not only from the beauty but also from the value of an impression. Artificial light should not be close to the paper, nor should it be directed toward it. Fluorescent light, incidentally, contains ultraviolet rays that are as harmful as sunshine. Damage incurred from light is frequently seen when examining an impression outside its frame. The area of paper that was covered by the mat or a wide frame will have a different color than the exposed part. Unfortunately, it is the exposed area that is bleached out and the margin that is in good condition.

Don't keep your print in a room with very humid or overly dry air. Dry heat affects the paper by making it brittle, but that is less detrimental than moisture. Humidity causes paper to buckle and is a perfect breeding ground for insects and foxing, described below. Paper made of linen or rag content can expand and shrink. Its fibers absorb the moisture and swell or stretch. As it buckles, it will touch the glass—where more moisture has condensed. If it is in a storage box, it may develop creases.

In sum—consider some wall spaces as "off limits." This includes those near radiators, those opposite windows that have direct sunlight, the fireplace wall, the spot that always leaks when it rains. On the other hand, a large, airy kitchen, a powder room, hallways, etc., are often needlessly ignored. Arrangements within bookshelves are sometimes very attractive and safe. Make it a habit to draw the curtains or blinds when the sun is strong or when you are going out for a long time.

FOXING
Foxing causes tiny, light brown spots on the paper (Fig. 8-2). It develops from a fungus mold that grows best and quickly in a damp atmosphere without much air circulation. If you store prints, and foxing is present in one impression, separate it from the others, since the fungus may spread. Some experts advise treating the attacked print to stop the mold growth. If you have a foxing problem, consult a good conservator or ask for advice in museum print rooms. By no means try to remove it or treat it without proper knowledge.

Insects such as silverfish or termites eat cellulose and wood pulp in paper, and they are also of concern, although proper framing and care for your collection make them less hazardous. If it is necessary to use insecticides, *never* use them on the paper itself.

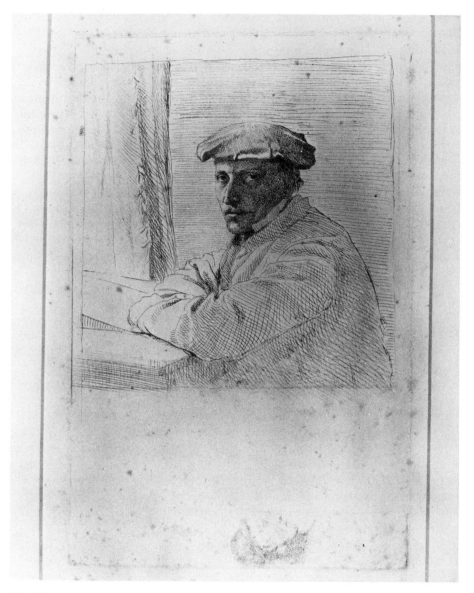

Fig. 8-2. *Le Graveur Joseph Tourney*, Edgar Degas. Print showing the effects of foxing—the darkish spots. (Courtesy of The National Gallery of Art, Rosenwald Collection.)

FRAMING AND MATTING

If you have a graphic art work to be framed, don't take it quickly to the nearest framing shop and leave it there for a few days or weeks without asking questions. Determine whether or not the framer knows about proper procedures. A good framer is an asset not only from the aesthetic point of view but also with regard to the protection of the work of art. A bad framer—one who is not aware of the dangers—can cause damage and

reduce the monetary value of the print. A very valuable work is probably best framed right at the gallery where you buy it.

Recently I had occasion to remove a woodcut from its frame. It was a signed original, titled and numbered. Many years ago the framer had given me a lovely frame and mat and sealed it with paper on the back. To my horror I found that he had glued it to a backing to avoid its buckling later. Imagine if it had been an old, rare impression by a great master! A graphic work of art should never be glued to a backing, nor should it be placed too close to the glass. If it must buckle, then it is better to allow some "breathing space" for the paper. The space required is made available by the mat.

When possible, rag mat should be used. It is acid-free and therefore does not discolor the impression. As a matter of fact, it is made from rag, just as good paper is. Unfortunately, it is available only in white and ivory, but these colors are traditionally used with prints. The thickest is the ⅛-inch board, and that allows just enough air space between the printed surface and the glass.

When the print is placed inside the frame, another backboard may be used for better sealing, and finally a sheet of paper is glued on the rear of the frame to make it all dustproof. No wood backing should be used, since this can discolor the impression.

MARGIN

Often you will see a graphic work with a small printed area on a full sheet of paper. This margin of a large white area may not be to your liking or may present a framing problem. As a general rule, margins should be left intact and not cut down. Very likely the artist had a reason for leaving it. There may even by a valuable blindstamp on it from the printer's shop. Some artists cut their margins themselves; others firmly believed that the whole sheet should be left intact.

STORAGE

Probably the best way to store prints is in a Solander box, which was mentioned in Chapter 5. This is a well-built box, generally black outside and white inside, with a hinged lid and tight-fitting rim. Rumor has it that it was invented by a butterfly collector, who needed airtight, dustproof, and moisture-proof chambers for his collection. Art dealers and museums keep their prints in Solander boxes, and they can supply you with the name of a source that sells them in your area. Inside the Solander box the prints should be matted and have a sheet of glassine (or crystal paper) inserted. It is also acceptable to store prints in wooden drawers, but be sure to check for insects regularly.

SOME GENERAL ADVICE

When in trouble, seek the help of experts, such as restorers or conservators. They are interested in the preservation of works of art and have both knowledge and experience.

Observe how museums, art galleries, and experts in general, store, hang, frame, mat, handle, and respect a graphic work; try to learn the "tricks of the trade."

Never place anything on the print's surface, and make sure that nothing can damage it from underneath.

A cover tissue should be placed over the print until it is framed. It is always best to store all impressions in a mat.

Be a conservationist; the value of a work of art is not only a material one. Remember that as a collecter you have a responsiblity to future art lovers. What is not valuable today might be so in the future. Remember the Picasso story at the beginning of this chapter.

I hope that I have not intimidated you so much that you will quickly remove all the lovely graphics on your walls and put them in a storage box. If you are a print lover, you will want to surround yourself with the best examples available to you so that you can look at them. This in no way precludes giving them the proper care.

Concerning the arrangement of prints on a wall, it is really a matter of personal preference and may require a little thought and creative effort. Mixing graphics with other art or even crafts is a good idea, provided one does not overshadow the other. Each piece is entitled to its own glory. That also applies to the frame. A modern print might look very good in an old, gilded, embellished frame and, if it is not overpowered by it, there is no reason why you cannot use it. The frame should blend with the print and should not call attention to itself. The traditional thin black border is usually not the best solution. If you prefer nonreflecting glass, there is no special reason to avoid it. My feeling, however, is that it tends to deaden the appearance of the graphic work.

Now that I have warned you, I must confess that I have not always adhered to the rules either. Some of my prints are in silk mats, which look very good, but the silk is glued to a cardboard that is not a rag mat. Those works are watched carefully with a feeling of guilt, and they would be removed immediately if any spots or other indication of damage were to appear. It is not advisable to make a practice of framing this way, especially if a valuable or rare print is involved. A fine booklet, written by the conservators of the Museum of Fine Arts in Boston and entitled *How to Care for Works of Art on Paper,* is available in that museum's bookstore and in most libraries.

9. Let's Talk Printese:
A Glossary

As with many other fields of specialization, the graphic arts have their own vocabulary. This chapter contains many of these special terms; some have appeared in the book, some have not. No attempt has been made to cover foreign-language terms unless they appear frequently in catalogues raisonnés or other literature. If you cannot find an expression either in the index or in this chapter, I would suggest that you look in the last volume of the Delteil catalogue raisonné, *Le Peintre-Graveur Illustré,* which contains some sixty pages of glossary in English, German, French, and Spanish.

After division of the plate. For various reasons, usually large dimensions, a plate may be cut in parts either by the artist or after his death. Generally this is not desirable, and it should be viewed with some caution.

Algraphy. Lithographic method using an aluminum plate instead of a stone to make the matrix. Aluminum is less cumbersome than the stone, but the impression will differ in appearance, since the metal is not as porous.

Aquatint. An etching technique.

Authographic ink. Greasy ink used in the printing of lithographs.

Authorized edition. An artist or his estate may give permission to print an additional edition of a graphic work, or to have a reproduction made of a painting by graphic means. Such impressions may be signed, and the edition may be limited, but the practice is deplorable.

Before division of the plate. *See* After division of the plate.

Baren. Japanese tool used to print woodcuts. It is a small pouchlike object formed of a dry leaf. After the wood block is inked and paper is placed on it, the back of the sheet is rubbed with a baren to transfer the design.

Bister. Brownish ink used to print graphics. The result resembles ink drawings.

Bite. The action of the acid on the etched plate.

Blind printing. White-on-white relief print. *See* Gauffrage.

Blindstamp. *See* Chop mark.

Block books. Early books made before metal-cast letters were in wide use. The illustrations and the letters were hand cut on a wood block, and each page was made from such a block. Such books are very rare and valuable.

Bon à tirer. Also called RTP (Right To Print). French for "good to be printed." Mostly used in lithography.

Brayer. Roller used to ink plates.

Burin. Engraving tool, also used for drypoint.

Burnisher. Tool used to remove lines or portions of the design in intaglio plates.

Burr. Ragged curl thrown up in forming an incised line on metal.

Catalogue illustré. An illustrated collection of an artist's work. Similar to a catalogue raisonné.

Catalogue raisonné. Also called definitive catalog. A compilation of an artist's work, usually with illustrations, and giving data about states, edition, provenance.

Center crease or **center fold.** May be the result of the drying process of hand-made paper, or a result of folding the sheet for storage by a careless owner. Paper may be brittle at this line.

Chiaroscuro woodcut. Type of woodcut using more than one block to attain color and tone in the impression.

Chine appliqué. Printing process involving two sheets of paper.

Chine volant. Very thin China paper, almost like tissue.

Chop mark. Also called blindstamp. Uninked, embossed stamp either of the printer's workshop or of the artist.

Chromolithography. Process of making colored lithographs.

Clair-obscur. French term for chiaroscuro woodcut.

Codex. Another word for book; usually used for early books.

Collograph. Relief print. The matrix is made by piling objects on a surface in the manner of a collage to create the design.

Colophon. Inscription on the last page of a book or folio.

Coucher. Person who removes the formed sheet of paper from the mold.

Counterproof. A sheet of paper is placed on a wet, fresh impression and both are put through the press. The impression taken from the impression (the counterproof) will be directionally the same as the matrix and allows the artist to make corrections on the plate with less effort.

Cum privilegio regis. Old form of copyright; right of ownership to his own design given the artist "by privilege of the king." It barred copying of the design.

Cypher. Usually refers to the abbreviation *imp* in a circle; means that the artist printed the impression himself (as in: signed with cypher). *See also* Impressit.

Dauber or **Dabber.** Roll or stuffed ball used to apply ink to the matrix.

Delineavit. (Abbreviated *del.*) Means "drew it." Used on old prints when work was often divided between designer and artisan.

Diapositive. Photographic positive.

Drypoint. An intaglio print-making method on metal.

Early impression. Print taken at the beginning of an edition; in old-master prints, an impression taken in the artist's lifetime.

Eau forte. French term for etching.

Eigendruck. German term for cypher.

Estate print. After the artist's death, plates, blocks, and stones become the property of the estate. Sometimes new editions or additional printings are made posthumously by the heirs. This is usually indicated on the impression as *succ,* followed by the signature of a family member.

Etcher's needle. Tool used to draw the design on grounded plate.

Ex coll of. . . . May be found in the provenance. Means that the impression was once in the collection of. . . .

Exudit. (Abbreviated *exc* or *exud.*) Means "published it."

Facsimile woodcut. Refers to the method of preparation of the wood block. The design by the artist is drawn on the wood, or on paper fastened to the wood, and cut by a craftsman. This practice was common during the time of the old guild system, which insisted on such a division of labor.

Fecit. (Abbreviated *f* or *fec.*) Means "made it."

Folio. *See* Portfolio.

Formschneider. German term for the artisan who did the cutting of the block.

Foul bite. Occurs when acid penetrates the etching ground, where it is not desired or planned. It printed, the area will look sloppy and pitted.

Frontispiece. First page of a series or a folio.

Frottage. Print made by rubbing rather than printing in the press.

Gauffrage. Three-dimensional relief printing method. Pure gauffrage uses no ink (blind printing). This process may be combined with other media.

Graver. Engraving tool.

Ground. Coating applied to the plate before it is etched.

Halftone block. Similar to, but offers better results than, a line cut. This process produces fine tone gradations. Under magnification a fine dot pattern may be discerned. It is the result of the fine screen grid used to get the tonal variation. This photomechanical method is used for reproductions and book illustrations.

Halftone cut. *See* Halftone block.

Heliogravure or **Heliography.** A photoengraving method of producing fine reproductions; often sufficiently faithful to the original to pass undetected, but can be detected under considerable magnification.

Hors de Commerce. (Abbreviated *H.C.*). Literally means "outside of business." Usually applies to special proofs.

Impressit. (Abbreviated *imp.*) Means "printed it." *See also* Cypher.

Incunabula. The "infancy" or earliest efforts in printmaking and books. Block books are in this group.

Invenit. (Abbreviated *inv.*) Means "designed it."

Laid down. Impressions pasted into books or on backings are backed or laid down. This differs from Chine appliqué, which is done as part of the creating and printing processes and is thus an integral part of the impression.

Late impression. Prints made later than the original edition, after the artist's death. Mostly concerns old masters.

Lift-ground etching. A solution of water, india ink, and either sugar, glycerin, or corn syrup, is applied to the plate with a brush. When the solution is almost dry, regular ground is applied over the whole plate and it is immersed in a warm bath. The brush design will "lift" the ground above it and expose the plate surface, which can then be bitten in the acid bath.

Limited edition. Predetermined number of impressions made from a matrix. The limitation may be fifteen or 1,500. Always ascertain the limitation of a limited edition.

Line block. Inexpensive photomechanical method for printing black and white. Used for reproductions and in newspapers.

Line cut. *See* Line block.

Lino cut. *See* Linoleum cut.

Linoleum cut. Similar to a woodcut, but the block or block surface is linoleum, which is easier to cut than wood.

Litho etch. Part of the process for setting the drawn design on the lithograph stone. Not to be confused with the etching medium.

Lithotint. Lithographic method that uses washes in the preparation of the design on the stone.

Maculature. Sometimes two impressions are taken from a plate without reinking. The second impression is the maculature. This is done to draw excess ink out of the lines.

Mat burn. Discoloration of the area on an impression that was covered by the mat.

Matrix. Refers to block, plate, stone, stencil, or other surface from which a design is printed.

Mezzotint. An engraving technique on metal.

Mixed media. Refers mostly to intaglio processes, but the mixture, especially in contemporary prints, may be any combination of different media.

Monochrome. Use of only one color. In prints this generally means black-and-white.

Monograph. A "one-of-a-kind" print that is repeatable. It may be the only impression taken from the matrix or the only one in a color. Differs from monoprint which cannot be repeated.

Monotype. A print-making technique that results in an edition of a single print.

Mordant. Acid used in the etching process.

NFS. Not for sale.

Paper loss. Refers to damage in an impression. Paper may have been torn off or removed accidentally.

Papier vélin. Wove paper.

Papier vergé. Laid paper.

Peau de crapeaud. Literally means "skin of a toad" in French. A textural effect in lithography that resembles wrinkles in the skin.

Pinxit. (Abbreviated *pinx*.) Means "painted it." Usually found on an old print that is a copy of a painting.

Pirated copy. Copy made by an artist of another artist's print. This was the case with Raimondi, for example, whose engraved works from Dürer's woodcuts would be called pirated copies.

Platemark. Imprint left in the paper from the edge of the plate used in intaglio methods. Generally the edge is slightly beveled so that the paper is not injured.

Portfolio. Collection of prints by one or more artists published together. Usually the sheets are loose, not bound in book form.

Preferred edition. May be indicated by a Roman number on the impression. It is an additional printing to an edition and usually has better paper quality or may differ in size. In contemporary prints this custom has led to abuses, since the preferred edition can appear after the original and limited one.

Preliminary proof. Proof taken while the work on the matrix is in progress.

Pressbed. Part of the lithograph press that moves the stone through the press.

Print cabinet. European equivalent of the American museum print room.

Printed with plate tone. *See* Retroussage.

Pristine condition. Term often used to describe a print in perfect condition. Does not refer to the quality of the impression.

Process print. Print made by mechanical or photomechanical means.

Provenance. The "pedigree" of a work of art, i.e., its past history.

Recto. Front face of a sheet of paper (opposite of verso).

Recueil. French term for restrike.

Repousser. Refers to process of fixing a plate due to damage or change in design. It entails burnishing and hammering the area.

Restrike. An additional printing of the original plate, usually not authorized by the artist.

Retroussage. Leaving ink on the plate for tonal effects, as in some Whistler or Rembrandt etchings.

Rocker or **spiked rocker.** Tool used to roughen the plate for mezzotint.

Rotogravure. Photomechanical process related to halftone; used to reproduce intaglio graphics. Ink is not raised as in an original. Needs magnification to be detected.

Roulette wheel. Tool used for etching and mezzotint; similar to the rocker.

Sanguine. Reddish-rust-colored ink sometimes used in graphics.

School of. . . . As in School of Rembrandt. Indicates print was made by a pupil or assistant in the style of Rembrandt.

Scrim. Cloth used for wiping an inked plate.

Sculpsit. (Abbreviated *sc* or *sculp*.) Means "engraved it."

Sepia. *See* Bister.

Signed in brushpoint. The artist signed print with a brush rather than a pencil.

Silverpoint. Drawing made with a silver-tipped stylus on a specially prepared paper. Used in the sixteenth century.

Sinopia. Underdrawing of a fresco; usually a brownish color.

Solander box. Box designed to be dustproof and moisture-proof. Excellent for storing art on paper.

State proof. A proof taken after changes were made that constitute a state.

Steelfacing. Metal may be electroplated so that the engraved or etched lines hold up longer in printing. Usually not a desirable feature because of the harshness of line. Restrikes are often made this way. Some artists have the complete edition printed in this manner.

Stopping out. Process of covering already etched lines in the plate. Used when more than one bite is necessary.

Sugar lift. *See* Lift-ground etching.

Thread margin. A very narrow margin, cut close to the platemark.

Tone block. In chiaroscuro technique, usually one of the color blocks.

Tone-on-tone. Usually applied to soft shadings of beige-to-brown found in chiaroscuro.

Trimmed into the subject. Occurs when paper has been cut past the margin and into the design. Not a desirable feature.

Trimmed to the platemark. Often found in old prints, where paper was used so sparingly that the margin may be one millimeter.

Tusche. Greasy ink used in lithography.

Unique impression. Only one example exists. This may be due to the fact that only one (of an early state) was made, or if more existed, they were destroyed or lost. More impressions of a later state may be available.

Unpublished plate. Not everything an artist produces reaches the public. He may reject it or there may be no demand. Possibly the artist is "discovered" much later, and his matrixes may be printed then. May also refer to an unused book illustration.

Vatman. Person who forms the paper sheet on the mold.

Verso. Back side of a sheet of paper (opposite of recto).

Watelet retouch. Watelet, like Basan, reworked Rembrandt's plates and issued restrikes in the eighteenth century.

Working proof. Impression taken while work is in progress.

Zincography. Lithographic method using image made on a zinc plate.

10. Read, Read, Read: A Bibliography

In the following pages you will find a list of books and other sources that will be helpful to you in all areas of print collecting. Some are as necessary for the beginner as they are for the expert. Others, like the reference books, you will use only occasionally. The list of catalogues raisonnés will come in handy when you want to authenticate a print. The books on art in general are important for gaining deeper understanding of the development of art and your own expertise. The more you learn about art movements and techniques of printmaking, the more refined your taste and judgment will become.

The bibliography offered is by no means complete, nor is it unbiased. Many of the books listed have their own bibliographies from which you can choose further reading material according to your interest. Look in museum book stores when you have an opportunity, and also in college bookshops. There are a number of very good art-book mail-order suppliers who will send you their catalogs for perusal. Very often you will find the latest information in magazine articles and exhibition catalogs.

A good bibliography is the pride of many scholars. If you come across books that are of special interest to you, make notes on an index card for future reference and start your own file. You might make a notation as to where you saw the book. If it came from a library, record its classification number. This can save much time when you want to see the material again. Not all books listed here are meant to be read from cover to cover. Look for those topics that are important to you.

When using a catalogue raisonné, be sure to look at the text and appendix. The Dürer catalogue by Meder (in German) has a section at the end that discusses the watermarks and papers used by Dürer and those that were used by the artist in the earliest (and now most expensive) impressions in an edition. Bloch's text in his volume on Picasso's graphics sheds light on the artist's working methods. Remember that the authors of such works are either scholars or intimate friends of the artist, and in compiling the information they can relate some very interesting and valuable facts.

There are, for obvious reasons, no complete catalogues raisonnés avail-

able on living artists. Those listing that do exist usually confine themselves to a particular time span. An example is the Jasper Johns book by Fields.

To establish the best catalogue raisonné for a particular artist, you can look at an exhibition or auction catalog. Typical sources for these are the National Gallery of Art (especially for early prints), the Boston Museum of Fine Arts, Sotheby Parke Bernet, and other well-known museums and auction houses. I have included in the catalogue raisonné section some books that are known as catalogues illustrés. Such books have reproductions of the prints made by a particular artist without including the complete data regarding states, edition size, watermarks, etc. Crommelynck's *Picasso 347* is an example of a catalogue illustré. It differs from Bloch's catalogue raisonné, which does include the information on states and edition size.

One of the greatest places for people interested in prints is the print room in the Main Public Library in New York. You need a special pass to enter, but this is available if you are a collector or have a scholarly interest. You cannot browse there, since every book and print is under lock and key. The print collection contains some 150,000 impressions—from the earliest woodcuts to contemporary works. There is always a print exhibit in the hallway. Their book collection is among the best in the United States. It is used by scholars, dealers, and collectors, as well as by graduate students. You will be welcome if you handle the materials with care and are serious about learning or researching a print.

With most books listed below you will find a brief annotation to give you some idea of the content. The selection includes many outstanding works, as well as a broad spectrum of the literature of interest to print collectors.

Printmaking Techniques

Antreasian, Garo Z. **Tamarind Book of Lithography.** New York: Abrams, 1971. A very complete and step-by-step illustrated book covering everything concerning lithography. Comes in paperback.

Brunner, Felix. **A Handbook of Graphic Reproduction Processes.** New York: Hastings House, 1964. An explanation of graphic techniques and their history. In English, French, and German.

Chieffo, C. T. **Silk Screen as a Fine Art.** New York: Van Nostrand Reinhold, 1972. Step-by-step illustrated explanation of this printmaking method. Very easy to follow.

Curwen, Harold. **Processes of Graphic Reproduction.** London: Faber, 1966. Reproductive processes are clearly illustrated; assists in the recognition of fakes.

Edmondson, Leonard. **Etching.** New York: Van Nostrand Reinhold, 1973. Well illustrated; shows the latest intaglio methods clearly, including photos of work in progress.

Franke, Herbert W. **Computer Graphics—Computer Art.** New York: Phaidon, 1971. One of the few books that deal with this subject. Discusses method, history, and problems of computer art.

Hayter, S. W. **New Ways of Gravure.** London: Oxford University Press. Hayter is a graphic artist and describes the method with knowledge.

Heller, Jules. **Printmaking Today.** New York: Holt, Rinehart and Winston, 1972. A studio handbook with good explanations and illustrations.

Ivins, William M. **How Prints Look.** Boston: Beacon, 1967. A small but excellent book. Explains how to distinguish different media easily. Considered a bible for the print collector. Paperback. Look also for Mr. Ivin's other books; he was print curator at the Metropolitan Museum of Art.

Knigin, Michael, and Zimiles, Murray. **The Technique of Fine Art Lithography.** New York: Van Nostrand Reinhold, 1970. A very good book by two working artists. Well illustrated. Covers latest photographic and color processes.

Laliberté, Norman. **The Art of the Stencil.** New York: Van Nostrand Reinhold, 1971. History and technique described in simple form.

Laliberté, Norman. **Twentieth Century Woodcuts.** New York: Van Nostrand Reinhold, 1971. Well illustrated; good if you want to try your hand at making a woodcut.

Lumsden, E. S. **The Art of Etching.** 1924. Reprint. New York: Dover, 1962. Covers artists and materials, development of the medium, different effects of ground and inking. Paperback.

Pennell, Joseph. **The Graphic Arts.** Chicago, 1920. An account by the etcher, Whistler's brother-in-law, on the state of the art at the time.

Peterdi, Gabor. **Printmaking.** New York: Macmillan, 1971. A very useful explanation by a teacher and well-known printmaker.

Ross, John, and Romano, Claire. **The Complete Printmaker.** New York: Free Press, 1972. A well-illustrated book explaining printmaking methods and photographic techniques.

Schwalbach, M. and J. **Screen Process Printing.** New York: Van Nostrand Reinhold, 1970. A fine explanation of the process and its history. Covers both fine-art and fabric techniques.

Senefelder, Aloys. **A Complete Course of Lithography.** 1819. Reprint. New York: Da Capo Press, 1970. Written by the inventor of lithography.

Strauss, Walter L. **Chiaroscuro.** Greenwich, Conn.: New York Graphic Society, 1973. A very complete book on this printmaking method, its history and techniques, as used in sixteenth- and seventeenth-century Germany and Holland.

Art—General

Adhémar, Jean. **Graphic Art of the 18th Century.** New York: McGraw-Hill, 1964. One of the few books treating graphics of this period. Good as general background reading.

Adhémar, Jean. **Twentieth Century Graphics.** New York: Praeger, 1971. A good introduction to modern prints. Presents the important artists and events from the turn of the century to the present day. Paperback.

Amman, Jost. **293 Renaissance Woodcuts for Artists and Illustrators.** Reprint. New York: Dover, 1972. Amman made these woodcuts at the end of the sixteenth century. They depict many occupations practiced at that time, among them printmaking, printing, paper making. The woodcuts are not so much great works of art as they are a historical document. Paperback.

Barnicoat, John. **A Concise History of Posters.** New York: Abrams. This book discusses the development of the poster and is well illustrated.

Battcock, Gregory. **Minimal Art: A Critical Anthology.** New York: E. P. Dutton, 1968. A collection of essays on this art movement. Paperback.

Battcock, Gregory. **The New Art.** New York: Dutton, 1966. An anthology with essays on twentieth-century art by outstanding writers with various points of view. Very enlightening. Paperback.

Berman, S. N. **Duveen.** New York: Random House, 1951. Duveen was the art dealer responsible for the most outstanding collections in our country (such as Frick and Kresge). The book tells the story of his ambitions and dealings. Comes in paperback.

Canaday, John. **Embattled Critic.** New York: Farrar, Straus, 1962. The well-known art critic selected some essays on art that were published in **The New York Times.** Paperback.

Canaday, John. **Mainstreams of Modern Art.** New York: Holt, Rinehart and Winston, 1959. A survey of art from the nineteenth and twentieth centuries. Easy to read.

Clark, Kenneth. **Rembrandt and the Italian Renaissance.** New York: New York University Press, 1966. Aside from the discussion of Italian influences on Rembrandt's work, this book contains an appendix that lists the **Inventory of Rembrandt's Possessions in 1656,** the articles that were sold at auction when the artist declared bankruptcy. It is one of very few original documents concerning Rembrandt. Paperback.

Coremans, P. **Van Meegeren's Faked Vermeers and De Hooghs.** London: Cassell, 1949. A scientific examination and explanation of a well-known scandal.

Field, Richard S. **Jasper Johns: Prints 1960–1970.** New York: Praeger, 1970. A clear discussion of John's graphics and concepts. A valuable book for the understanding of contemporary prints. Many illustrations.

Gallwitz, Klaus. **Picasso at 90.** New York: Putnam, 1971. The painting of the late years—as the title implies.

Gardner, Helen. **Art through the Ages.** New York: Harcourt Brace Jovanovich, 1969. An excellent general introduction to the history of art.

Gilbert, Creighton E. **History of Renaissance Art.** New York: Abrams, 1973. A discussion of history and art in western Europe.

Gombrich, Ernst. **The Story of Art.** Revised edition. New York: Praeger, 1972. A good general book on the history of art. Includes all art forms, clear explanations. Paperback.

Goodrich, Lloyd. **The Graphic Art of Winslow Homer.** New York: Braziller, 1968. About the etchings, lithographs, and wood engravings of one of America's best-known artists.

Greenberg, Clement. **Art and Culture.** Boston: Beacon, 1961. Essays by the well-known art critic.

Hamilton, George H. **19th and 20th Century Art.** New York: Abrams, 1972. Good background for these centuries, including the artistic developments that led to contemporary art.

Hayter, S. W. **About Prints.** London: Oxford University Press, 1962. Sheds light on this phase of the art world as seen by the artist and author.

Hind, A. M. **An Introduction to a History of the Woodcut.** Reprint. New York: Dover, 1963. A comprehensive and general discussion of this medium. Very good, if somewhat dry. Paperback.

Hind, A. M. **A History of Engraving and Etching (15th Century to 1914).** 1923. Reprint. New York: Dover, 1963. All of Hind's books contain good and reliable material. Paperback.

Irving, Clifford. **Fake: The Story of Elmyr de Hory, the Greatest Faker of our Time.** New York: McGraw-Hill, 1969. Makes one aware that fake art is produced for "fun and profit." Comes in paperback.

Ivins, William M. **Prints and Visual Communications.** Cambridge, Mass.: M. I. T. Press, 1953. A well-thought-out book on pictures in print, their uses and effects. Ivins, a former curator of prints at the Metropolitan Museum of Art, covers print history from its beginning to the twentieth century. Paperback.

Janson, Horst W. **History of Art.** Englewood Cliffs, N. J.: Prentice-Hall, 1956. This is probably the most widely read book on the history of art. It is a basic college text too, because it is complete and well stated. It covers art from its beginning to the middle of our century.

Kubler, George. **The Shape of Time.** New Haven: Yale University Press, 1962. A very interesting but difficult theory relating art, artist, and time.

Levey, Michael. **Early Renaissance.** College Park: University of Maryland Press, 1967. Art history, style and civilization are the topics. Paperback.

Leymarie, Jean. **The Graphic Works of the Impressionists.** New York: Abrams, 1971. A really fine book with illustrations, text, and catalog information on Manet, Pissarro, Renoir, Sisley, Cézanne.

Leymarie, Jean. **Picasso, Artist of the Century.** New York: Viking, 1971. Very comprehensive and well written. Picasso's work in all media. Many illustrations.

Lippard, Lucy R. **Pop Art.** New York: Praeger, 1971. Covers this contemporary art movement quite completely. Paperback.

Man, Felix H. **Artists' Lithographs 1803–1953.** New York, 1970. History of lithography from Senefelder to modern times. Informative, well illustrated.

Metropolitan Museum of Art. **Art Forgery.** New York, 1967. A very informative, inexpensive booklet.

Novak, Barbara. **American Painting of the 19th Century.** New York: Praeger, 1969. One of the best surveys on the subject. Paperback.

Panofsky, Erwin. **The Life and Art of Albrecht Dürer.** Princeton: Princeton University Press, 1955. Professor Panofsky was one of the outstanding art historians of our time. His book on Dürer must be read by anyone seriously interested in this artist and in early prints.

Panofsky, Erwin. **Studies in Iconology.** New York: Harper & Row, 1939. A reasonably difficult book by a great thinker. All books by this author are recommended. Paperback.

Pennell, Joseph. **Lithography and Lithographers.** New York: Macmillan, 1915. Written by the artist, a contemporary of Whistler, on technique and artists.

Philipson, Morris. **Aesthetics Today.** Meridian, Ohio: Meridian Books, 1961. Selected essays by many outstanding scholars. Book is on the "heavy" side, but worth the effort. Comes in paperback.

Rewald, John. **Post-Impressionism: From Van Gogh to Gauguin.** New York: Museum of Modern Art, 1956. Excellent book and most informative. Professor Rewald has written **The History of Impressionism** (1961), which is also highly recommended.

Roger-Marx, Claude. **Graphic Art of the 19th Century.** New York: McGraw-Hill, 1962. Very helpful for information covering this period, a lucrative time for printmaking. Author traces development clearly and illustrates it fully.

Rosenberg, Harold. **The Anxious Object.** New York: Horizon Press, 1964. Good for learning about contemporary artistic styles.

Shahn, Ben. **The Shape of Content.** Cambridge, Mass.: Harvard University Press, 1957. An artist and teacher discusses philosophical and artistic concepts in a clear, intriguing manner. Paperback.

Shattuck, Roger. **The Banquet Years.** New York: Vintage, 1968. A good book on modern art. Paperback.

Sotriffer, Kristian. **Modern Graphics, Expressionism to Fauvism.** New York: McGraw-Hill, 1972. Covers graphic art in the early twentieth century, its development and the individual artists.

Spies, Werner. **Victor Vasarely.** New York: Abrams, 1971. A fine and comprehensive volume on this artist. Many illustrations.

Timm, Werner. **The Graphic Art of Edvard Munch.** Greenwich, Conn.: New York Graphic Society, 1969. A survey of work by Munch from the turn of the century to 1943.

White, Christopher. **Rembrandt as an Etcher.** London, 1969. A detailed study of some of Rembrandt's etchings by one of the foremost scholars on the subject. Not a book for beginners.

Zigrosser, Carl. **Guide to Collecting and Care of Original Prints.** New York: Crown, 1965. A small and informative book. Mr. Zigrosser's other publications will also be of interest.

Biographies

Delacroix, Eugène. **The Journal of Eugène Delacroix.** Translated by Walter Pach. New York: Crown, 1948. Writings by the artist, together with some of his drawings. Comes in paperback.

Dürer, Albrecht. **Diary of his Journey to the Netherlands.** 1520. Reprint. Greenwich, Conn.: New York Graphic Society, 1971. This diary is among the most revealing documents in art history. If you are at all interested in Dürer or his time—or if you want to become interested in them—read this book.

Gauguin, Paul. **Paul Gauguin's Intimate Journals.** Translated by Van Wyck Brooks. Bloomington, Ind.: Indiana University Press, 1958. Gauguin's diary, covering mostly the time he spent in Tahiti. Reproductions of his drawings and paintings.

Gogh, van, Vincent. **Dear Theo.** Edited by Irving Stone. New York: Doubleday, 1950. Letters from Vincent to his brother about his art, his health, his needs, and his thoughts.

Kollwitz, Kaethe. **Diary and Letters of Kaethe Kollwitz.** Chicago: Regnery, 1955. This book provides great insight into the work of a very sensitive artist.

Prideaux, Tom, and the Editors of Time-Life Books. **The World of Whistler.** New York: Time-Life Books, 1970. A very easy-to-read biography and a good way to become familiar with the artist's life and work.

Rewald, John. **Camille Pissarro: Letters to His Son Lucien.** New York: Pantheon, 1943. Pisarro's letters discuss graphic processes, other artists and his own work.

Ruppel, A. **Johannes Gutenberg.** Berlin: Gebr. Mann, 1947. A study of all aspects of the life and work of Gutenberg, the inventor of movable type. (In German.)

Sabartés, Jaime. **Picasso, an Intimate Portrait.** New York: Prentice-Hall, 1948. Biographical material by Picasso's friend.

Whistler, J. A. M. **The Gentle Art of Making Enemies.** New York: Dover, 1967. Letters and articles written by Whistler. Offers insight into the artist's personality and his art. Paperback.

Catalogues Raisonnés and Catalogues Illustrés

Bartsch, Adam. **Le Peintre Graveur.** 21 vols. Vienna: J. V. Degen, 1803–21.

Bartsch, Adam. **Catalogue raisonné de toutes les estampes qui forment l'oeuvre de Rembrandt.** Vienna, 1797.

Biörklund, George. **Rembrandt's Etchings, True and False.** Stockholm: Published by the author, 1968. Includes section on restrikes, inking, paper.

Bloch, George. **Picasso: Catalogue of the Printed Graphic Work.** Berne: Kornfeld and Klipstein, 1971.

Breeskin, Adelyn D. **The Graphic Work of Mary Cassatt.** New York: Bittner, 1948.

Cole, Sylvan. **Raphael Soyer: 50 Years of Printmaking 1917–1967.** New York: Da Capo, 1969.

Crommelynck, A. and P. **Picasso 347.** 2 vols. New York: Random House, 1969. A catalogue illustré of the complete series.

Delteil, Loys. **Le Peintre-Graveur Illustré.** 32 vols. Reprint. New York: Da Capo, 1971. Delteil's catalogue raisonné covers the prints of the following artists: Millet, Jongkind, Ingres Carpeaux, Rodin, Huet, Goya, Carrière, Degas, Zorn, Corot, Rude, Bary, Géricault, Toulouse-Lautrec, Pissarro, Leys, Leheutre, Renoir, Ensor, Daubigny, Sisley, and Daumier.

Geiser, B. **Picasso: Peintre-Graveur, Graphics 1899–1931.** Paris, 1955.

Guérin, Marcel. **Catalogue raisonné de l'oeuvre gravé et lithographié d'Aristide Maillol.** Geneva: H. Floury, 1965.

Guérin, Marcel. **L'oeuvre gravé de Gauguin.** Paris: H. Floury, 1927.

Guérin, Marcel. **L'oeuvre gravé de Manet.** Reprint. New York: Da Capo, 1969.

Harris, Jean C. **Edouard Manet, Graphic Works.** Reprint. New York: Collectors Editions Ltd., 1971.

Harris, T. **Goya: Engravings and Lithographs.** 2 vols. London: Oxford University Press, 1964.

Hind, Arthur M. **A Catalogue of Rembrandt's Etchings.** New York: Da Capo Press, 1967.

Hind, Arthur M. **Giovanni Battista Piranesi.** New York: Da Capo, 1967.

Hind, Arthur M. **Early Italian Engravings.** 7 vols. New York: Knoedler, 1938–48.

Hollstein, F. W. H. **Dutch and Flemish Etchings, Engravings and Woodcuts (1450–1700).** 19 vols. Amsterdam: M. Hertzberger, 1949. Volumes 18 and 19 are by White and Boon on Rembrandt.

Hollstein, F. W. H. **German Engravings, Etchings and Woodcuts (1480–1700).** Amsterdam: M. Hertzberger, 1954ff.

Kallir, Otto. **Egon Schiele: The Graphic Work.** New York: Crown Publishers, 1970.

Kennedy, Edward G. **The Etched Work of Whistler.** New York: Grolier Club, 1910. Only covers etchings. *See* Way for lithographs.

Klipstein, A. **Kaethe Kollwitz: Verzeichnis des Graphischen Werkes.** Berne: Klipstein, 1955.

Lehrs, Max. **Geschichte und Kritischer Katalog des deutschen, niederländischen und französischen Kupferstichs im XV. Jhdts.** 9 vols. 1908–34. Reprint. New York: Collectors Editions Ltd., 1970. Covers engravings of the fifteenth century in Germany, the Netherlands, and France. Very comprehensive.

Leiris, M. **The Prints of Joan Miró.** New York: C. Valentin, 1947.

Lieberman, W. S. **Matisse: 50 Years of His Graphic Art.** New York: Braziller, 1956.

Lieure, Jules. **Jacques Callot.** 9 vols. Reprint. New York: Collector's Editions Ltd., 1970.

Meder, Joseph. **Düerer Katalog.** Reprint. New York: Da Capo Press. Includes section on watermarks of the papers used by the artist. Text in German.

Mellerio, André. **Odilon Redon.** New York: Da Capo, 1968.

Mourlot, Fernand. **Art in Posters.** New York: Braziller, 1959. Posters by Chagall, Dufy, Léger, Matisse, Miró, and Picasso. Catalogue illustré.

Mourlot, Fernand. **Braque Lithographs.** Monte Carlo: A. Sauret, 1963.

Mourlot, Fernand. **Lithographs of Chagall.** 3 vols. New York: Braziller, 1960–67.

Mourlot, Fernand. **Picasso Lithographs.** 4 vols. Monte Carlo: A. Sauret, 1949–64. In French. Catalogue illustré.

Nowell-Usticke, G. W. **Rembrandt Etchings, States and Values.** Livingston, Pa., 1967. Compiled by a collector. Includes some interesting information from the collector's point of view.

Pallucchini, R., and Guarnati, G. **Le Acqueforti del Canaletto.** Venice: Fanelli, 1944. In Italian.

Paulson, Ronald. **Hogarth's Graphic Works.** 2 vols. New Haven: Yale University Press, 1965.

Paulson, Ronald. **Rowlandson.** New York: Oxford University Press, 1972.

Picasso for Vollard. New York: Abrams, 1956. Catalogue illustré of 100 etchings made by Picasso 1930–37.

Rizzi, Aldo. **The Etchings of the Tiepolos.** Italy: Doretti, 1970. Covers the work of the father and two sons.

Robert-Dumesnil, A. P. **Le peintre-graveur français.** 2 vols. 1855. Reprint. Paris: F. de Nobela, 1967. Artists of the seventeenth century (Lorrain, Millet, Watteau, etc.).

Roger-Marx, Claude. **Bonnard Lithographe.** Monte Carlo: A. Sauret, 1952.

Roger-Marx, Claude. **French Original Engravings from Manet to the Present Time.** New York: Hyperion Press, 1939.

Roger-Marx, Claude. **L'Oeuvre gravé de Vuillard.** Monte Carlo: A. Sauret, 1948.

Waldman, Diane. **Ellsworth Kelly, Drawings, Collages, Prints.** Greenwich, Conn.: New York Graphic Society, 1971. A catalogue illustré of a portion of Kelly's work.

Way, Thomas R. **The Lithographs by Whistler.** New York: Kennedy, 1914. (For Whistler etchings, see Kennedy.)

Werner, Alfred. **The Graphic Works of Odilon Redon.** New York: Dover. Catalogue illustré. Paperback.

White, Christopher (and Boon). **Rembrandt's Etchings.** Amsterdam: M. Hertzberger, 1970. This catalogue raisonné is the latest one on Rembrandt. It is Volume 19 of the Hollstein series. Many experts feel that it is the most reliable source.

Wuerth, Louis A. **Catalogue of Lithographs of Joseph Pennell.** Boston: Little Brown, 1931.

Zerner, Henri. **The School of Fontainebleau.** New York: Abrams, 1969. French graphics from Renaissance to Mannerism.

Zigrosser, Carl. **The Complete Etchings of John Marin.** Philadelphia: Philadelphia Museum of Art, 1969.

Reference Books

American Art Directory. New York: Bowker. A yearly publication. Names and addresses of museums, organizations, literature, etc.

Art at Auction. Published by Sotheby Parke Bernet, Inc. (London and New York auctions.) An annual publication that has a section devoted to graphics. Each year it lists the outstanding examples of sales. Helpful general source.

Art Index. New York: H. W. Wilson Co. An author-and-subject index of articles in arts periodicals. Appears quarterly. Found in most libraries.

Briquet, Charles. **Les Filigranes.** Reprint. New York: Hacker, 1966. Watermarks from 1282–1600, each illustrated. Excellent reference for early prints.

Carrick, Neville. **How to Find out about the Arts.** New York: Pergamon Press, 1965. Bibliography; sources of information in art.

Chamberlin, Mary. **Guide to Art Reference Books.** Chicago: American Library Association, 1959. Not too recent, but a very helpful reference. Has a section for prints.

Churchill, W. A. **Watermarks in Paper.** Amsterdam: M. Hertzberger, 1935. Covers watermarks in the Netherlands, England, and France in the seventeenth and eighteenth centuries.

Encyclopaedia of Art. 4 vols. New York: Praeger, 1971. Articles are written by experts and cover almost anything you will want to know.

Encyclopaedia of World Art. 15 vols. New York: McGraw-Hill, 1958. Use these volumes as a source for any information regarding art and artists.

International Directory of Arts. Berlin: Deutsche Zentraldruckerei. Found in most larger libraries. A reference book that lists names, addresses of museums, art movers, appraisers, colleges, restorers, dealers, publishers, artists, etc., internationally. Very comprehensive.

Lucas, Louise. **Art Books: A Basic Bibliography on the Fine Arts.** Greenwich, Conn.: New York Graphic Society, 1968. A compilation of over 6,000 titles. Comes in paperback.

Lugt, Frits. **Les Marques de Collections de Dessins et d'Estampes.** Amsterdam: Vereenige Drukerijen, 1921, 1956. A widely used reference book listing and illustrating collector's marks.

McGraw-Hill Dictionary of Art. 4 vols. New York: McGraw-Hill, 1969. Good general information for quick reference.

Nagler, G. K. **Neues Allgemeines Künstler-Lexikon.** 25 vols. Vienna: Schwartzenberg & Schumann, 1904–14. A listing of artists. (In German.)

Phaidon Dictionary of 20th Century Art. New York: Praeger, 1971. A guide to art and artists of this century. Good reference book.

Plenderleith, H. **The Conservation of Antiquities and Works of Art.** London: Oxford University Press, 1957. Includes a section on prints and drawings.

Schiller, Gertrude. **Iconography of Christian Art.** Greenwich, Conn.: New York Graphic Society, 1967. Mostly used for scholarly research, but helpful if you want to know about symbolic content in old-master prints.

Thieme, U., and Becker, F. **Allgemeines Lexikon der Bildenden Künstler.** 37 vols. Leipzig: Wm. Englemann, 1907–50. This collection contains invaluable references. (In German.)

Vasari, Giorgio. **The Lives of the Artists.** Reprint. New York: Penguin Books, 1963. This is the beginning of art history. The accounts are not reliably truthful or documented, but it is a very enlightening book written in the lifetime of Leonardo da Vinci and Michelangelo by a contemporary. Paperback.

Oriental Prints

Boller, Willy. **Japanese Color Woodcut.** London: 1957. Boston: Boston Books, 1949. Good introduction to the subject and well illustrated.

Kikuchi, Sadao. **Treasury of Japanese Wood Block Prints (Ukiyo-e).** New York: Crown, 1969. Survey of ukiyo-e masters and woodcuts; heavily illustrated in color and black and white.

Michener, James. **Flowering World.** New York: Scribner, 1967. Easy to read; an account of Japanese life and art from seventeenth to the nineteenth centuries.

Michener, James. **Japanese Prints.** Pleasant to read and an easy way to learn about the subject. Rutland, Vt.: Tuttle, 1959.

Takahashi, Seiichiro. **Traditional Woodblock Prints of Japan.** New York: Weatherill, 1971. Deals with ukiyo-e woodcuts: the works of Hokusai, Utamaro, Hiroshige, and others. Good background information.

Tschichold, Jan. **Chinese Color Prints from the Ten Bamboo Studio.** New York: McGraw-Hill, 1970. Illustrations are superb, the text is scholarly, all on a topic that is not widely known.

Paper and Papermaking

Blum, André. **Les origines du papier.** Paris: Editions de la Tournelle, 1935.

Clapperton, Robert. **Modern Papermaking.** London: Oxford University Press, 1952.

The Dictionary of Paper. New York: American Paper and Pulp Association, 1965. Also has a bibliography that will be helpful.

Hunter, Dard. **Papermaking.** New York: Knopf, 1967. Mr. Hunter devoted most of his life to the study of paper. Very good introduction to the topic. Full of information but not necessarily the latest in scholarly research.

Labarre, E. J. **Dictionary of Paper and Papermaking Terms.** Amsterdam: Swets & Zeitlinger, 1952. Has a bibliography and some sample pieces of papers with descriptions.

Papermaking. Washington, D.C.: Library of Congress, 1968. Excellent short description of process; beautifully illustrated; quite inexpensive.

Sutermeister, Edwin. **The Story of Papermaking.** Boston: S. D. Warren, 1954. History and method.

Institute of Paper Chemistry. Appleton, Wisconsin 54911. This is a paper museum. Their staff is very helpful. Contact them if you are interested in books connected with paper.

Some Exhibition Catalogs

Boston Museum of Fine Arts. **The Artist and the Book.** 1860–1960. Greenwich, Conn.: New York Graphic Society, 1961. An interesting volume on book illustrations by well-known artists, many contemporary ones. Best used for reference.

Boston Museum of Fine Arts. **Albrecht Dürer, Master Printmaker.** Greenwich, Conn.: New York Graphic Society, 1971. An excellent book. Discusses the fine prints in the museum's collection. It is very informative and the illustrations are very good. Also comes in paperback.

Field, Richard S. **15th Century Woodcuts and Metalcuts.** Washington, D.C.: National Gallery of Art, 1965. A beautiful and very scholarly catalog of fifteenth-century prints from the Rosenwald collection. Very informative on early graphics.

Filedt Kok, J. P. **Rembrandt Etchings and Drawings in the Rembrandt House.** Maarssen: Gary Schwartz Publ., 1972. Illustrates the collection of Rembrandt's etchings, nearly complete, in the house where the artist lived for twenty years. Includes discussions of his technique and individual entries for each print.

New England Undergraduate Print Exhibition. Dartmouth College, 1973. A very clear and complete description of the latest methods in printmaking.

Rembrandt: Experimental Etcher. Greenwich, Conn.: New York Graphic Society, 1969. One of the finest catalogs of an exhibit. Discusses paper, ink, and techniques used by Rembrandt.

Shapiro, Barbara S. **Camille Pissarro.** Boston: Museum of Fine Arts, 1973. Discussion in detail on a selection of prints by this artist. Well stated, well illustrated, full of information and new research. Paperback.

Shestack, Alan. **15th Century Engravings of Northern Europe.** Washington, D.C.: National Gallery of Art, 1967. A very fine catalog of early engravings in the Rosenwald collection. Many excellent illustrations and scholarly information.

Periodicals

Art News. A general approach to art: old, modern, all media; timely articles, widely distributed. (Sold at newsstands.) Advertisements may be helpful for locating galleries and supplies.

Artist Proof (now called **Print Review**). Greenwich, Conn.: New York Graphic Society. No longer in print, but do look at the issues in a library. A journal of prints and printmaking.

Burlington Magazine. A fine and scholarly publication.

The Print Collector's Newsletter. 250 E. 78th St., New York, N.Y. 10021. A very informative bimonthly publication with timely articles, book reviews, auction listings, print prices, lists of galleries, and new exhibition catalogs. Excellent for anyone who wants to know what is happening in the print world.

Print Review. New York: Pratt Graphics Institute and Kennedy Gallery. A biannual magazine, beautiful and very informative. The early issues of this magazine, **Artist Proof,** have become collector's items.

Some Art Book Sources

Museum bookstores are a fine place for print collectors to look for art books and general reference material. Those listed here are only a sampling.

Art Institute of Chicago, Chicago, Ill. 60603

Boston Museum of Fine Arts, Boston, Mass. Publications put out by the Print Department cover a wide range of topics, artists, research. The collection of graphics is among the finest.

National Gallery of Art, Washington, D.C. One of the finest print collections in the world is owned by this museum. It includes the Lessing J. Rosenwald prints. Periodically the museum publishes catalogs and books that are invaluable for the print lover.

Philadelphia Museum of Fine Art, Philadelphia, Pa. Some very interesting and scholarly material has been published by this institution.

Rhode Island School of Design, Providence, R.I. Exhibition catalogs of shows arranged by graduate art history students of Brown University. Among them are an exhibit of early lithographs, a show of Callot etchings, one on iconography, etc. All are well worth looking into.

General bookstores, of course, have varying selections of art books. Following are the names of a few booksellers who specialize in the field.

Franz Bader Inc., Washington, D.C. 20037

H. G. Daniels, Los Angeles, Cal. 90057

Legion of Honor Bookstore, San Francisco, Cal. 94121

Museum Books, 48 East 43 Street, New York, N.Y. 10017.

Paul A. Stroock, Jericho, N.Y. 11753

Weyhe, Inc., Lexington Ave. and 61st St., New York, N.Y. They carry current and out-of-print books. Worth going there to browse.

Wittenborn and Company, 1018 Madison Ave., New York, N.Y. Mostly mail or telephone order bookshop that deals only in art books. Rare books, foreign books, exhibition catalogs, art magazines, portfolios—everything can be found here.

Index

Accession number 72, 100
Acid bath 21, 81
'after' Boucher 49, 124
'after' letters 125
Albers, Josef 55, 83
Altdorfer, Albrecht 82
Amman, Jost 77
Antique shops 130
Appraisal 115, 116, 121, 124
Aquatint, See also Intaglio, 8, 25, 26
Art books 97-98, 144, 152
Art dealer, See also galleries, 99
Art dictionary 97, 107
Art libraries 97, 108, 110
Art magazines 97, 152
Artist's proof 59, 65
Auction 44, 108, 116, 120-128
Auction bidding 123, 125
Auction catalog, See also Catalog, 72, 116, 149
Auction mail bid 123, 124
Auction presale exhibit 123
Authentication 57, 71, 72, 107, 117, 126-128, 130, 144

Backboard 133, 137
Backing 133, 137
Basan, Pierre François 108-115
Bavarian limestone 33, 81
Beckmann, Max 48
'before' letters 125
Bite 21, 81
Blindstamp 33, 71
Blockbook 85
Bon á tirer 34, 127
Book illustration 98, 100, 101, 103, 104
Bosse, Abraham 81
Boucher, François 49
Boxwood 18, 81
Braque, Georges 86
Burr 27, 29, 32, 59, 114

Callot, Jacques 23, 81, 82, 93
Canaletto (Antonio Canale) 22, 23
Cancellation proof 65
Cancelled matrix 66, 67
Caravaggio, Michelangelo 104

Catalog (exhibits and auctions) 98, 99, 100, 117, 123, 124, 144, 149, 151
Catalogue illustré 71, 149
Catalogue raisonné 71, 80, 97, 107, 108, 110, 114, 117, 119, 121, 124, 125, 126, 144,
 145, 149
Chagall, Marc 43
Chain lines 75, 79
Chiaroscuro woodcut 18, 19, 82
China paper 74
Chine appliqué 43, 133
Chop mark, See also blindstamp, 65, 71
Clarity of line, 17
Cliché verre 43
Collector's mark 69, 70, 72
College art show 130
Color block 17, 83
Color lithography 34, 82, 105
Color separation 83
Color woodcut 14, 18, 82
Computer graphics 8, 10, 41-43, 64
Computer program 42, 43
Condition of print 101
Conservation 133, 135, 137, 138
Corot, Jean-Baptiste-Camille 37, 43
Counterproof 61, 62
Crisp line 14, 17, 21, 57, 108, 115, 129
Cross grain woodblock 18
Crosshatching, See also hatching, 14, 21, 25, 82, 104

Damage 71, 125, 138
Dandyroll 80
Daumier, Honoré 33, 93, 95
Deckle 75
Deckle edge 69, 75
Definitive catalog, See also Catalogue raisonné, 71, 108, 110, 120, 149
Degas, Edgar 47
Direct image 37
Drypoint, See also Intaglio, 8, 23, 25, 27, 29, 59, 68, 114, 115
Dürer, Albrecht 10, 11, 12, 13, 16, 27, 29, 30, 31, 69, 91, 105, 144
Dutch mordant 81

Early impression 14, 108, 114
Échoppe 82
Edition 17, 29, 36, 44, 57, 58, 59, 60, 64, 65, 68, 71, 99, 127, 129
Edition sequence 59, 68
Edition size 65, 68, 100, 101, 110, 129
Eichenberg, Fritz 20
Embossing 23, 25
End grain woodblock 17
Engraving, See also intaglio, 8, 27-32, 93
Enlarging lens 21, 27
Estimated auction prices 124
Etched glass 21

Etched line 23, 81
Etching, *See also* Intaglio, 8, 21-25, 81, 93, 108-119
Exhibits 98-101

Facsimile edition 74
Fake 102, 128, 129
Flea markets 130
Forged signature 66
Forgeries 129
Formschneider 10
Foxing 135, 136
Framing 136-137, 138

Galleries 98, 99, 100, 120-122, 125
Gauguin, Paul 15, 100, 101
Glassine paper 137
Goode, Joe 59
Goya, Francisco 26, 33, 93, 95
Grease pencil 33
Ground 21, 25, 82
Guarantee 124
Gutenberg, Johann 74, 85, 102

Haden, Seymour 81
Halftone cut and screen 34, 129
Hand cut lettering 85, 88, 102
Handmade paper 68, 69, 74, 75
Hard-ground etching 23, 82
Hard wood (for block) 81
Harunobu, Suzuki 45
Hatching, cross and parallel, 21, 23, 25, 110, 115, 116, 129
High number 17, 68
Hollar, Wenzel 81

Iconographic symbols 86, 87, 88, 104
India paper 74
Ink 17, 23, 57, 101
Ink film (on plate) 23, 114, 119
Intaglio method 21-32
Intaglio process *See also* Engraving, Etching, Drypoint, Mezzotint, Aquatint,
 Mixed media, 8, 21

Japan paper 74
Johns, Jasper 44, 53, 149

Keith, Chris 41-43
Key block 17, 19, 82
Key stone 82

Laid lines 79, 102, 115
Laid paper 75, 80
Late impression 14, 29, 108, 124
Legros, Alphonse 61, 62, 63
Lewis, Martin 32
Leyden, Lucas van 45
Lichtenstein, Roy 36, 54
Light-sensitive solution 36
Limited edition, see also Edition size, 37, 39, 65, 129
Linoleum cut 105
Lithograph stone 34, 81
Lithography, See also Planograph, 8, 33-37, 68, 81, 82, 93, 101, 124
Low number 17, 68

Mail order graphics 130
Maillol, Aristide 51, 117
Manet, Édouard 101
Maniere-noir 32
Mantegna, Andrea 27
Margin 57, 71, 101, 119, 124, 137
Matisse, Henri 50
Matrix 36, 58, 59, 60, 64, 65, 66, 82
Matting 133, 135, 136-137, 138
Mechanical method 8
Meryon, Charles 60
Metal etching 21
Mezzotint, see also Intaglio, 8, 32
Mimeographic stencil 39
Miró, Joan 43
Mirror image 36, 61
Mixed media, See also Intaglio, 25
Monet, Claude 94
Monograph 97
Monoprint 43
Mordant 21, 23, 81
Movable type 85, 88, 102, 104
Multiple bit 21
Multiple original 64, 72, 99
Machine made paper 68, 74, 75
Magnifying lens 21, 27, 100, 104

Numbered edition 44
Numbered impression 37, 64, 65, 100

Off register 17
Off-set, See also Photo off-set, 8, 33, 35-38, 43, 64, 65, 81
Oriental papers 74, 80, 114
Original 33, 37, 64-65, 66, 97, 98, 99, 101, 102, 107, 108-117, 123, 129
Original edition 44, 64, 65

Panofsky, Erwin 84
Paper and paper making 17, 23, 57, 68, 69, 73-81, 110, 114, 115, 151
Paper sizing 79
Papermold 68, 69, 73, 74-77, 80
Papyrus 73
Parallel hatching, See also Hatching, 29, 82
Parchment 73, 86, 114
Peintre-graveur 29
Picasso, Pablo 27, 33, 43, 51, 68, 94, 95, 96, 126-128, 144
Piranesi, Giovanni Battista 96, 105, 107
Pissarro, Camille 23, 24, 81
Photographic method, See also Off-set, 36, 64, 94, 129
Photographic stencil 39
Photography 94
Photo-lithography 34
Photo-mechanical copies 66
Photo-mechanical method 98
Photo off-set, See Off-set
Planographic method, See also Lithography, 8, 33-42
Plate wear 29
Platemark 71, 115, 119, 129
Poster art 33, 39, 43-44
Posthumous impression 65, 71, 124
Preservation 134
Print club 129
Print room 29, 97, 100, 108, 114, 126, 133
Print values 6, 7, 99, 108-115
Printer's skill 33
Printing sequence 65, 68
Proof 34
Provenence 72, 108, 116
Pulp 73, 74, 76, 79

Quality difference 108-115

Rag mat 137
Rauschenberg, Robert 36, 38, 39
Redon, Odilon 46
Register 17, 18, 39, 79, 82, 83
Relief etching 25
Relief method, See also Woodcut, Wood engraving, and Relief etching, 8, 10-12
Relief print 14
Rembrandt van Rijn 10, 23, 25, 27, 28, 65, 66, 69, 73, 81, 94, 98, 108-115, 126
Repair 71, 125
Reprints 65
Reproduction 34, 37, 44, 64, 98, 101, 102, 108, 122, 123, 131
Reserve 123
Restoration 71, 133, 137, 138
Restrike 25, 66, 108, 122, 129, 130, 131

Reversed image 37
Reversed signature 36
Reworked matrix 67
Rich black 23, 34, 108, 114, 115
Roman numeral 61, 65, 127, 128
Rosin 25
Rouault, Georges 52

Schongauer, Martin 27
Screen print, See Silk screen
Senefelder, Aloys 33
Serigraph, See Silk screen
Shady practices 124, 126, 131
Signed edition, See also Signature, 44
Signed in the plate 59, 100, 110
Signature 17, 33, 36, 37, 44, 64, 65, 66, 71, 100, 101, 119, 125, 129
Silk screen 8, 37-40, 43, 44, 65, 68
Sloan, John 7
Soft-ground etching 21, 23, 82
Solander box 100, 137
Soyer, Raphael 58
Spiked rocker 32
Sqeegee 39
State 60-63, 68, 71, 100, 107, 108, 109, 110, 111, 112, 113, 114, 115, 127
Steelfacing 59, 66, 129
Stella, Frank 40
Stencil, See Silk screen
Stone-to-stone transfer lithography 36
Stop-out liquid 39
Stopping out 21, 25
Storage 135, 137, 138
Style 94, 95, 96, 97
Sunlight 135
'Superdealers' 122
Swelling line 14, 29

Tapering line 14, 29
'Text on verso' 125
Tiepolo, Giovanni Battista 96
Tinted paper 18
Tonal gradation 23, 25, 29
Tone block 18
Tone-on-tone color block 18
Toulouse-Lautrec, Henri de 33, 35, 43, 44, 105, 125
Transfer lithography 33, 34, 35, 36, 64, 119
Transfer paper 34, 36
Trento, Antonio da 19
Trial proof 60, 65
Tusche 34

Twilight dealers 126

Ukiyo-e woodcut 82
Unauthorized edition 124
Uneven inking 17

Vellum 68, 73
Vlaminck, Maurice 33

Warhol, Andy 7, 37, 39, 83
Watermark 57, 69, 70, 71, 75, 77, 79, 80, 85, 100, 102, 108, 114, 115, 125, 133
Whistler, James Abbot McNeil 23, 81, 117-119
Wood engraving, See also Relief, 18, 20, 101
Wood grain 14, 17, 81
Woodblock 11, 12, 81, 104
Woodcut 8, 11-21, 93, 102, 104, 105 See also Woodcutter Relief 10-11
Working proof 21, 60
Worn block 14, 104
Worn impression 57, 114, 116
Worn plate 114, 116
Wove paper 75, 80

Xerography 64